# DESIGNING
# CREATURES & CHARACTERS

## HOW TO BUILD AN ARTIST'S PORTFOLIO FOR VIDEO GAMES, FILM, ANIMATION AND MORE

### MARC TARO HOLMES

**IMPACT**
CINCINNATI, OHIO
www.impact-books.com

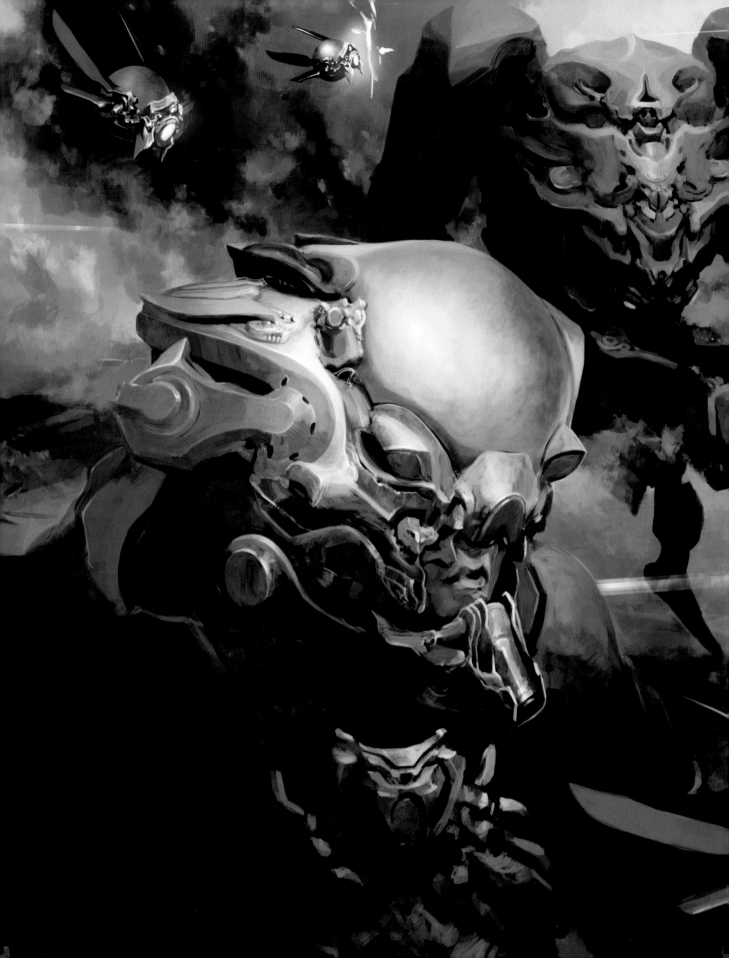

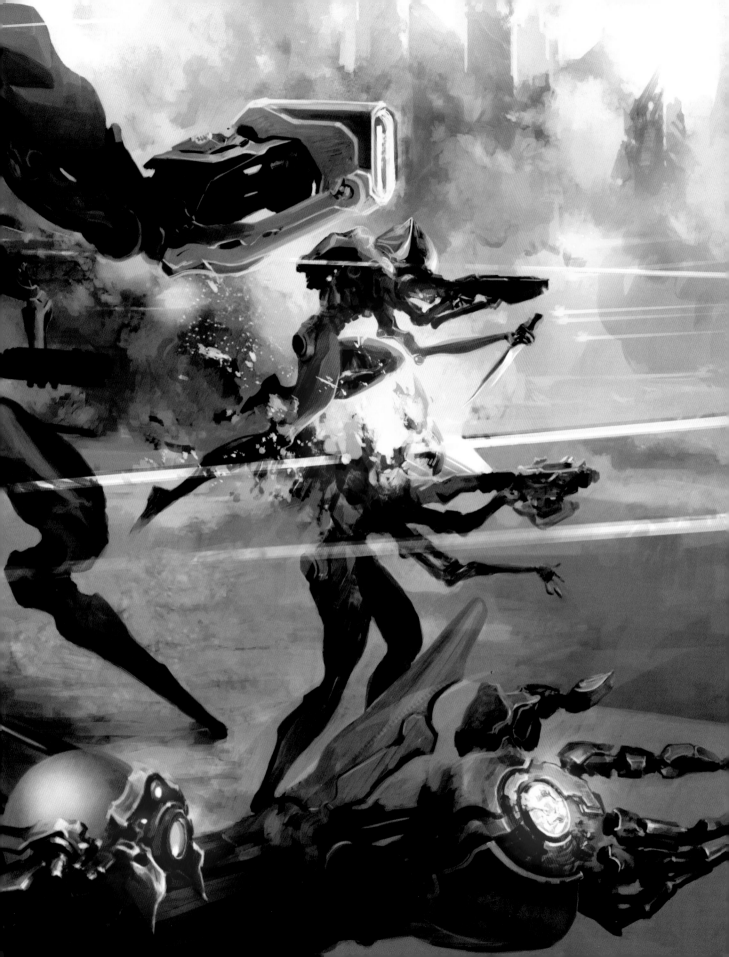

# CONTENTS

## LEVEL ONE

# IDEATION:

*BRAINSTORMING, THE EXPLOSION OF IDEAS*

PG: 24

## LEVEL TWO

# ANATOMY:

*PLANNING FOR CONSTRUCTION*

PG: 70

LEVEL THREE

# ANIMATION:
## *SHOWING YOUR CHARACTERS IN MOTION*

LEVEL FOUR

# ILLUSTRATION:
## *THE FINAL PRESENTATION*

# WHAT IS THIS BOOK ALL ABOUT?

*Designing Creatures and Characters* is the answer to the question: "How do I get a job as a concept artist?"

Inside this book you'll find a self-guided, work at your own pace, hands-on training program for aspiring entertainment media concept artists. The program will help you build a professional artist's portfolio demonstrating a complete understanding of the design process.

Hiring managers need to see that you can be creative within constraints, that you can match the emotional tone of an ongoing project, and most importantly, that you can be relied upon to support the art team with an unlimited flow of innovative ideas.

The projects within are designed to help you apply your existing drawing skills to character design. Or if you are still training your drawing, they'll help you do that faster while at the same time developing your mind into an idea generating machine.

All the projects are based on twenty-plus years of experience working as a concept artist and art director in video games and feature animation. Most are developed from actual on-the-job situations. All of them are based on the things hiring managers look for when selecting concept artists for their teams.

Over the 36 projects with 155 possible artistic achievements that follow, you'll be exposed to every type of conceptual problem you might encounter as a professional creature or character designer.

# WHO IS IT FOR?

Ideally you are someone interested in video game development, comics, animation or film production and you want a little help enriching your portfolio. Even if you're still just honing your drawing skills, this book will show you where to go on your journey and help you improve your work.

Maybe you're a recent graduate coming out of art school or an illustrator working in another field, or maybe you've just been drawing all your life for the enjoyment of it.

Possibly you're already a 3-D artist or animator, and you want to expand your skills to include the ideation behind the production art you already do.

If you feel like one of these describes you—I wrote this book for you!

# WHAT IS A CONCEPT ARTIST?

The concept artist is the imagination engine that drives the production team.

They, along with the art director and sometimes a game designer, storyboard artist and scriptwriter, invent the visuals that convey the story.

A concept artist has to offer a wide range of ideas from which the art director, producer and director choose the final designs. It's not enough to make one amazing version. The team often needs to see alternate suggestions. You're very likely to be sent back to the drawing board— sometimes repeatedly. You must be a fountain of ideas, and never get discouraged if any of them don't stick.

The concept artist must also be a skilled illustrator. Ideas need to be clearly understood and presented in the best light possible. You must *sell* the concepts to the team. This can mean mastering drawing and digital painting, or becoming a 3-D modeler or possibly even sculpting in clay.

A concept artist is also a bit like an industrial designer or architect. A concept artist may have to create blueprints and construction diagrams that will be used by the production team building the in-game or on-screen content.

It's a demanding career, but it's also a lot of fun. Artists who develop their imaginations along with their drawing skills will be rewarded the rest of their lives. There is a great deal of fulfillment and satisfaction to be had in the conceptual designer's role. Should you move on to other things, you'll find the process you've learned is applicable to any kind of creative work.

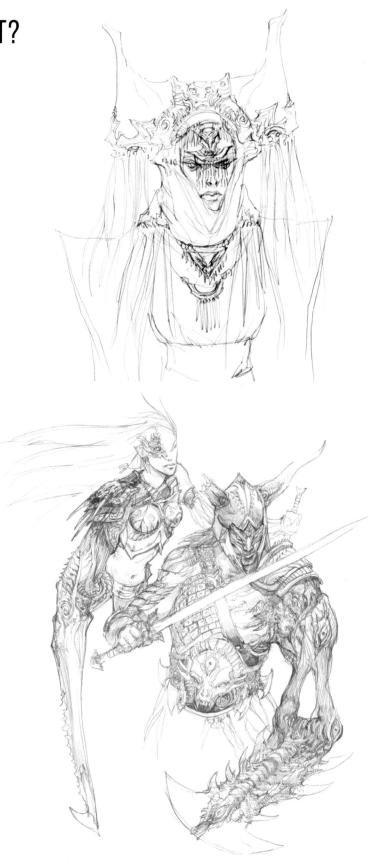

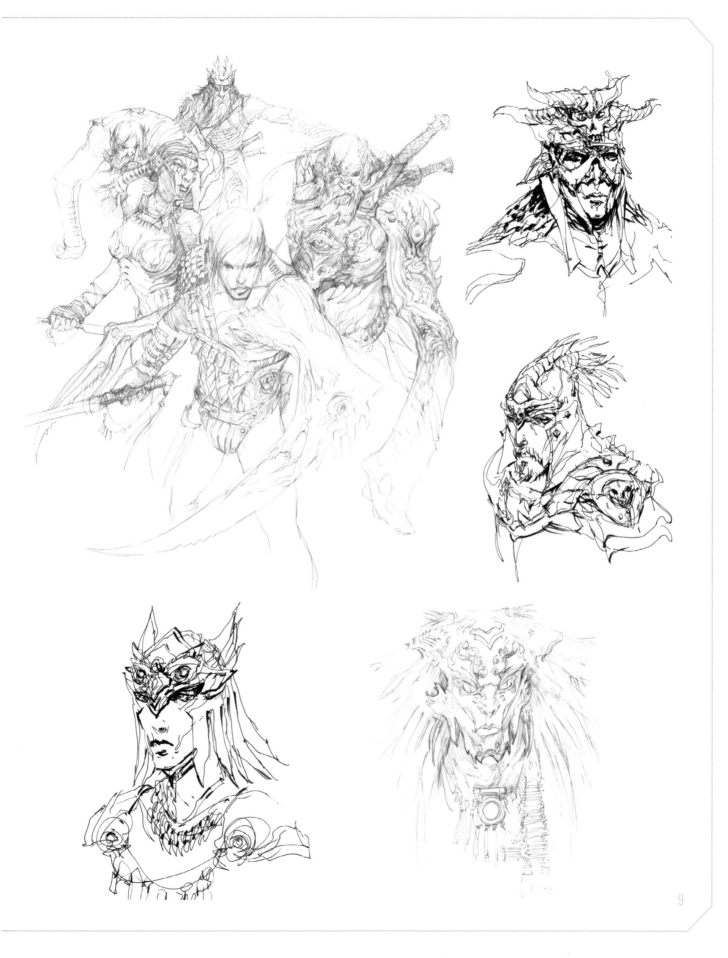

# HOW CAN I GET THE MOST OUT OF THIS COURSE?

This course is focused on thinking and sketching. We are exercising the brain, not the hand. This is a workout for the imagination, a boot camp for creativity.

Any working concept artist needs to be proficient in digital painting. It's simply the easiest way to work quickly, be responsive to multiple revisions and share your work with the team.

But in this book we're not going to worry about that. I'm going to assume you have the digital art skills in hand, or at least you're working on them. There are plenty of online courses, video tutorials and web communities that can help with that.

*I'll let you in on a secret:* I actually don't feel the finished artwork is all that important.

It might be the highest goal for the illustrator or a fine artist, but it's not the most critical element for the conceptual designer. Creating a pretty drawing is just the cleanup after the explosion of ideas.

Don't get too absorbed with making beautiful paintings and certainly not at the expense of generating more ideas. This is not a case of less is more. More is actually more. When you feel you can't possibly have a better solution, go back and try for three more.

One day you'll notice you have some amazing ideas in your portfolio. You'll look around and wonder "Why is everyone else's stuff so boring? Couldn't they come up with something less derivative, less obvious?" You'll suddenly find you're thinking at a different level from more technically minded artists.

Of course, there's a time for polishing, and there are good reasons to make compelling images, but there is a great danger in taking a weak idea to completion. Don't get lured down that path. Your goal should always be the most innovative ideas and the freshest vision.

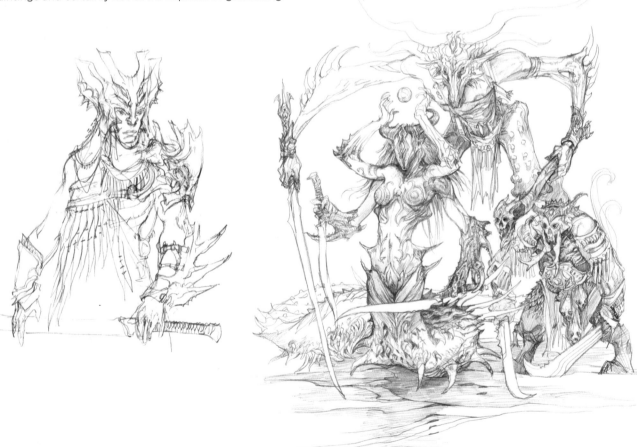

# HOW DO THE PROJECTS WORK?

There are four levels, organized to follow the creature design process from start to finish:

- Level One: Brainstorming
- Level Two: Anatomy
- Level Three: Animation
- Level Four: Illustration

Each level incorporates skills from the level before. As levels advance, they offer increasingly complex design problems that call for increasingly skillful artistic rendering and problem solving.

Within a level, the projects are designed to offer a range of thought-provoking subject matter, each with its own unique requirements. These have been carefully planned to guide you toward the results that art directors will want to see.

Take as much time as you like to complete a project. Naturally on the job you'll be given deadlines, but for training purposes it's worthwhile to invest in the work. As you build up your skills, you'll get faster.

If you find something too easy, then push to complete all the bonus achievements, or move up a level. You can always come back if you want more practice on fundamentals.

You can do projects in any order. Choose which projects appeal to you, maybe skip anything that doesn't. The choice of what you do, and what you skip, will be part of customizing your own portfolio. However, each project has its own unique requirements, so there is a lot to be gained from completing everything.

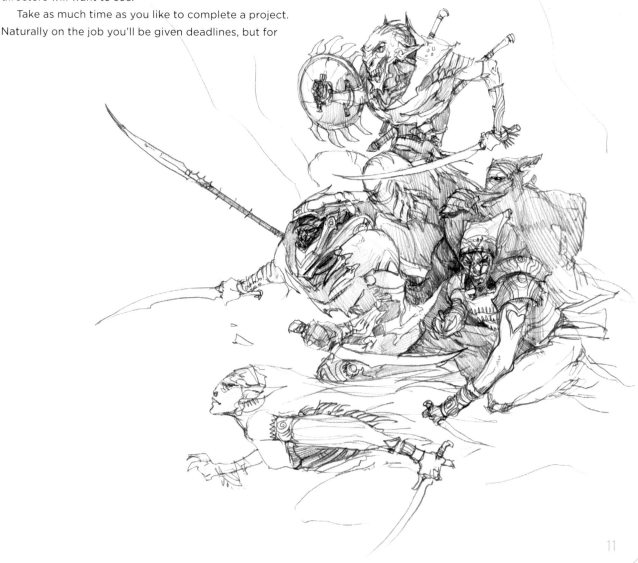

# ABOUT ACHIEVEMENTS

Any self-training program must have a way to track progress. Achievements are virtual merit badges—small rewards you can claim for reaching specific goals, bragging rights or self-congratulations. However you think of them, it's one way to track how much you've accomplished.

In sports it's easy to judge progress. The amount of weight you can lift or the speed you can run, these things are measured numerically. If you track the numbers, you can see a nice graph of your progress. And you can give the person with the biggest numbers a medal.

With art, it's a little harder to measure. To that end, I've borrowed the idea of *Achievements* from modern video gaming. This is a motivational, self-assessment tool that will be very familiar to anyone who plays video games.

## GETTING ACHIEVEMENTS

You'll see as you dive into the projects that each project has a list of **minimum achievements**. These are the basic things you would have to submit to get an idea into the next stage of production. If you just do all of these minimum goals, you'll have done quite a bit of work already, and you can cheerfully claim the achievement.

**Bonus achievements**—These are larger goals worth pursuing. You can do bonus achievements in any order, pick and choose, do only your favorites or try to do them all. And, of course, you can push any project even further, overdelivering even beyond the suggested bonus content. Go ahead. Make everyone else look bad.

Some of these achievements are about the total quantity of sketches. Often the first few ideas come easily, but pushing on to a few more and a few more after that becomes hard work. Your brain is wrung dry. It seems like there aren't any ideas left. This idea-generating ability is exactly what you need to train the most. Build your mental stamina and your powers of imagination.

Other achievements are about the visual quality of your drawings. They are there to challenge your drawing ability and advance your digital painting, to keep pushing yourself to provide the most compelling presentation.

All of them contribute toward your speed. If you are able to complete the stretch goals, you'll be forced, by the sheer effort involved, to get faster and faster at thinking and drawing.

Claiming some of these achievements might seem unnecessarily difficult. But that's why they are there. The people who go the extra distance can claim the bragging rights, and of course, reap the benefits from the extra practice.

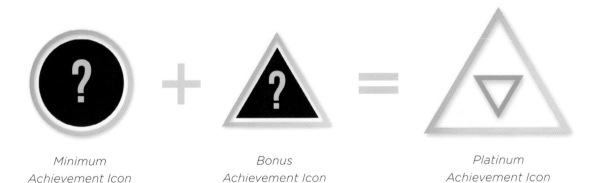

*Minimum Achievement Icon*   +   *Bonus Achievement Icon*   =   *Platinum Achievement Icon*

Received once all Chapter Achievements have been completed

# WHY IS THE BOOK DESIGNED THIS WAY?

I'm hoping you'll want to approach these exercises with a mindset of overdelivering. What's the point of doing the minimum required?

You are investing in yourself, in training your drawing and thinking. You're developing your judgment as a designer. Why would you want to skate through doing the minimum? The more you can do, the more you will learn.

I would love it if, when you finish a project, you enjoy it enough to try it again with a new approach. If you can come back to a challenge with fresh eyes, trying it in different ways, having fun with it, you will find yourself doing your best work.

I believe that artistic ability is not a gift or a talent. It's a skill developed by repetition, by practice, by self-training. Just like a sport or playing a musical instrument, you need hours of self-guided practice to etch skills into your brain.

The ability to invent imaginary things is just as challenging as the ability to draw from reality—possibly more so. In order to master drawing the human figure, an artist might draw from the live model for hundreds of hours. The same time investment in self-training applies to having ideas on demand.

You need to be a fluent, descriptive illustrator, capable of communicating clearly on any subject matter with any emotional tone. You'll need a vast data bank of design solutions in your head and the experience to quickly incorporate new subjects you have never drawn before. That's a tall order.

So you might as well get started training. And you certainly should have fun with it. If you're enjoying yourself, drawing things that entertain you, you'll be more likely to put in the hundreds (even thousands) of hours it might take to reach your goals.

| *Minimum Achievement Icon* | *Bonus Achievement Icon* | *Platinum Achievement Icon* |
|:---:|:---:|:---:|
| ? | ? | ▽ |
| YELLOW = LEVEL 1 | | |
| ? | ? | ◇ |
| RED = LEVEL 2 | | |
| ? | ? | ⬡ |
| BLUE = LEVEL 3 | | |
| ? | ? | ⯃ |
| PURPLE = LEVEL 4 | | |

# A NOTE ON INDIVIDUAL STYLE

Every concept artist should be working to define their individual style: the style of drawing or painting we prefer to work in combined with the subject matter we are expert in.

You have to know yourself. Know what you're passionate about.

An employer is going to be looking at your style and deciding if it works for them. You're seeking the best fit possible. If you love lighthearted, stylized cartoons, you're probably not a great fit for a studio that does gritty realism and dark, brooding story lines. They wouldn't find your work helpful, and you wouldn't enjoy being in that mindset day in and day out. Equally, if you want to do serious adult-oriented work, you'll just be frustrated if you're making cute cartoon animals all day long.

So it's best for everyone if you don't try to be too flexible. You have to decide how much variety you are going to offer. Yes, some flexibility opens more doors.

But too much makes you look indecisive, someone who isn't 100 percent committed to the project the studio is looking to build.

I recommend an 80/20 rule. Stick to your passions (80 percent of the time), but have a few pieces (20 percent) in reserve that show the range of styles you're comfortable with. Don't lead with this work, but have it available to show if specifically asked.

As you go through the exercises that follow, take responsibility for your own style! Execute each one in a manner that is true to yourself.

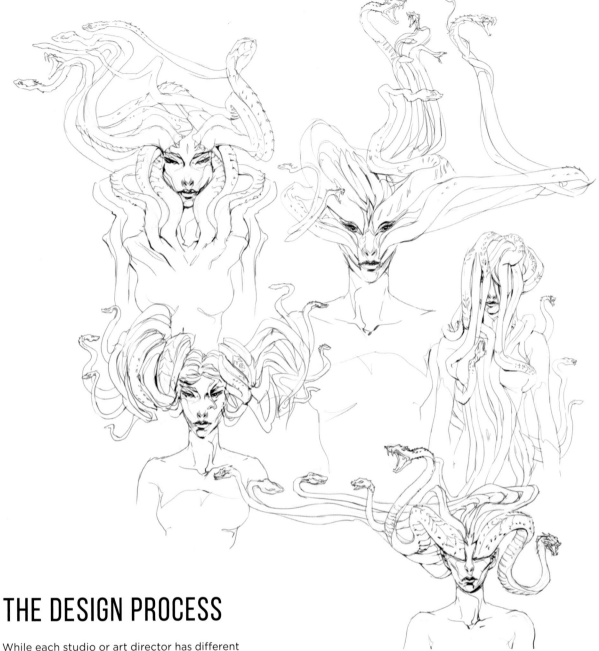

# THE DESIGN PROCESS

While each studio or art director has different expectations, there is a generally shared method to concept art. It's similar to what is done in industrial or product design, or the steps that go into an advertising campaign.

I'll go into detail about the artwork you'll be doing at the beginning of each level. For now, this is a summary of the working method.

## 01: IDEATION

The first step is brainstorming. This is where you get your ideas on paper. You'll do your research and make tons of rough sketches. The total quantity of ideas is what matters here. There are no bad ideas while brainstorming. Rough drawings are a cheap way to explore. Many ideas will be rejected along the way to finding the best approach.

## 02: ANATOMY

Before the team can build your character, they need the blueprints. This stage is about accurately describing anatomical details. You need to document the character from all sides. Any unusual forms need to be spelled out, and any clothing or equipment has to be described. Sometimes you'll need to show internal hidden structures.

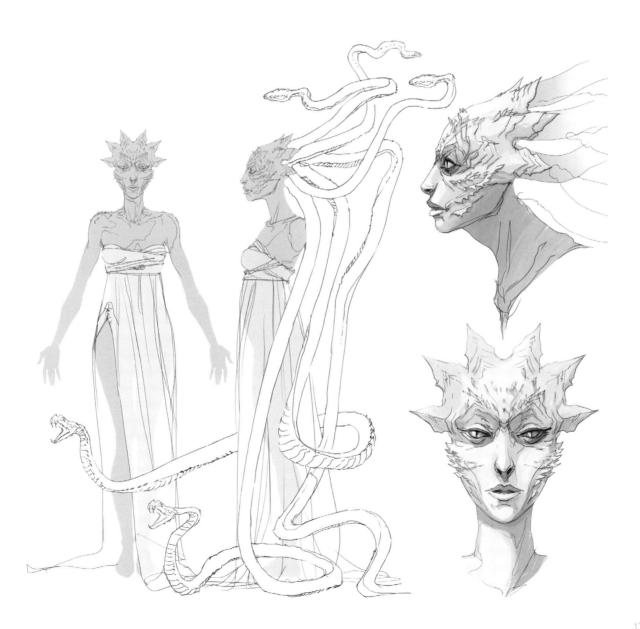

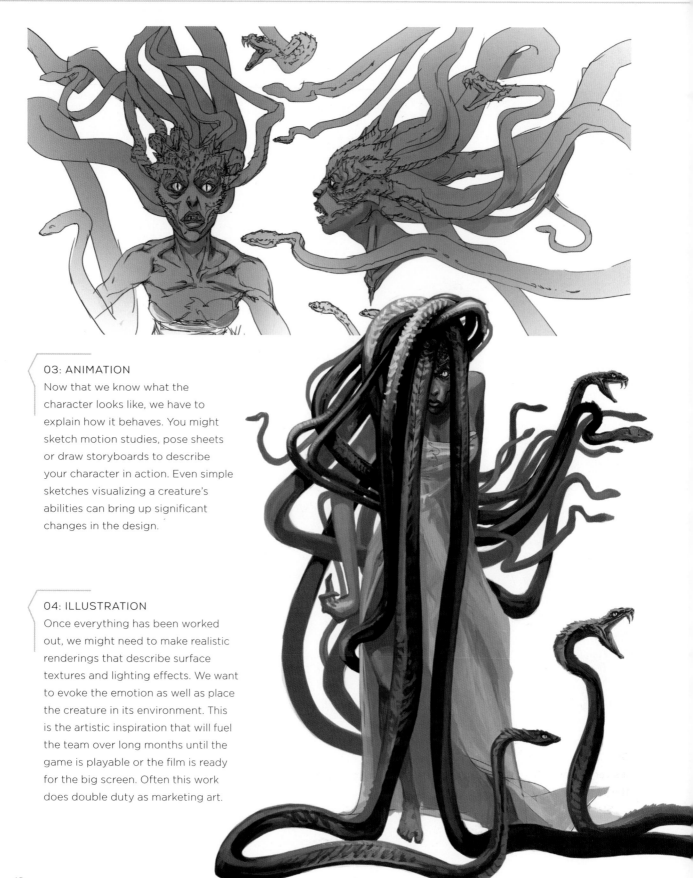

### 03: ANIMATION

Now that we know what the character looks like, we have to explain how it behaves. You might sketch motion studies, pose sheets or draw storyboards to describe your character in action. Even simple sketches visualizing a creature's abilities can bring up significant changes in the design.

### 04: ILLUSTRATION

Once everything has been worked out, we might need to make realistic renderings that describe surface textures and lighting effects. We want to evoke the emotion as well as place the creature in its environment. This is the artistic inspiration that will fuel the team over long months until the game is playable or the film is ready for the big screen. Often this work does double duty as marketing art.

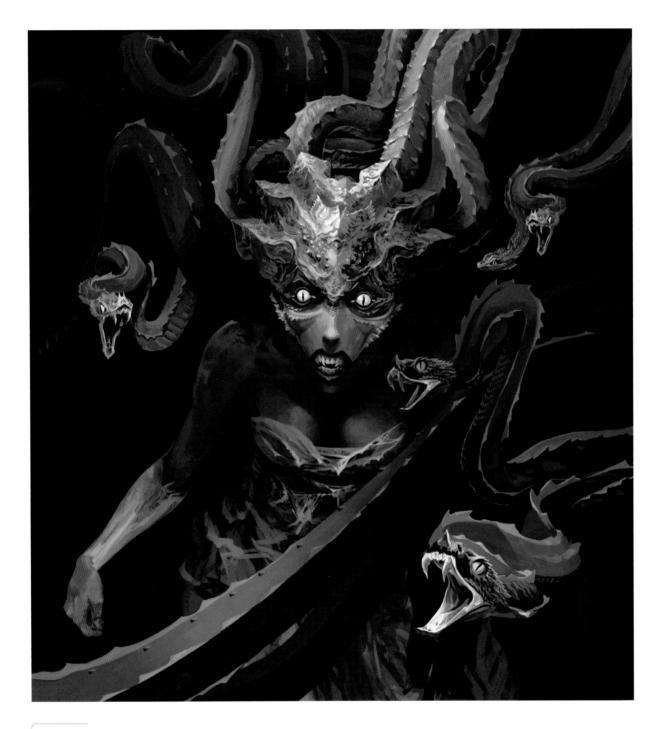

## 05: RINSE AND REPEAT

It's very common to be sent back to a previous stage in the process.

Stakeholders outside the art department often need to see a completed design before they can make a judgment call. Often nobody wants to approve the first few ideas in case they can get something even more amazing with just a bit more of your effort.

A professional should never see this as criticism. It's not! Asking to see more ideas is all part of your value as a concept artist. Your role is to be a never-ending fountain of possibilities.

# PAINTING BASICS:
## *FROM BLOCKING IN TO SELECTIVE FINISH*

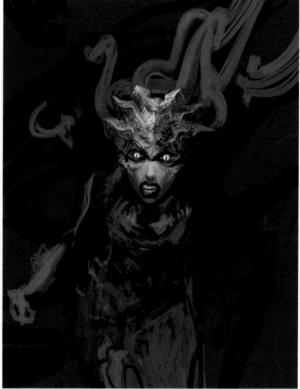

### 1 BLOCK IN VALUES

In general, while a sketch will often start with a line drawing, an illustration usually starts as a painted value study. An image built from the start in value and color is more suitable for dramatic lighting, which is the secret to conveying emotion.

To achieve strong lighting, I start on a dark background, working from dark to light in the same way as a traditional oil painter. You can begin by blocking in the silhouette shape with broad brushstrokes. You want to set up the composition of the image before painting small details. Get the movement right before sinking a lot of time into detailed surface texture.

### 2 DEVELOP THE FEATURES

This character is a fairly classic version of the mythological Medusa. Structurally, it is just a woman with snakes for hair, nothing more complex than that. But the devil is in the details. How we will design *our* version of the snake-haired demon.

The extreme length of this character's snakes allows them to flow from her head like a veil touching the ground. The concept is the snakes form a screen hiding the face, and only at the last minute are they thrown back to reveal the eyes that turn you to stone.

## 3 ADD LIGHT AND FORM

Starting from an almost abstract composition of twisting snake bodies, we can gradually add in light to sculpt forms. It's not necessary to make realistic detail on the skin or cloth. The human aspect of the character is common sense information that can be answered with reference photos. In the illustration, you should spend more time showing the scaly headdress and the spiny snake bodies. These are unique details that explain the design.

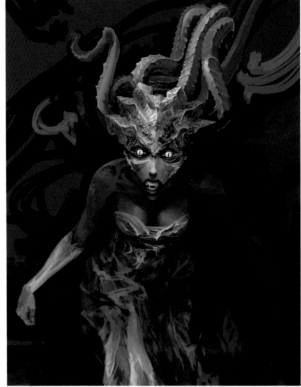

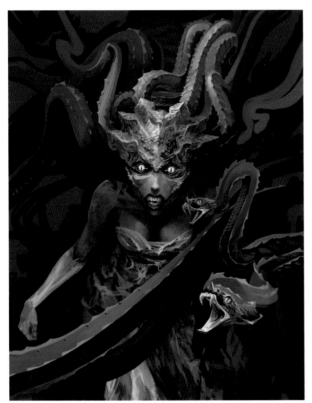

## 4 TIGHTEN FOCAL POINTS

The final steps are detailing the snake heads and smoothing out the lighting. Digital painting is ideal for control of light. This is not realistic lighting. It is intentionally theatrical—designed to spotlight important details and to build the feeling of the character lunging out of the darkness.

The entire composition from the first abstract design has been planned to properly organize the snake heads around the face. This may be mainly a character sketch, but it is also meant to be a storyboard frame, a composition for a final on-screen shot.

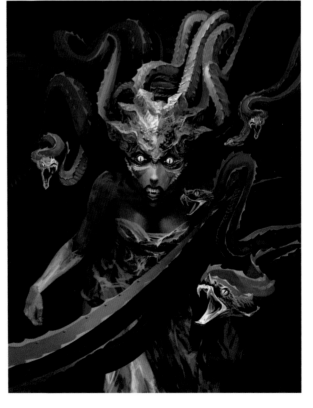

# FINAL PREPARATION: THE PROJECT BRIEF

Every project needs to start with a written project brief so everyone on the team has clearly established, mutually understood goals. Often this is a simple written description, sometimes just a single sentence or bullet points on a list of tasks.

If you end up in a situation where there is no written brief or if the description seems a bit thin, it's a great idea to write one yourself. A half hour spent on this task can save you a week of drawing. This is just good professional practice and everyone will respect you for taking the time to get on the same page.

There's no perfect checklist that fits all cases. Just think about what you need to know before you draw. Writers and designers might have hidden preconceptions. Sometimes the answer from the team is "We don't know, it's up to you!" That's great. It gives you the green light to come up with your own ideas.

Although this can be tricky, if there is no clear direction, it can turn into a case of "I still don't know. Keep trying. I'll know it when I see it." We'll go into detail later for how to deal with this common situation.

The main thing in this step is to find out if there are any hidden requirements before you begin. See the example project brief for the kind of questions you might need to ask.

# REFERENCE MATERIAL

In addition to the written brief, it can be efficient to use reference images to narrow down the conceptual search.

Much of the time, the art director or the game designers will provide you with reference images. But as a concept artist, I like to volunteer to do this for them. If you're the one who chose the inspirational images, if they come from your own taste and judgment, it's much easier to generate ideas.

It's common to see two types of reference collection:

**Mood boards:** A mood board is a collage of images taken from any source imaginable—other products and artists, from art history, from stock photos, from your own photos—and presented in a compact collage (small images, densely packed). The goal is an at-a-glance visual summary of the project's tone and color space.

**Reference collages:** In an anatomical collage, you are identifying specific structural or scientific details that might go into a creature.

If the design in question is based on reptiles, for instance, you would catalog a specific range of real-world reptile anatomy to be your agreed-upon starting point.

With both of these types of reference material, it's important that your selections be consistent. Be decisive, don't leave things open ended. Answer questions; don't provide too many options. What you leave out is just as important as what you put in. Anything that can be cut from the reference material now is saving everyone time later.

This way, when you hand in a creature that looks like a newt living in a jungle, they are less likely to say "I was expecting a komodo dragon on an ice planet."

# PROJECT BRIEF

## WHAT ROLE WILL THIS CREATURE/CHARACTER PLAY?

Antagonist, sympathetic character, sidekick, background element?

_____

## DOES IT HAVE ANY SPECIAL ABILITIES OR PHYSICAL DESCRIPTION REQUIRED BY THE SCRIPT/GAMEPLAY?

_____

_____

_____

_____

_____

- Is it unusually powerful or exceptionally weak?
- Is there an unusual magic ability, special power or combat skill?
- What is its size: human scale, elephant size, house size, 30 stories tall, planetary scale?
- What form of locomotion: walk, fly, swim?
- Biped, quadruped, other?
- Is it based on an animal: reptile, mammal, insect, some combination?
- Should it reflect a geographic setting or environment?

## WHAT IS THE TARGET LEVEL OF REALISM?

_____

_____

_____

- Creature should look convincingly real as if it could exist in the real world.
- Creature is exaggerated for heroic effect.
- Both of the above (most common).
- Creature should look stylized in a specific way, e.g., 3-D cartoon animation.

## IS THERE ANY THEMATIC ART DIRECTION?

_____

_____

_____

- Fictional genre: science fiction, fantasy, military, modern-day horror, historical.
- Pop cultural cues: retro, kid friendly, anime, manga.
- Mythological or cultural themes: Norse, Mayan, etc.

## MOST IMPORTANTLY: WHAT IS THE OVERALL EMOTIONAL TONE WE ARE TRYING TO HIT?

_____

_____

_____

- What kind of people are the target audience (age, geographical region, demographics)?
- What reaction should they have to this creature (fear, love, hate, intrigue, lust)?
- What is the intensity of reaction we want to provoke (amusing fun, pants-wetting shock)?

## LEVEL ONE
## *IDEATION*

### ACHIEVEMENTS

**MINIMUM:**

**BONUS:**

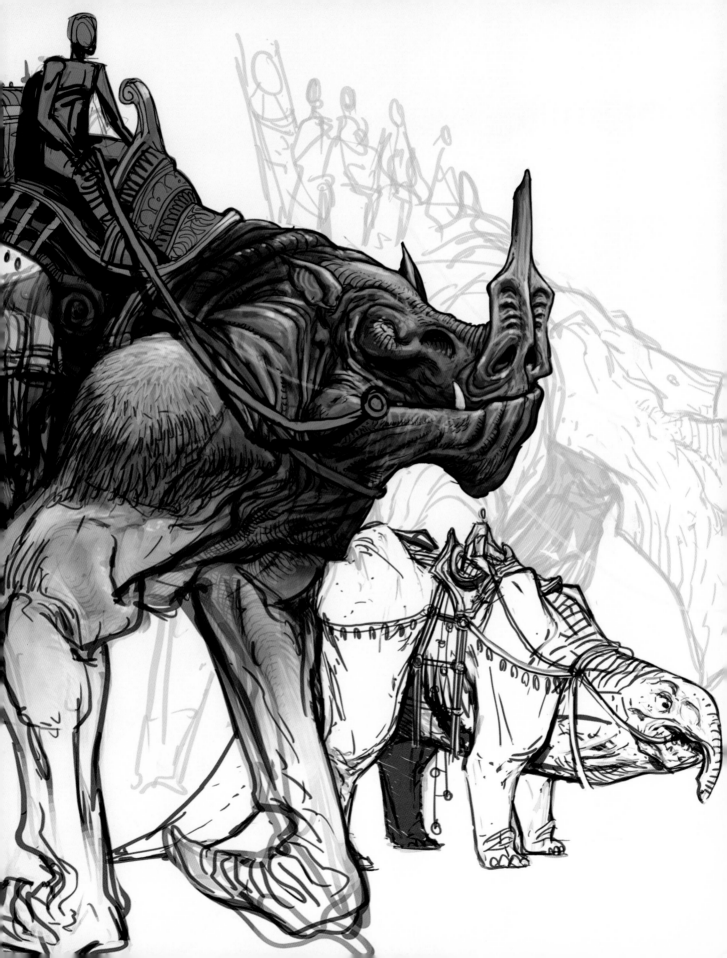

# IDEATION:
## *BRAINSTORMING, THE EXPLOSION OF IDEAS*

What kind of drawings do I start with? Ninety-five percent of the drawings you will do as a concept artist will be little more than doodles—each one an idea sketched as efficiently as possible. Your first goal is to discover the widest range of unique ideas in the shortest amount of time.

You want to provide useful options for your art director, presented as objectively as possible. Aim only to communicate the concept. Don't worry too much about a perfect drawing. Don't get tied up in rendering. For now, these drawings are disposable, a means to an end. Most will be cheerfully discarded in your search for the best approach.

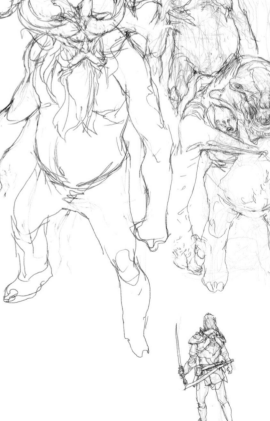

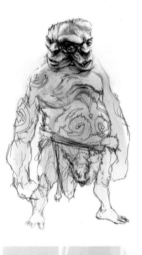

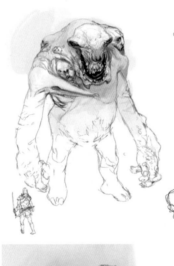

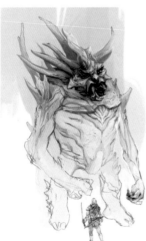

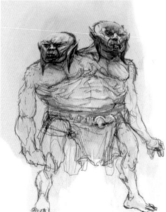

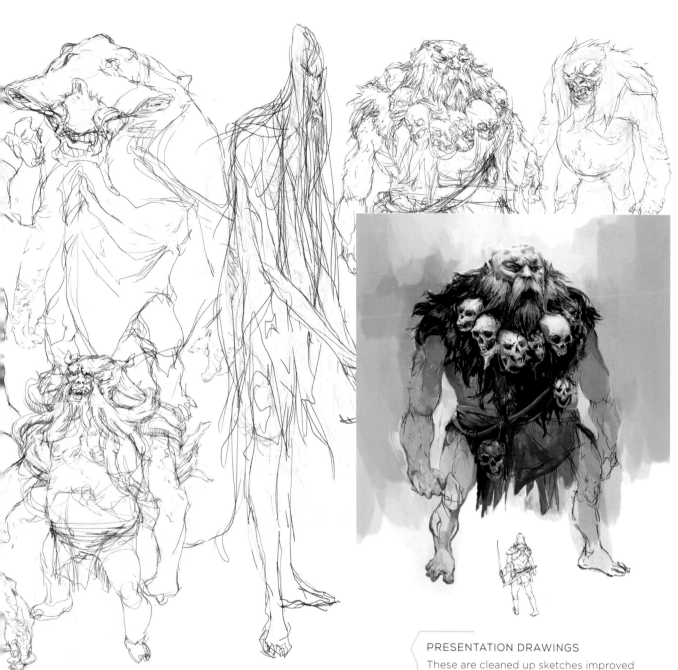

### BRAINSTORMING SKETCHES

These are often pencil or pen-and-marker drawings (or digital equivalents), executed very quickly, sometimes in as little as ten to fifteen minutes each. These are almost always black and white, but sometimes accented with shadow tone.

Many people work on a graphics tablet or touch-and-stylus-screen (Wacom Cintiq, Microsoft Surface, etc.). There is a natural efficiency to digital drawing. It's easier to refine a drawing in layers and to be able to copy and paste or scale and stretch parts of drawings.

### PRESENTATION DRAWINGS

These are cleaned up sketches improved just enough to present for critique. Clarity is everything. Composition or style isn't that important yet. At this point, you are just after feedback about the ideas.

Occasionally this is an entirely new drawing, but usually I'll start with the brainstorming sketches and paint over top. This might be a two-hour job or a day's work, depending on the importance of the design.

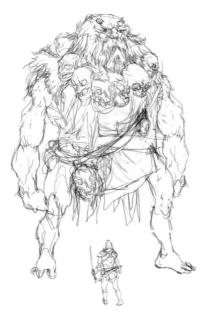

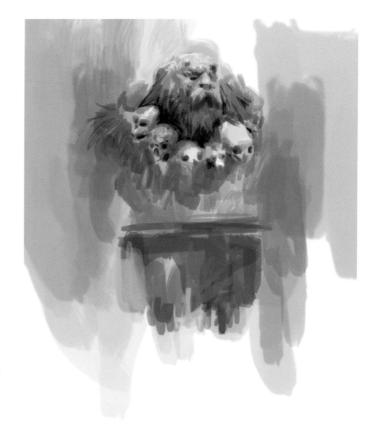

## 1   SKETCH

Often you'll end up with dozens of quick sketches that represent possible solutions. The best way to improve all these drawings for presentation is to bring the sketch into Adobe® Photoshop®.

## 2   UNDERPAINTING

The fastest way is to start painting color *underneath* the drawing—like a cartoon animation cel or comic book drawing where the line art is above the tone. This lets you try out color ideas very quickly, as you can paint loosely without interfering with the drawing. You can use as many layers as you like, trying out different color combinations before merging them together.

This is what is actually painted on the layer underneath the drawing. See how little detail is required? Let the line drawing do the work!

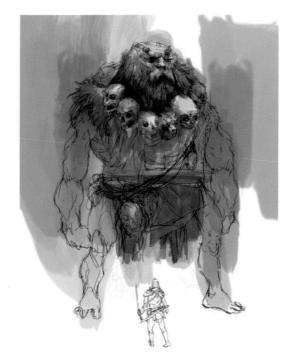

## 3   MULTIPLY THE DRAWING OVER THE TOP

When you set the line drawing layer to Multiply on top of your roughly painted color, the line art and underpainting combine like this.

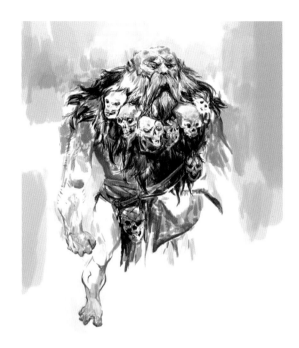

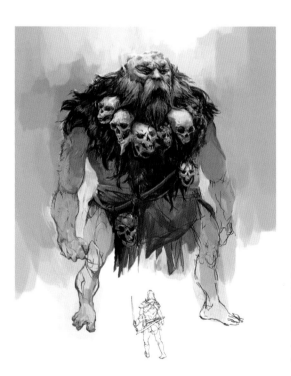

## OVERPAINTING FINE DETAILS

**4** The next step is to selectively refine the details with a third layer on top of the stack. You really need only three layers: base tone, line art and opaque retouching. They work together to make the final image. Again, see how little is actually painted on top? What is the least work you need to improve what's below? Because the sooner you can see your idea, the sooner you can evaluate if you need to try another one!

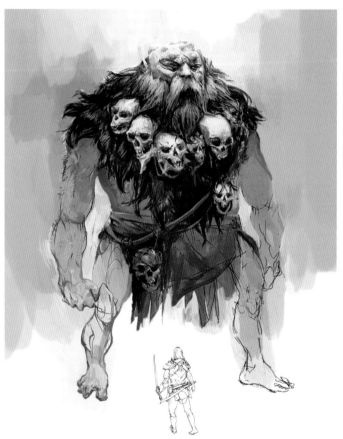

## FINAL COMBINED STACK

**5** When you put it all together you get the best of both worlds. The sketch is still doing a lot of the work—it's full of detail after all—but you can paint over the face or other important areas and make focal points look more finished and more three-dimensional. This method lets you target where you want to invest in detail and where you want to let the drawing stand on its own.

# ABOUT BRAINSTORMING

For a concept artist, brainstorming is the act of thinking on paper, as quickly as possible. This is not making bad drawings on purpose, but not worrying about refinement either. Just get the ideas down, showing them clearly and being quick about it.

There are two reasons why this is the most important part of the concept artist's job.

**First: Great ideas are found on paper.** Every artist will tell you they can't just sit there and come up with ideas. During the act of drawing, the subconscious kicks into gear and the connections occur like magic. Ideas happen while your conscious brain is distracted doing hand-skills.

**Second: Drawing an idea is the fastest way to prove if something works (or not).** Every concept has equal potential in script form. Only after it's visualized can it be judged.

You need to identify the things that sound great on the written page but just don't look amazing when you see them come to life. The scriptwriters and game designers are full of awesome ideas. But it's up to you to deliver that awesomeness in visual form.

Always strive to add value to what's in the script. Or, if you feel it's somehow lacking, give them a better way to get the same feeling. Be true to the intent or the mood, but with an artist's eye for detail and drama. You're never intentionally rewriting the script but can always be improving it.

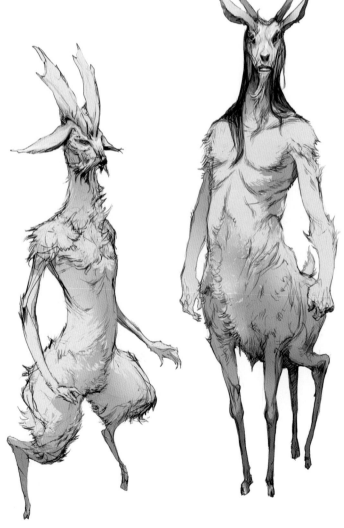

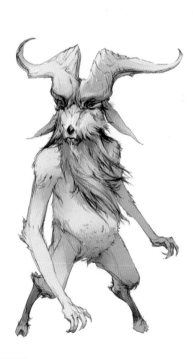

SIMPLE DRAWINGS WORK BEST
With these satyr designs I was able to explore a wide range of ideas in a short time by drawing in a simple, unadorned style and never drawing the same thing twice.

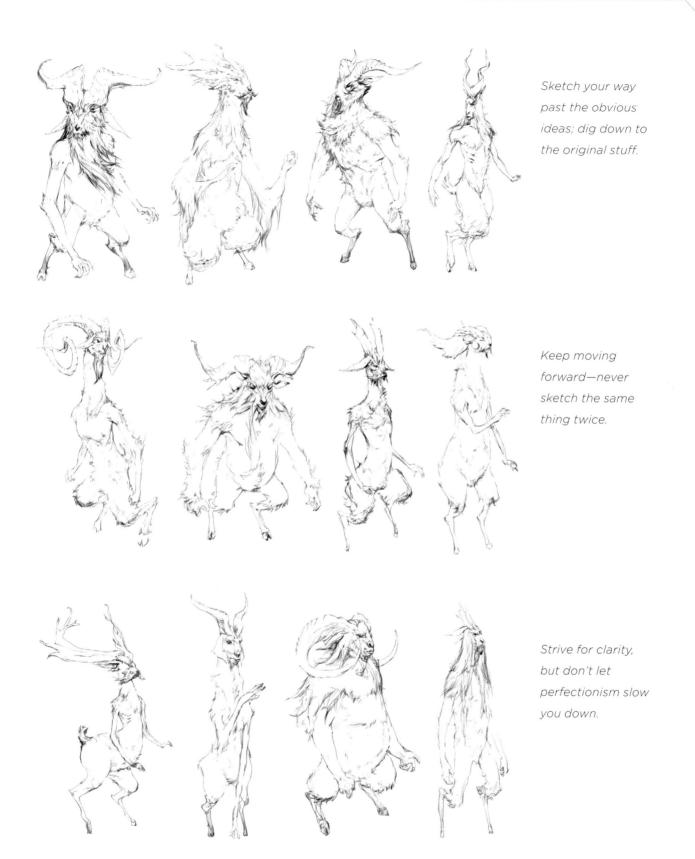

*Sketch your way past the obvious ideas; dig down to the original stuff.*

*Keep moving forward—never sketch the same thing twice.*

*Strive for clarity, but don't let perfectionism slow you down.*

# THE IMPORTANCE OF RESEARCH DRAWINGS

Let's back up a minute. Even before the brainstorming, if I have the luxury of time, I always start by building up my visual data bank with some research drawings. These are just copies of photographic reference material. I try to be reasonably accurate with these without investing so much time I fall behind schedule. The idea is to learn about the subject at hand by drawing it. Capture some intriguing details with your pen.

This doesn't have to take long. I might spend an hour or two making sketchbook pages before each new topic. It's like doing a life drawing class for your creature. If the project involves bat-demons, you better be able to draw a convincing bat! You've probably never really drawn one before. Get to know the texture of its fur, the grooves on its weird cartilage nose, the shape of its big ears.

This might feel like a waste of time at first—drawing real things when you want to be drawing monsters—but if you internalize the reference material to know how to draw the anatomy from memory, you'll find your drawings from imagination are much more successful.

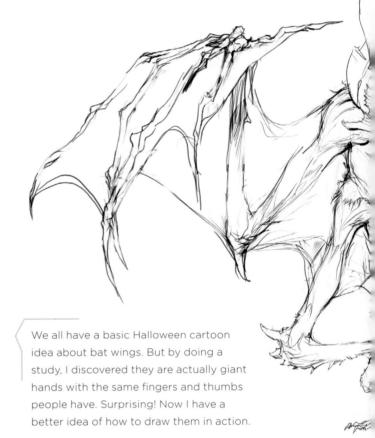

We all have a basic Halloween cartoon idea about bat wings. But by doing a study, I discovered they are actually giant hands with the same fingers and thumbs people have. Surprising! Now I have a better idea of how to draw them in action.

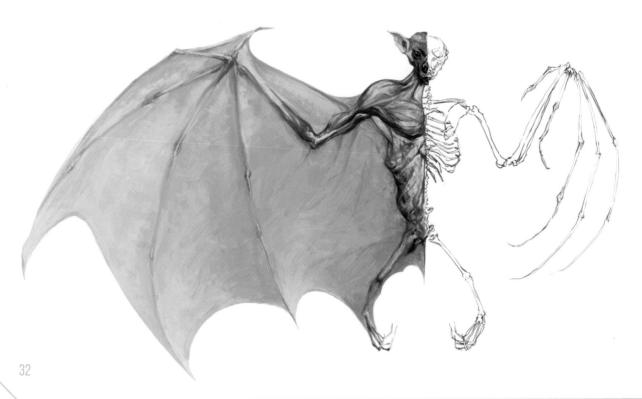

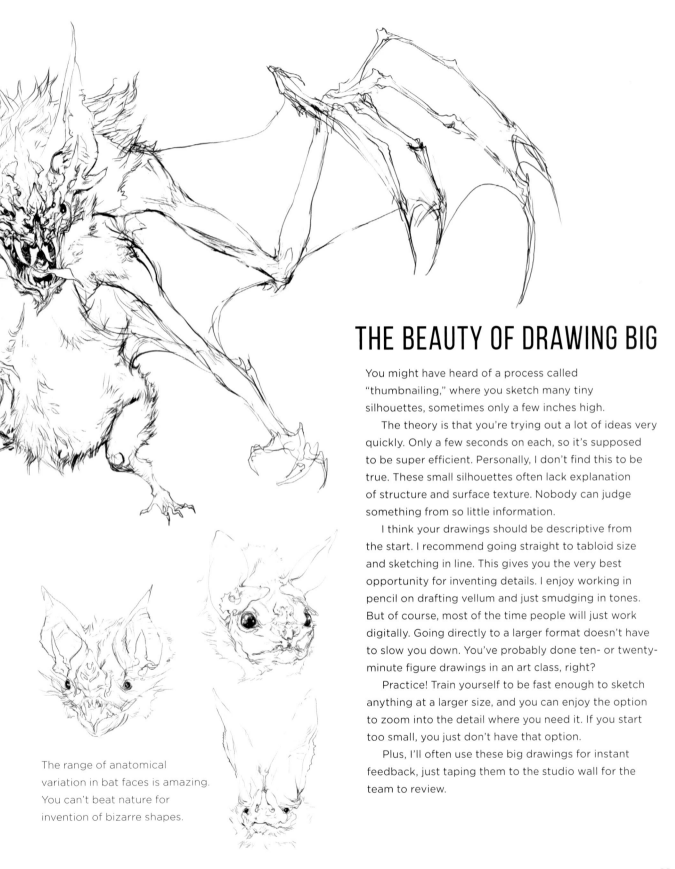

# THE BEAUTY OF DRAWING BIG

You might have heard of a process called "thumbnailing," where you sketch many tiny silhouettes, sometimes only a few inches high.

The theory is that you're trying out a lot of ideas very quickly. Only a few seconds on each, so it's supposed to be super efficient. Personally, I don't find this to be true. These small silhouettes often lack explanation of structure and surface texture. Nobody can judge something from so little information.

I think your drawings should be descriptive from the start. I recommend going straight to tabloid size and sketching in line. This gives you the very best opportunity for inventing details. I enjoy working in pencil on drafting vellum and just smudging in tones. But of course, most of the time people will just work digitally. Going directly to a larger format doesn't have to slow you down. You've probably done ten- or twenty-minute figure drawings in an art class, right?

Practice! Train yourself to be fast enough to sketch anything at a larger size, and you can enjoy the option to zoom into the detail where you need it. If you start too small, you just don't have that option.

Plus, I'll often use these big drawings for instant feedback, just taping them to the studio wall for the team to review.

The range of anatomical variation in bat faces is amazing. You can't beat nature for invention of bizarre shapes.

# FOUR BASIC STRATEGIES FOR IDEATION

Every kid who's played make-believe has already found the common strategies for ideas-on-demand. Children don't have preconceptions; they're in an open-minded state. A concept artist should harness that ability to see linkages and combinations between things. Here are some basic mental exercises:

## 01: EXAGGERATING REALITY

Everything in a video game universe is exaggerated, taken to the extreme. Does a critter have teeth? It should have *lots* of teeth! It has tusks? What about *huge* tusks. Any aspect of your reference material can be exaggerated.

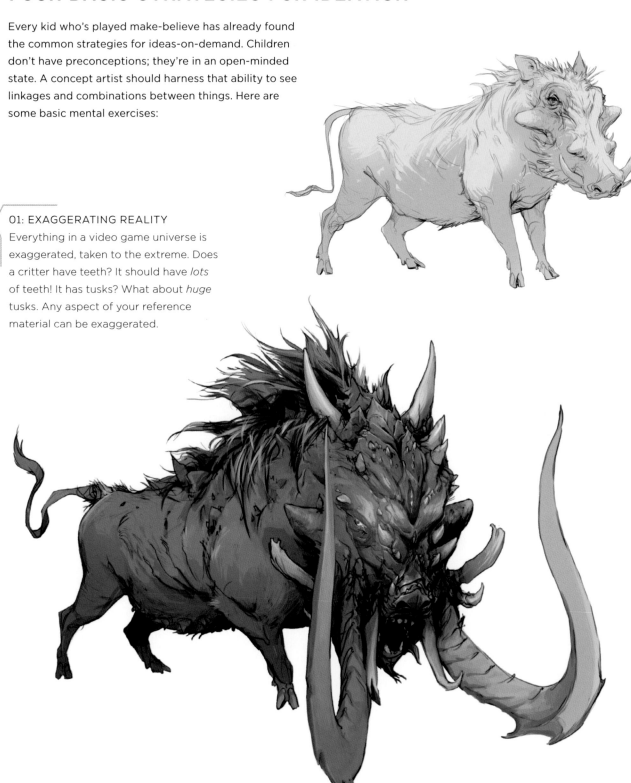

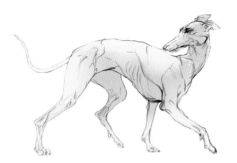

## 02: COMBINING SOURCES

A very common approach is to combine real world sources. A bat crossed with an alligator = a dragon! Visual interest, strangeness, weird characters and happy accidents often result from combining real sources in new ways. Try pairing up unlikely combinations. I picked these two source creatures completely at random, a greyhound and a hickory horned devil caterpillar, just to show that *any* two creatures can be combined.

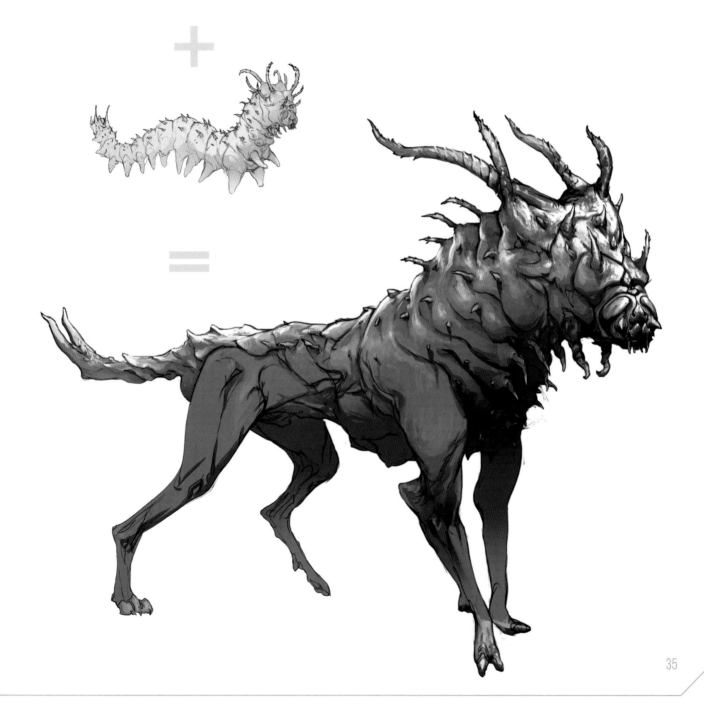

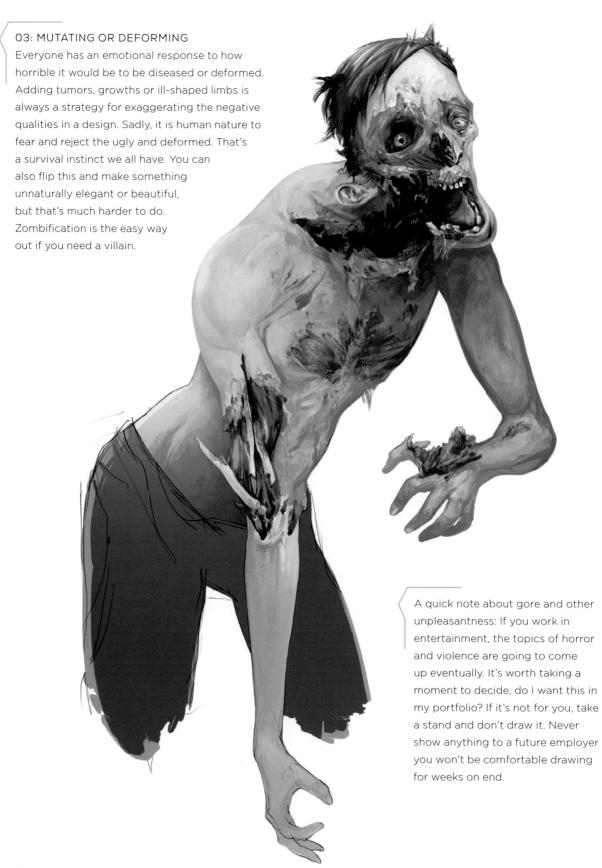

## 03: MUTATING OR DEFORMING

Everyone has an emotional response to how horrible it would be to be diseased or deformed. Adding tumors, growths or ill-shaped limbs is always a strategy for exaggerating the negative qualities in a design. Sadly, it is human nature to fear and reject the ugly and deformed. That's a survival instinct we all have. You can also flip this and make something unnaturally elegant or beautiful, but that's much harder to do. Zombification is the easy way out if you need a villain.

A quick note about gore and other unpleasantness: If you work in entertainment, the topics of horror and violence are going to come up eventually. It's worth taking a moment to decide, do I want this in my portfolio? If it's not for you, take a stand and don't draw it. Never show anything to a future employer you won't be comfortable drawing for weeks on end.

## 04: INTEGRATION OF A CULTURAL THEME

If things are too alien, invented from whole cloth, people might not know how to react. Perhaps there are mythological sources you can research. There's a lot to borrow from art history. Using cultural touchstones (myth and legend or historical clothing and architecture) can help your design resonate with the audience.

Note: Of course, if you're working with a foreign culture, always be respectful. Don't just take people's art forms and make fun of them or use them as a shorthand for evil.

# FOCUSING IDEAS WITH BOUNDARY CHECKING

Boundary checking is comparing two designs at a time from different ends of the spectrum. With this technique, you can compare different stylistic options and choose which direction you're going.

We have discussed the value of brainstorming. We've seen how rapidly executed rough sketches, iterating through every possible solution you can think of, can give you a stack of potential solutions in a very short amount of time. We've seen the four most common ways to jumpstart research drawings: exaggeration, combining unlikely sources, mutating/deforming and integration of a cultural theme.

So now we're ready to discuss a method for choosing from among all these potential ideas with boundary checking. This is one way you (or your art directors) can take your massive collection of roughs and narrow them down to the one direction that will go into production. It's also a very effective way to draw out specific instructions from your director or producer.

The game or film producers who evaluate your designs are often not artists themselves, and it can be difficult for them to make subjective choices. What makes a design cool? What makes something badass? These are the typical positive but hard-to-define responses you're trying to get from an audience.

This is also a way teams can evaluate concepts as a group. Achieving team consensus about artwork can be challenging. Inevitably everyone has a different opinion. This will give you a mechanism for focus testing your own team.

## BOUNDARY CHECKING

At its core, this idea is as simple as comparing only two designs at a time. But the key is to compare two ends of a spectrum. Look for opposing directions, stylistic options that represent a binary choice. The final choice can be only A or B. It can never be both. For instance: the choice of how realistic vs. how fantastic the project style should be.

Something is either a fairly realistic design—based on research or practical examples, something that looks cool, but that could actually exist in the real world. Or it can be fantastic. Something that is more cool than practical, that is intentionally style-over-substance. The truly fantastic designs can be visually striking or carry poetic symbolism, anything but simply being practical.

To try this out, choose an opposing polarity such as Realistic vs. Fantastic and make two test drawings that represent the far ends of your spectrum. Put your presentation drawings side by side for comparison. Don't cheat and spend more time on one or the other drawing. Aim for an objective comparison.

Now you can answer, which is better? Is it A or B? It's like a vision test at the optometrist. Which one feels right?

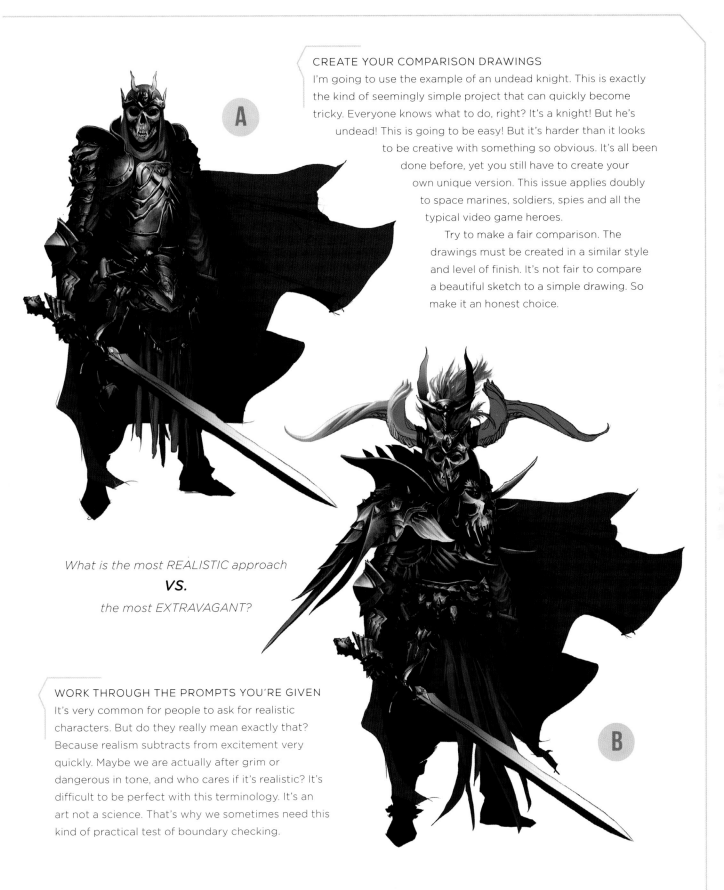

## CREATE YOUR COMPARISON DRAWINGS

I'm going to use the example of an undead knight. This is exactly the kind of seemingly simple project that can quickly become tricky. Everyone knows what to do, right? It's a knight! But he's undead! This is going to be easy! But it's harder than it looks to be creative with something so obvious. It's all been done before, yet you still have to create your own unique version. This issue applies doubly to space marines, soldiers, spies and all the typical video game heroes.

Try to make a fair comparison. The drawings must be created in a similar style and level of finish. It's not fair to compare a beautiful sketch to a simple drawing. So make it an honest choice.

*What is the most REALISTIC approach*

**vs.**

*the most EXTRAVAGANT?*

## WORK THROUGH THE PROMPTS YOU'RE GIVEN

It's very common for people to ask for realistic characters. But do they really mean exactly that? Because realism subtracts from excitement very quickly. Maybe we are actually after grim or dangerous in tone, and who cares if it's realistic? It's difficult to be perfect with this terminology. It's an art not a science. That's why we sometimes need this kind of practical test of boundary checking.

# INTERPOLATION: FINER AND FINER SUBDIVISION

When seeking feedback from other people, don't allow them to be indecisive. It can't be both. You're going to actually build only one of these designs.

Often you'll get the obvious feedback "What about somewhere in between?" or "Can you combine these two?" That's good info. It tells you the conceptual boundaries are too far apart.

Every time you hear that, the search gets smaller and you get closer to success. You are beginning to narrow down the boundaries. If the decision is that both ends are too extreme—the realistic choice is too boring, and the fantastic choice is too whimsical— well then perfect. Test out a third design that is conceptually in between the two.

You can even repeat this a few times. A design in the middle can get divided again, either to the left or right of the spectrum. It won't take more than a few of these in betweens to get very close to the target.

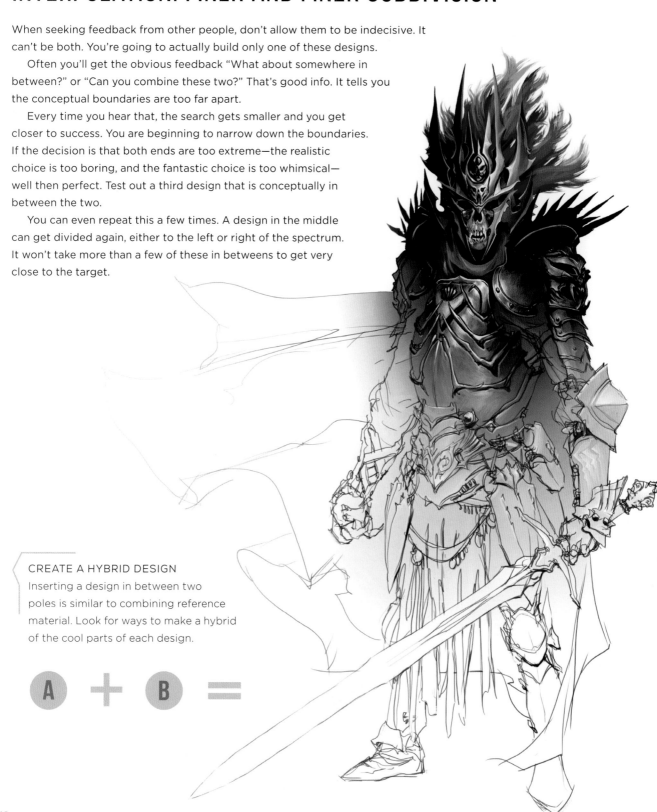

CREATE A HYBRID DESIGN
Inserting a design in between two poles is similar to combining reference material. Look for ways to make a hybrid of the cool parts of each design.

A + B =

# DESTRUCTION TESTING: PUSH BOUNDARIES UNTIL THEY BREAK

Another possible response is "Oh, it can be way more extravagant than that." (Or, the opposite, "No, no, no, *both* of these are too crazy!") That tells you which direction to shift things. Choosing to go one way also removes the need to explore in the other direction. The beauty of this is no matter how wrong a sketch is, it helps you narrow down the boundaries. So it wasn't a waste at all. Ultimately, this method will give you the kind of practical feedback that can help solve the classic "I'll know it when I see it" direction writers and producers will often bring to the team. Once you begin showing them actionable choices, they can begin to move the team forward.

C

D

*If you like the fantastic direction, can you push it further?*

*How many times can you push the design until it jumps the shark?*

# KEEP TESTING OTHER BOUNDARIES

What are some other ways you can bracket the subject? Any theme with a spectrum of opposites can work. You have to remain within the scope of the project. You can't test Godzilla vs. a rubber ducky. But you should be able to come up with a wide range of choices that could actually work.

Compare things like the most physically powerful version of the character vs. an elegant or sophisticated solution. Compare the most mechanically complex or ornately decorated vs. the most streamlined. The most barbaric vs. the most cultured, modern vs. antique.

Explore any possible opposing themes you can think of. Keep digging for potential unique directions. You shouldn't be testing minor variations on an idea. Push for the far ends of the comparison. You can always hone in later.

By striving for new directions that are as different as possible, you give the art director useful decision-making options. Remember that every rejected drawing you make saves the team hours of effort. The more unique comparisons you can test, the stronger your idea will become.

As the sketch artist, you have an opportunity to bring up visual solutions that the scriptwriters may not have thought of. You can fulfill a description or mood in many different ways. What about testing out if the character should be male vs. female?

Think of it like casting an actor against type. Sometimes a surprising choice will make an otherwise ordinary role doubly interesting.

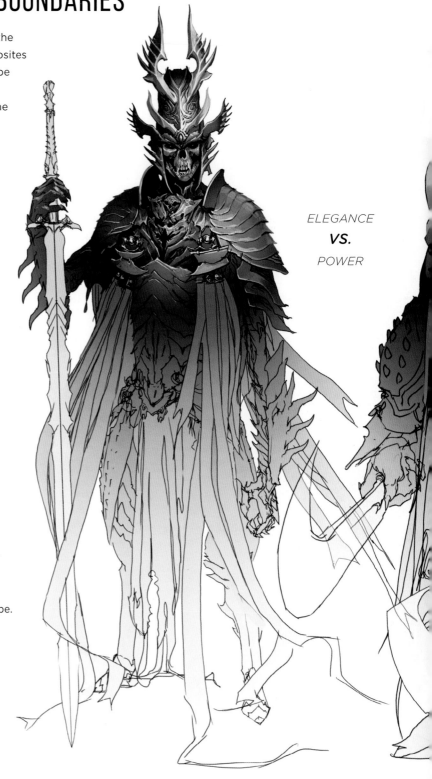

*ELEGANCE*
**VS.**
*POWER*

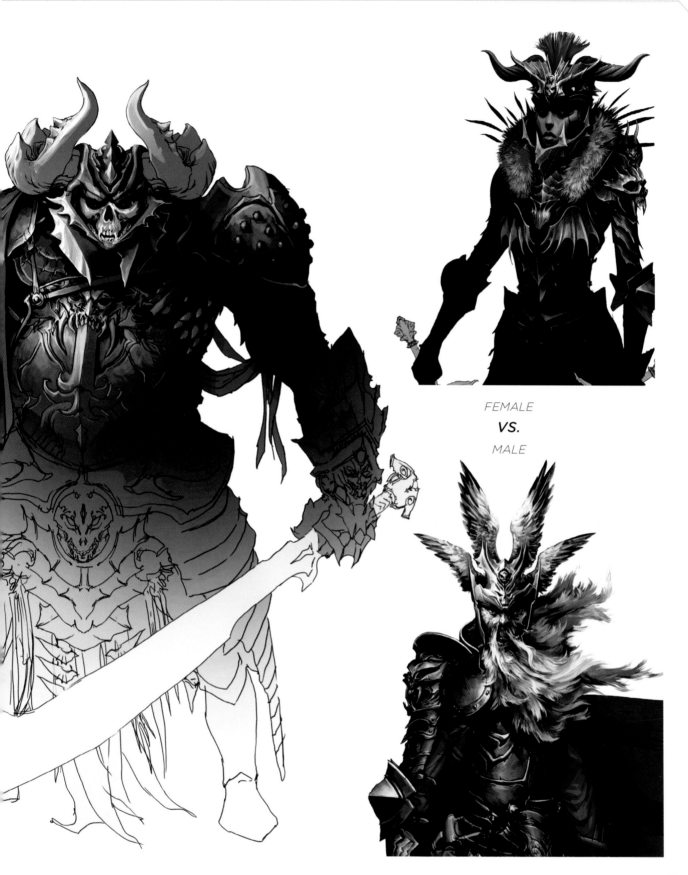

FEMALE
**VS.**
MALE

# SKIN AND BONES:
## *VARIATIONS ON A SKELETAL DESIGN*

Research a real-world animal skeleton to be the basis of a set of fantasy creatures. It could be a big cat, ostrich, elephant or whatever you prefer. Consider how fantastic you want the design to be. Feel free to exaggerate proportions of the skeleton to create a more interesting creature. You could try to invent a skeleton from whole cloth, but this is much more difficult than using a reference.

Create a final clean line drawing of the bones you can trace over. Choose an angle that's as descriptive as possible. Quadrupeds should probably be side views, bipeds can be shown from the front.

Using your skeleton, design a minimum of three different monstrous creatures that could fit over that same set of bones. Each creature should be as unique as possible while still fleshing out the same skeleton.

If you get stuck coming up with variations, you might have to start again with a more generic base skeleton. Or consider it a challenge and just keep pushing for ideas. But it's going to be hard to get enough interesting variations on an ostrich!

This used to be a very common situation in video game design, an opportunity to stretch the value of a basic creature design. Artists can make small but significant modifications to the shape of a creature—adding horns, armor or other rigid (non-animating) forms to make cosmetic changes that won't affect how the creature animates. Sometimes it is as simple as color or texture changes.

As long as the skeletal joints remain in a similar position, all the variations on a creature can share a common set of animations. This can save both the artist's time and reduce technical requirements such as the size of the game installation on disk or graphics card memory requirements.

**ACHIEVEMENT
Skin Changer**

- One clean drawing of your base skeleton
- Minimum of 3 sketched variations of fleshed out creatures built on your skeleton
- Minimum of one presentation drawing of your favorite creature

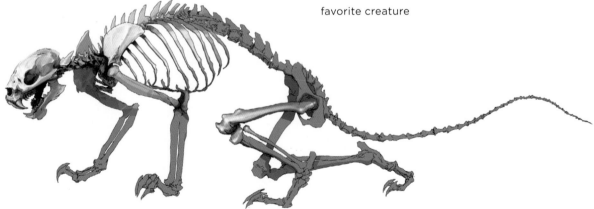

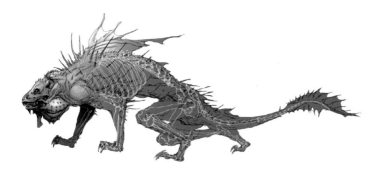

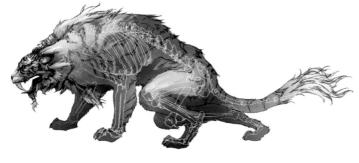

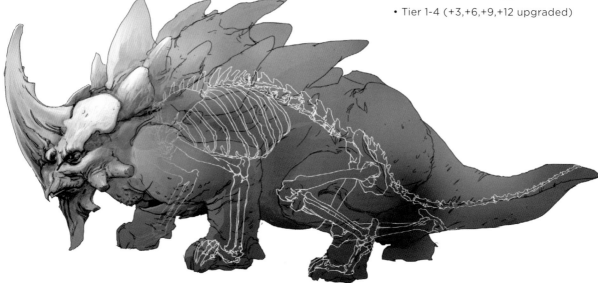

## BONUS ACHIEVEMENT
### Bone Clones

Additional creatures, up to 6, 9 or 12 total variations on your base skeleton. Gain a tier for each +3 additional creatures.

- Tier 1-3 (+3,+6,+9 sketches)

## BONUS ACHIEVEMENT
### Fleshed Out

Upgrade 3+ more sketches to presentation drawings. Gain a tier for each additional +3 upgraded sketches.

- Tier 1-4 (+3,+6,+9,+12 upgraded)

Choose in advance if your invented creatures will look biologically convincing or stylized. Remember, all your creatures will share the same skeletal proportions.

Consider variations such as interesting skin textures, hide, fur or scales. Feel free to use horns, fins, mutated growths, air sacs, cilia—any attachments to the animal's body that would not alter the way the creature walks or runs. Consider even larger physiological changes as long as you don't defy your basic skeletal structure.

# BIG GAME TROPHY HEADS:
## *A PORTRAIT COLLECTION*

Big game hunters have been known to have the heads of their trophy kills stuffed and mounted on the wall. Your task is to design trophy heads that might exist in the collection of the universe's greatest hunter.

All of your trophy heads must be fantastic creatures, not just renderings of real animals. Make them challenging opponents. Often these trophy animals are posed with a snarling or roaring expression. Each one should look like a trophy worth mounting with pride. Each should represent a unique beast and reflect the interesting environment they must have come from.

Bodies are not required, just heads and necks. The goal here is to show as much variety and imagination as possible with the least amount of drawing.

Choose in advance if these creatures will look biologically convincing or if the designs are stylized. Determine if there is a cultural or genre theme to your hunter (demon hunter, alien pest control, rogue-robot bounty hunter). This might influence your ideas.

Aim for a consistent level of detail and realism. If you want your style to appeal to an independent development team, try pixel art or a vector look. If you want to break into Hollywood, aim for gritty but exaggerated realism.

**BONUS ACHIEVEMENT**
Wild Huntsman

Upgrade 3+ sketches to presentation drawings. Gain a tier for each additional +3 upgraded sketches.
- Tier 1-4

**ACHIEVEMENT**
Big Game Collector

- Minimum of 12 sketched creature head variations

**BONUS ACHIEVEMENT**
Great Guns

A minimum of 7 sketched designs for weapons used to hunt

**BONUS ACHIEVEMENT**
Time to Go Vegan?

Additional sketches, up to 18, 24 or 48 total sketched heads. It can be extremely challenging to have this many unique ideas. Self-congratulations would be in order for each tier.
- Tier 1-3 (+6,+12,+36 sketches)

**BONUS ACHIEVEMENT**
Big Kahuna

A minimum of 3 sketched (or presentation quality) designs for the Hunter who bagged the beasts

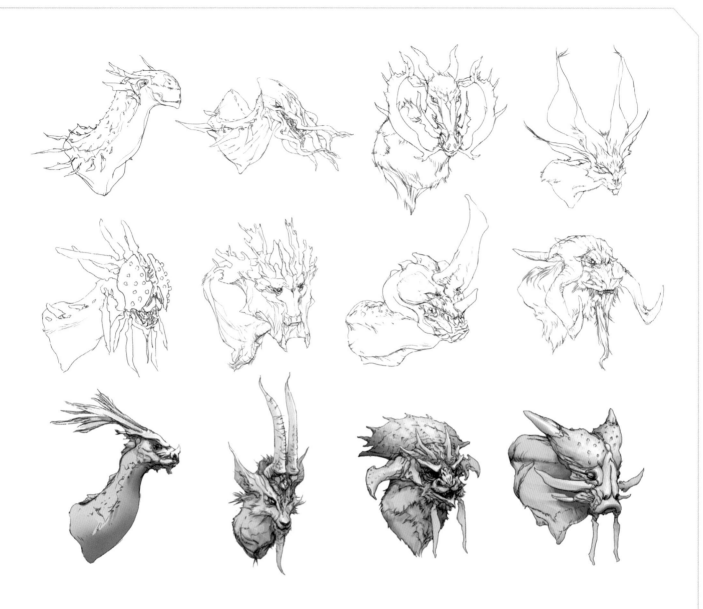

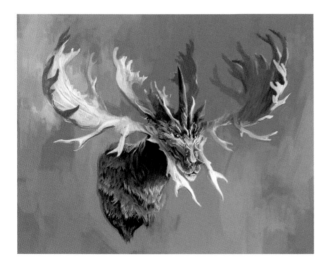

Bring your favorite sketches to the next level by adding some monochromatic shading to help you see the 3-D design.

## QUANTITY OVER QUALITY

You can add further realism with color, but never spend so much time on a sketch that you deliver fewer ideas. Total number of ideas is more important than visual quality at this stage of the game.

# FANTASY FISHING LEAGUE:
## *A CRITTER COLLECTION*

Your task is to populate an ocean of aquatic creatures that might be caught by a fisherman in a fantasy fishing game. Your designs don't all have to be fish. Research a range of possible aquatic creatures or mythological sea beasts that might be caught.

Choose your strategy: Realism or extreme exaggeration? Dangerous river monsters or cartoony sea-catch? Also consider using a theme for your location. Extreme ice fishing might be different than fishing the lava rivers of Hades.

One more thing: In this project you must aim for variety and storytelling in the designs but also rank them in three tiers: Chum, Good Catch and Trophy

Catch. Try to make the tiers of catch clearly defined. A Trophy Fish should look obviously more rewarding than a Good Catch.

This is a common problem in game design. You need to create a visual representation of the relative value of an object. Players should be able to see immediately if they have found something of value or are just picking up junk. When faced with multiple opponents, it should be instantly clear which ones are stronger or weaker.

**BONUS ACHIEVEMENT**
**Ichthyologist**

Upgrade 3+ sketches to presentation drawings. Gain a tier for each additional +3 upgraded sketches.

- Tier 1-4

**ACHIEVEMENT**
**Trophy Fisherman**

- Minimum of 15 sketched variations of fish, ranked in three tiers

**BONUS ACHIEVEMENT**
**Hook and Sinker**

A minimum of 7 sketched designs for interesting fishing rods, lures, spearguns, etc.

**BONUS ACHIEVEMENT**
**Catch of the Day**

Additional sets of 5 sketches, up to 20, 25, and 30 total sketched creatures. Continue to group your designs in defined quality rankings.

- Tier 1-3 (+5,+10,+15 sketches)

**BONUS ACHIEVEMENT**
**Bizarre Bycatch**

For each set of 5 exotic marine creatures
(Manta, Cucumber, Starfish, etc.)

When brainstorming large collections, not every drawing has to be finished. Just sketch the minimum required to get the idea across while giving a little love to your favorites.

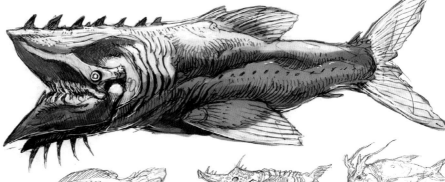

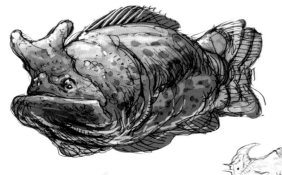

The simplest way to make something more important is to scale the level of detail. Bigger things need more small details.

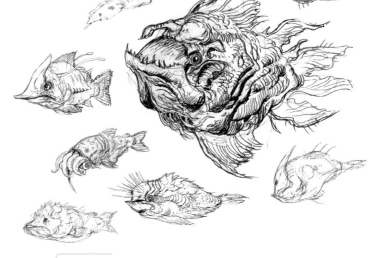

**BONUS ACHIEVEMENT**
**Cephalopods Abound**

For each set of 5 exotic marine creatures
(Squid, Octopus, Nautilus, etc.)

**BONUS ACHIEVEMENT**
**Crustacean Elation**

For each set of 5 exotic marine creatures
(Shrimp, Crab, Lobster, etc.)

Even when a creature seems to have a small or unimportant role, it deserves attention. You never know when a player is going to pause and take a close look.

# CAPTAIN AND CREW:
## VIKINGS AND SPACE RAIDERS

The romantic idea of pirates has been popular in fiction since the days of Blackbeard and Barbarossa. It's always an appealing idea to the common man: Drop out of society, sail the seas, get rich and take no crap from anyone.

Your goal is to design the captain and crew of a fantastic vessel. The setting could be seafaring, but it could easily be switched to sci-fi space raiders or Vikings sailing the frozen North Sea.

Decide in advance how straight you want to play this. You could make this a project on realistic human characters and costumes if that's what interests you, but there's no reason to limit yourself. Your vessel might be crewed by werebear marauders or undead samurai. Decide based on what appeals to you and what's a good match for the projects you'd like to work on in the future.

Regardless of your cultural theme, each creature in your band of villains should have a specific role on the team. Their design should make it immediately obvious to the audience what they do, and why they are perfect for their roles. No two creatures should look like they could exchange roles.

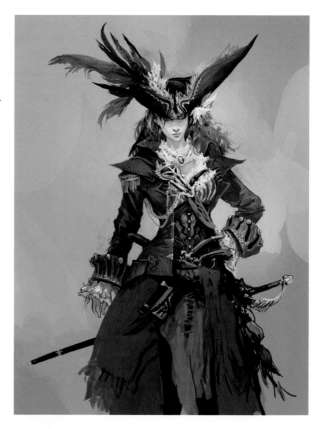

**ACHIEVEMENT**
**Captain Courageous**

- Minimum of 7 sketched characters in your pirate crew
- One presentation quality drawing of your ship's captain
- Minimum of 3 presentation drawings of other crew members

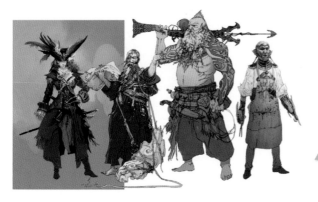

**BONUS ACHIEVEMENT**
**Avast Ye Varmints!**

Additional sketches, up to 17, 22 or 28 total sketched crew members.
- Tier 1-3 (+10,+15,+20 sketches)

Modelers and animators may need a scale reference chart to get relative character heights correct.

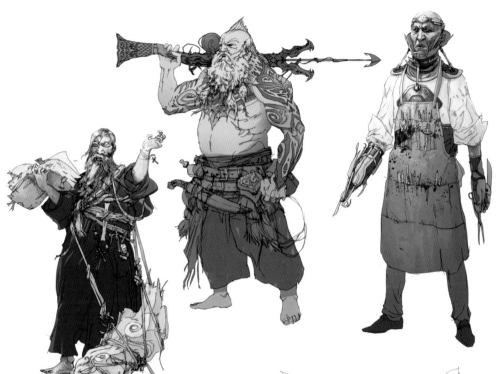

Example roles:
- Captain
- First Mate
- Navigator
- Ship's Doctor
- Cook
- Mutinous Sailor
- Marine
- Stowaway
- Foreign Mercenary
- Mad Monk
- Cabin Boy
- Runaway Slave
- Wealthy Hostage
- Femme Fatale

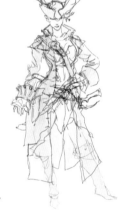

**BONUS ACHIEVEMENT**
**Shipwright**

Minimum of 3 sketches of the pirate vessel

Show your work! Art directors appreciate it when you show how you arrived at an idea. These sketches evolved from a typical sexy pirate into a woman who looks like a proper captain.

**BONUS ACHIEVEMENT**
**Privateer**

Upgrade 3+ more sketches to presentation drawings. Gain a tier for each additional +3 upgraded sketches.
- Tier 1-4

**BONUS ACHIEVEMENT**
**Quartermaster**

Design a flag, a figurehead and a cannon for your pirate vessel.

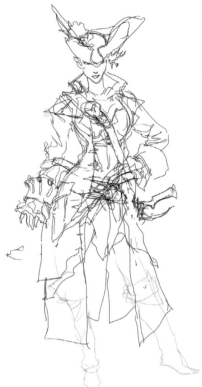

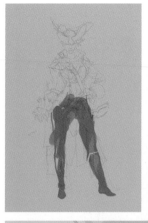
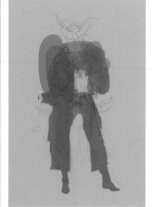
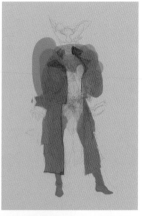

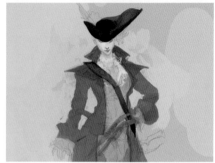

## 1 A SHAKY START

Here's the line art I chose from my sketches for the captain. I had been doing these quite rapidly, so it's actually pretty rough even for a sketch. But it's the design I want to go forward with, so I'll just have to improve it as we go.

## 2 BLOCK IN THE UNDERPAINTING

Paint in tone underneath the line drawing, using an approach borrowed from animation cels. You can paint very rapidly, not being worried about staying in the lines of the drawing. You can always cut back in with the background color to clean up the silhouette edges.

Build up the figure from back to front and large to small. Use a different layer for each bit of costume. That way if you want to change the coat color it can be done easily. Feel free to change the length of the legs and the width of the lapels. You don't have to be a slave to the original sketch.

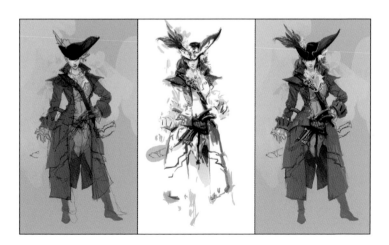

## 3 FIRST UNDER, THEN OVER

You can see the first round of over-painting separated from the drawing (on white). Note how, even though there are small brushstrokes all around the figure, the major changes are all things that alter the silhouette: putting in the red feathers and lengthening the hat, continuing to build up the points of the shoulders and jacket collar.

Begin detailing the belt and baldric, starting to describe the guns and the big belt buckle. These are opportunities to make focal points on the character. Like Superman's "S" these are graphic elements that help the viewer recognize the character.

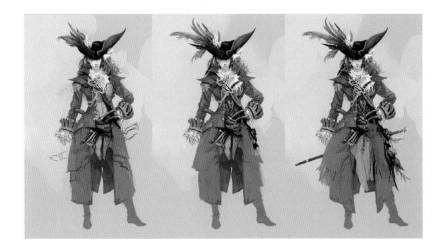

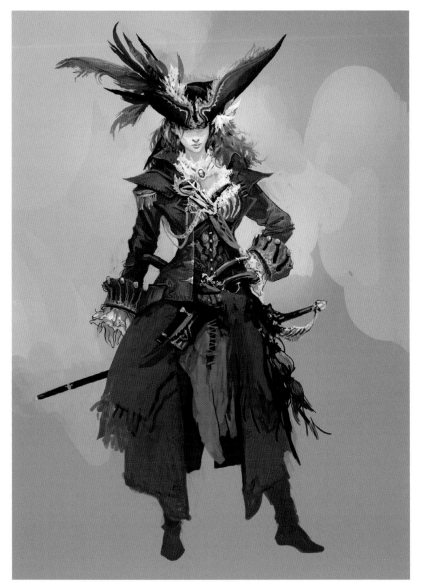

## CLARIFYING THE DESIGN

**4** Look for opportunities to emphasize the character's graphic design. Keep pushing the shapes. The hat and feathers keep getting more flamboyant, making an interesting silhouette. Add a frilly lace trim at the cleavage as well as a scarf to cover her plunging neckline. This is a strong, independent woman. It's more in character to cover up.

Establish two secondary color notes. First add antique gold braid on the cuffs and epaulettes. This matches her dirty blond hair, the brass on the guns and the pheasant feathers in the hat. Add peacock blue trim on the jacket, carrying it into a feathery trim on the hat and a ragged tassel on the belt.

These may seem like minor notes, but it's important to design color as an overall pattern across the figure. Think about super-hero designs or contemporary athletic clothing. The overall blocking of color patterns is what makes a figure iconic. If a color appears somewhere, it needs to be echoed in other parts of the design.

Add a slender sword that fits a female sea captain. Also widen the flare of the jacket over her hips to reflect the stiffness of fabric in a lined jacket and to give her more of an hourglass figure.

## FINAL COLOR ADJUSTMENTS

**5** I often do a Curves Adjustment Layer. This allows you to push the contrast up or down, tweaking it to your liking. In this case, use a Quick Mask to selectively remove the curves effect around the face, creating a soft highlight in the center of the image.

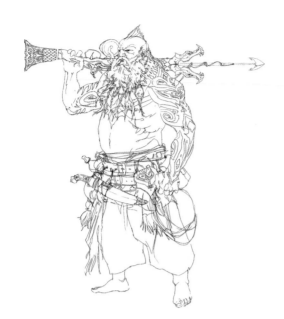

## 1 STARTING WITH A TIGHT DRAWING

Even a drawing can be done with layers. Sketch the basic figure first and then draw each element of the costume on its own layer above. This helps you experiment as you go. You don't have to redraw the face every time you try a different beard. You can design things like the sleeve tattoo without redrawing the arm over and over.

When you've taken the time to do a tightly rendered line drawing like this, it's natural to want to colorize the drawing. If you have a lot of detailed information already, why not build on what you have, instead of obliterating it with a paintover?

## 2 COLOR FLATTING

Comic book artists often work in this line and tone method. They call the stage where they build the color layers *flatting* because the basic color shapes are a single flat color.

Start this process by making the fleshtone silhouette first—filling the entire figure with skin tone—and then duplicating it and colorizing it to make each color flat in turn as you move from back to front. So the pants are on top of the skin, the sash is on top of the pants, belts are on top of the sash, etc.

Each of those color flats are made by selectively erasing the layer mask on a copy of the shape below. This saves a little time with each layer as they are always a subdivision of the one before.

### SHADOW AND LIGHT

**3** Now that you have a set of clean, flat colors, make two more layers (or they might be layer groups if you want to get complicated). These two layers will be used to create the illusion of light and shadow.

To make a shadow layer, set a new layer between 30 and 50 percent opacity and to Multiply mode and give it a Quick Mask using the *inverse* of the figure's silhouette. This gives you an empty silhouette of the character into which you can paint with gradients or brushes. Everything you paint in this Multiply layer will darken the flats underneath.

To make a lighting layer, set a new layer to Color Dodge, and again make a Quick Mask using the *inverse* of the figure's silhouette. Then proceed to paint with gradients or brushes. Everything you paint into this layer will brighten the flats underneath.

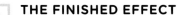

### THE FINISHED EFFECT

**4** This all sounds much more complicated than it is. You can see how the shadows and light layers, when stacked on top of the flats and under the line work, combine to give you a comic book or anime-style effect.

This is a fast and flexible way to colorize your drawings. Most of us can draw more accurately than we can paint, so this is a workhorse technique for communicating detailed concepts.

I like the clean look you get with this method and that you can fuss about endlessly while deciding on your color scheme.

# INTO THE WASTELAND:
## *MUTANTS AND MONSTROSITIES*

People have always had a fascination with the end of the world. The theme seems to have taken over our popular culture since the nuclear proliferation of the 1950s and continues to loom over us in the age of climate change, antibiotic-resistant disease and economic collapse.

Your task is to visualize one of these apocalyptic futures. How has humanity mutated? What creatures stalk the blasted wastelands and plague-ridden ruins of our cities?

Aim for a consistent look to your mutation. What is the theme you want to go with in this story? Has your world succumbed to an alien virus from space? Or are the mutants the result of radiation and pollution? There might even be a mystical-themed backstory. Zombies and demons are simply another version of mutation.

Whatever theme you settle on, start with the human victims but carry the idea further into the animals found in the region. What does your virus do to dogs and cats or mutated bears? Are there giant insects? Or do we see new creatures appear with uncertain origins? Also consider any healthy human survivors that might be your protagonists in this story. Design the scavengers and scouts of the last pockets of humanity.

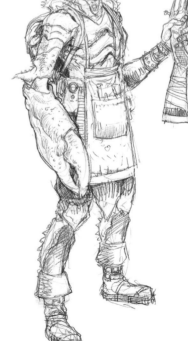

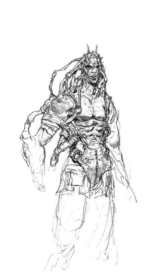

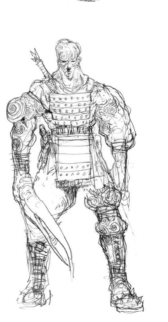

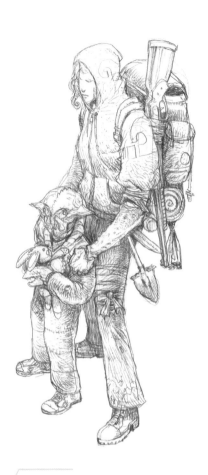

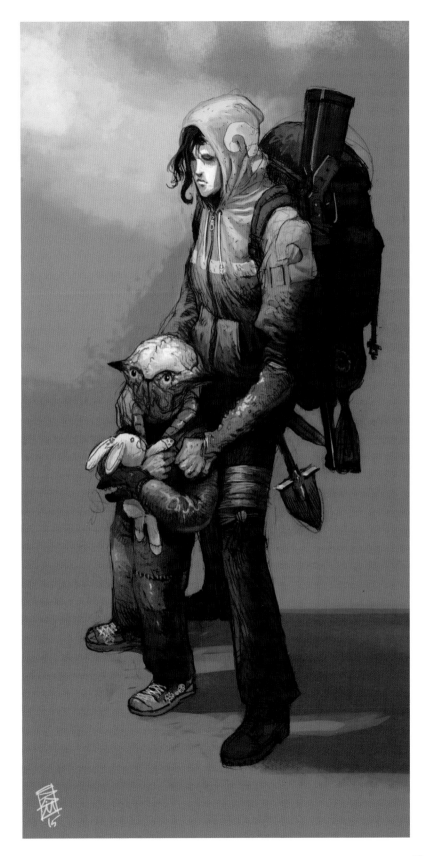

Try a wide variety of ideas on for size until you end up with the hook that you're looking for. A sketch of some guys with lobster claws and then a cute crab-faced boy led to the final direction for this crustacean mutation.

 **ACHIEVEMENT**
Into the
Wasteland

- Minimum of 9 sketched
  creatures, brainstorming 3
  or more different styles of
  mutations
- Minimum of 3 presentation
  quality drawings of your final
  mutation style documenting
  different species such as one
  human and two animals

 **BONUS
ACHIEVEMENT**
Staying Alive

Upgrade pairs of healthy survivors
to be heroes of your story. They
can be a man and his dog, or a
mother and daughter, any duo
of survivors. Make presentation
quality drawings. (+2 presentation
drawings per tier)

- Tier 1-3

 **BONUS
ACHIEVEMENT**
Mistakes of Nature

Brainstorm more sketches of
mutant animals. Gain a tier for
each additional +5 sketches.

- Tier 1-4

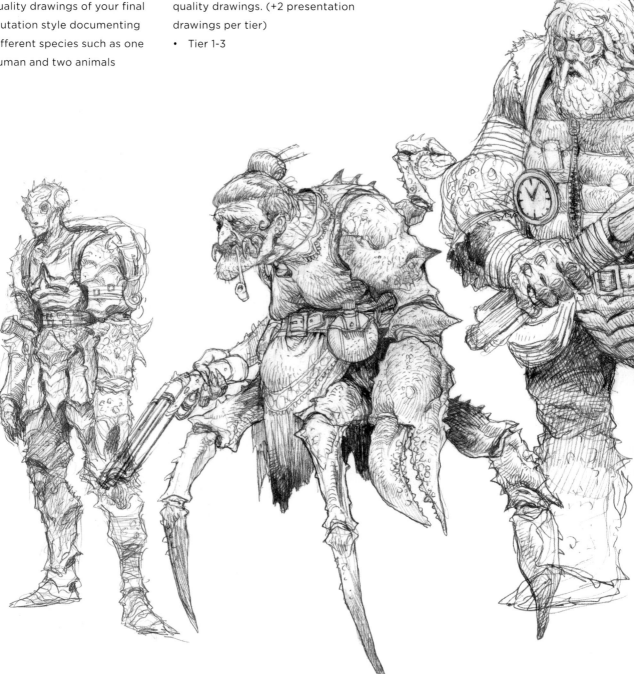

## BONUS ACHIEVEMENT
### Underdogs

Brainstorm sketches of healthy survivors. Invent unique roles such as scavenger, camp follower, bounty hunter, desert nomad. Gain a tier for each additional +5 sketches.

- Tier 1-4

## BONUS ACHIEVEMENT
### Freaks and Geeks

Upgrade 3+ sketches of mutant humans to presentation quality drawings. Gain a tier for each additional +3 upgraded sketches.

- Tier 1-4

## BONUS ACHIEVEMENT
### The Hills Have Eyes

Additional sketches of mutated humans showing unique character types. Remain consistent to your mutation theme, up to 19, 24 or 29 total sketches.

- Tier 1-3 (+10,+15,+20 sketches)

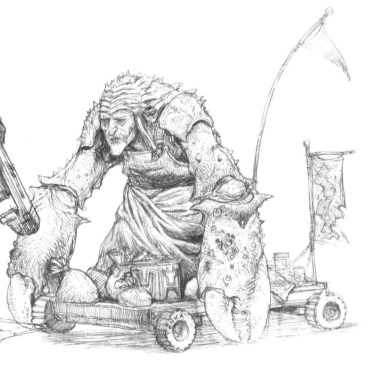

# RACIAL PROFILING:
## *DESIGNING A SPECIES*

Your task is to design an intelligent alien or fantasy race. The designs must communicate that the creatures are intelligent, with a society of some kind. They do not have to be biologically possible. Don't feel it's necessary to limit yourself to humanoids. These could be spirits, elemental creatures, demons. Anything goes as long as it's consistent and your designs feel like a single race, not a random collection of beings.

The key to this project is the social roles you will be portraying. This is a classic design problem: how to invent an exotic race that has a society, technology and culture. How to make an alien planet seem real. What is their story, the reason why they've become our adversaries?

In order to create a functioning society, we need to see a variety of social roles. Who's in charge here? Which aliens are dangerous? Which might be reasoned with? Who makes their culture function on a day-to-day basis? No living culture is entirely made up of disposable soldiers for the hero to knock down.

I would start with one basic anatomical design and work outward, designing the entire alien race. Also consider: Are there only males and females, or are there more than two sexes? Are there physical differences between castes or functional roles such as we see in insect species? Do they define themselves by technology or by a more mystical set of abilities?

It's very likely you'll need to research living creatures for designs. Insects and arthropods are a great source of inspiration.

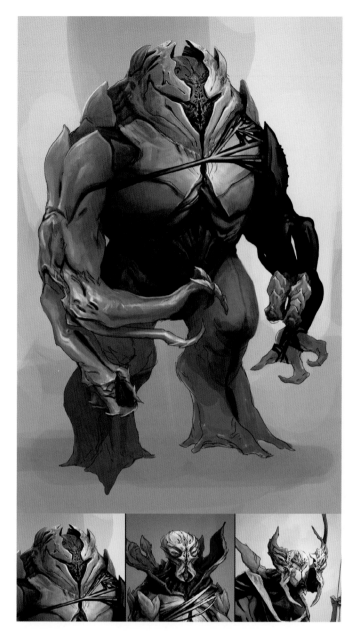

**ROLE SUGGESTIONS:**

- Worker
- Breeder
- Grunt/Soldier
- Ninja/Assassin
- Elite Warrior
- General

- Scavenger/Scout
- Medic/Healer
- Farmer/Gardener
- Oracle/Priest
- Outcast/Leper
- Whelp/Grub/Youth

### DESIGN PROGRESSION
I imagine, as this species ages, the fleshy layers around the head peel away, eventually calcifying into bony masks that might be able to open and close.

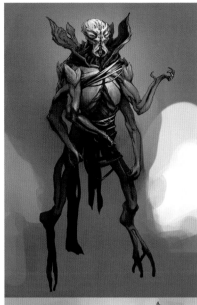

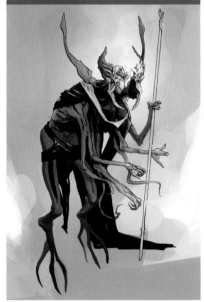

## ACHIEVEMENT
## Racial Profiler

- Minimum of 7 sketched variations of your alien cultural roles
- Minimum of 3 presentation drawings of your favorite designs

## BONUS ACHIEVEMENT
## Unusual Suspects

Additional sketches, up to 10, 15 or 21 total sketched alien roles.

- Tier 1-3 (+3,+8,+14 sketches)

## BONUS ACHIEVEMENT
## Alien Invader

Complete a set: Sketch a squad of 5 different kinds of alien soldiers. Make variations using weapons, tactics or ranks.

## BONUS ACHIEVEMENT
## Age of Aliens

Complete a set: (Sets can overlap with other achievements.) Sketch the aging process of your race: child, adult, ancient.

## BONUS ACHIEVEMENT
## XenoBiologist

Upgrade 3+ more sketches to presentation drawings. Gain a tier for each additional +3 upgraded sketches.

- Tier 1-4

## BONUS ACHIEVEMENT
## Propagation of the Species

Sketch the family unit of your species: Is it a male/female/child, or is it something else? Queen and fertile soldiers? A neutral clone blank that is programmed by gene priests? What can you imagine?

### TIE THEM TOGETHER

Any species has to share genetic similarities underlying their various forms. These aliens have different proportions, but share the concept of bifurcating limbs that continue to split apart as they age.

# PREDATOR AND PREY:
## *THE FOOD CHAIN*

All organic life is dependent on a food source. At the lowest level small organisms—algae, plants, single cell creatures (called "producers")—feed off sunlight or hydrothermal heat. These producers are eaten by small bugs or fish, which are then eaten in turn by birds, rodents, etc. (called "consumers").

Above these we have the carnivorous predators. There can be species in competition—wolves and mountain lions, sharks and killer whales. In some cases there are apex predators, creatures with nothing to fear in their own domain.

The goal is to create a food chain with a specific, consistent tone. Is your world a quirky side-scrolling video game in which funny birds eat colorful frogs? Or is it a living hell in which ravenous beasts shred each other in a decaying fungal forest?

It is not always a linear progression of small > medium > large > huge. Some ecosystems include gigantic herbivores—whales, elephants, brontosauruses. This can lead to carnivores hunting in packs, culling the weak while avoiding the bulls. There can also be scavengers that are not exactly in the food chain but feed off the remains of carnivore kills.

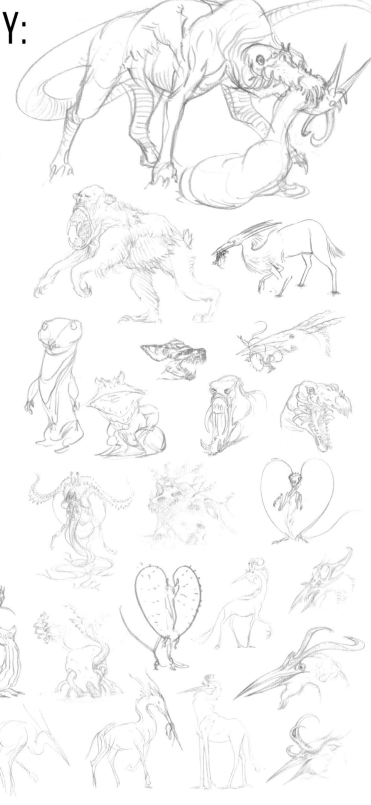

## THE CIRCLE OF LIFE

It might be a nice touch if you can show your food chain as a closed loop. When apex predators die, they go back to the earth as food for your base producers.

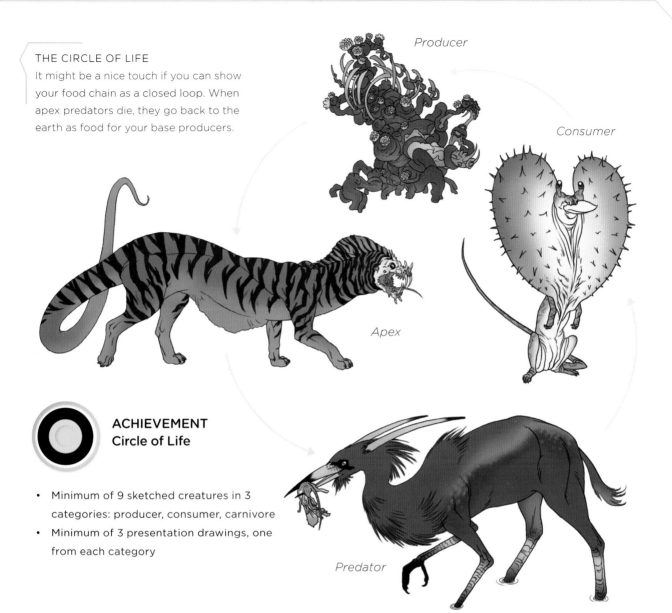

*Producer*

*Consumer*

*Apex*

*Predator*

### ACHIEVEMENT
### Circle of Life

- Minimum of 9 sketched creatures in 3 categories: producer, consumer, carnivore
- Minimum of 3 presentation drawings, one from each category

### BONUS ACHIEVEMENT
### Dog Eat Dog

Extend your predation chain with more links. Add apex predators that eat your carnivores, or introduce competition into the ecosystem: up to 12, 18 or 27 total sketched creatures.

- Tier 1-3 (+3,+9,+18 sketches)

### BONUS ACHIEVEMENT
### Ecoterrorist

Upgrade 3+ more sketches to presentation drawings. Gain a tier for each additional +3 upgraded sketches.

- Tier 1-4

### BONUS ACHIEVEMENT
### Waste Not, Want Not

Successfully recycle 3 Big Game Trophy Heads from Project 02 into this project by adding a body to each head.

# ALIEN GLADIATORS:
## *ARMORED BEASTS AND LIVING WEAPONS*

Your goal in this project is to design a set of alien gladiators featuring arms and armor that may be organic parts of their bodies—armored carapaces, bony swords, spines, horny growths, possibly even projectile weapons that spit spines or teeth.

These creatures are meant for fighting! Go ahead and be powerful and aggressive with the forms you design. Consider how they will fight, and how they will be damaged and die.

Choose if you want low-intensity light entertainment, a cartoony CrabMan vs. NinjaToad, or high-intensity cinematic drama like a big budget reboot of classic Japanese monster movies. This could also work with giant robots.

The meat of this assignment is the fighting! Once you've developed some good designs, make additional drawings showing a damaged and a defeated state. How will they show battle scarring, broken weapons, damaged armor, blood and guts? Do you reveal what they look like under their armor? And how will they look moments before defeat when all is lost?

Have fun murdering your creatures in outrageous ways. Don't take it too seriously. It's all fun and games. Your two damaged/defeated states don't have to be entirely new drawings. Trace on top of your base design to make changes if that helps.

**ACHIEVEMENT**
**We Who Are About to Die**

- Minimum of 5 sketched alien gladiators with organic weapons
- Minimum of 3 presentation drawings of your favorite fighters

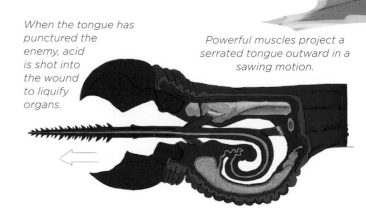

*When the tongue has punctured the enemy, acid is shot into the wound to liquify organs.*

*Powerful muscles project a serrated tongue outward in a sawing motion.*

*Sac filled with flesh-dissolving acid.*

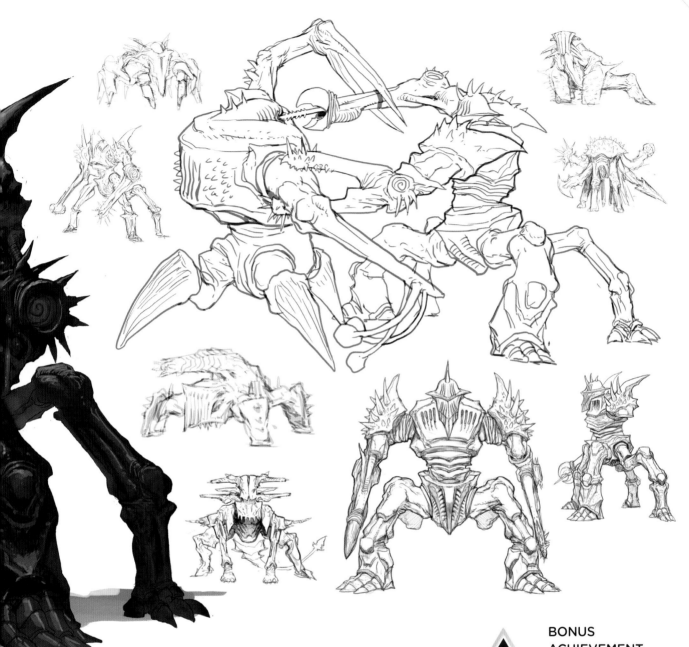

## BONUS ACHIEVEMENT
### Blood on the Sand

For your top 3 fighters, sketch two additional states: damaged and dead.

- +6 presentation drawings

## BONUS ACHIEVEMENT
### Win the Crowd

Additional sketches, up to 7, 12 or 20 total sketches of alien gladiators

- Tier 1-3 (+2,+7,+15 sketches)

## BONUS ACHIEVEMENT
### Are You Not Entertained?

Complete the Damaged and Dead states for 3+ additional gladiators. Gain a tier for each additional +6 upgraded sketches.

- Tier 1-4 (+6,+12,+18,+24 damage states)

# BEAST RIDERS:
## *FANTASTIC MOUNTS*

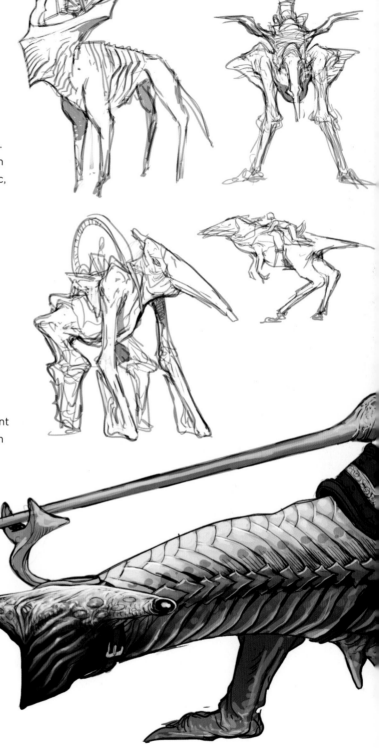

In this exercise we are looking for a fantastic mount, a creature that might be ridden into battle. A loyal steed that transports the hero across a wild landscape. Besides the armored knight and his draft horse, we can think about war elephants or something more fantastic, a giant lizard or a riding spider.

You might consider an alternate approach and design a working animal. A beast harnessed for its great strength, a reimagined version of an ox and cart or a massive working elephant. Think about how the creature will move. How many limbs does it have, and how are the joints and muscles constructed? These should explain how it might walk, run or glide.

Secondly, what kind of saddle or harness does it need. Is there something unusual about the rider's posture or the size of the creature compared to its master? How is the animal guided? Are there reins or spurs or something else entirely?

Consider how the rider stores weapons or equipment and complete the storytelling value of your mount with a suitable cultural design for the saddle, panniers, and/or harness.

**ACHIEVEMENT**
**Easy Rider**

- Minimum of 3 sketched fantastic mounts
- Minimum of 3 sketched upgrades showing saddle/harness/panniers + rider

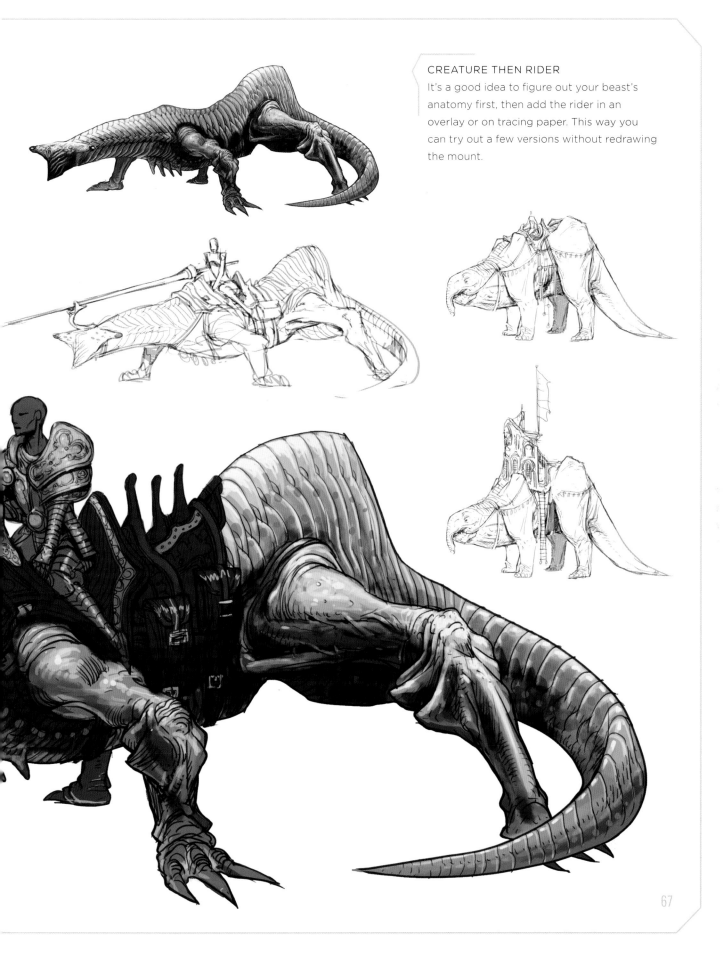

## CREATURE THEN RIDER

It's a good idea to figure out your beast's anatomy first, then add the rider in an overlay or on tracing paper. This way you can try out a few versions without redrawing the mount.

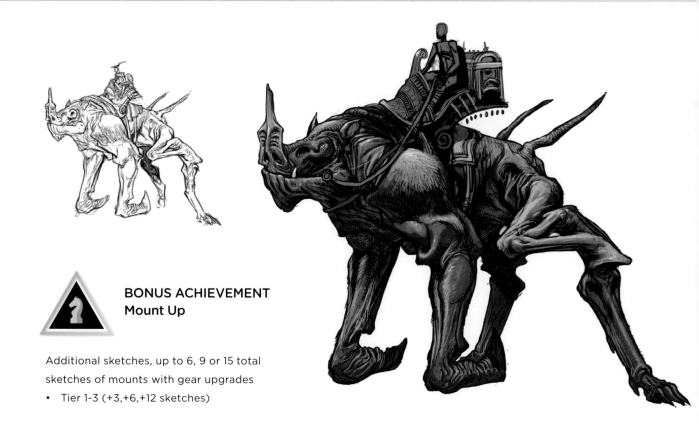

### BONUS ACHIEVEMENT
**Mount Up**

Additional sketches, up to 6, 9 or 15 total
sketches of mounts with gear upgrades
- Tier 1-3 (+3,+6,+12 sketches)

### BONUS ACHIEVEMENT
**Beast Rider**

Upgrade 3+ sketches to presentation
drawings. Gain a tier for each additional +3
upgraded sketches.
- Tier 1-4

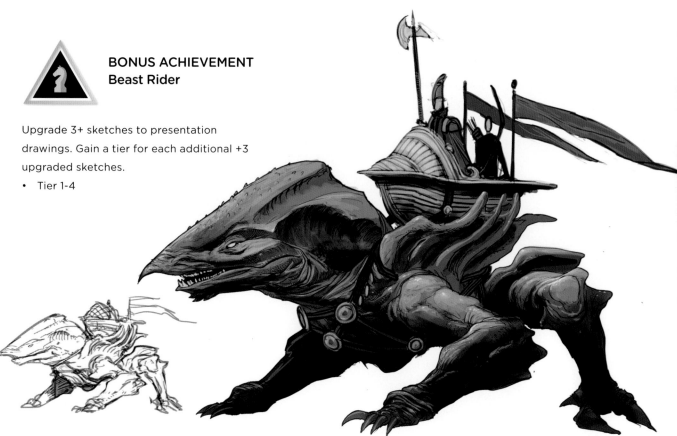

# BONUS ACHIEVEMENTS
Iron Horse (Armor)
Airborne Ranger (Flight)
Hell Bent for Leather (Demonic)
Riding a Pale Horse (Undead)

Presentation drawings showing thematic upgrades to existing designs. Themes include armored (natural or otherwise), flying, demonic and undead.

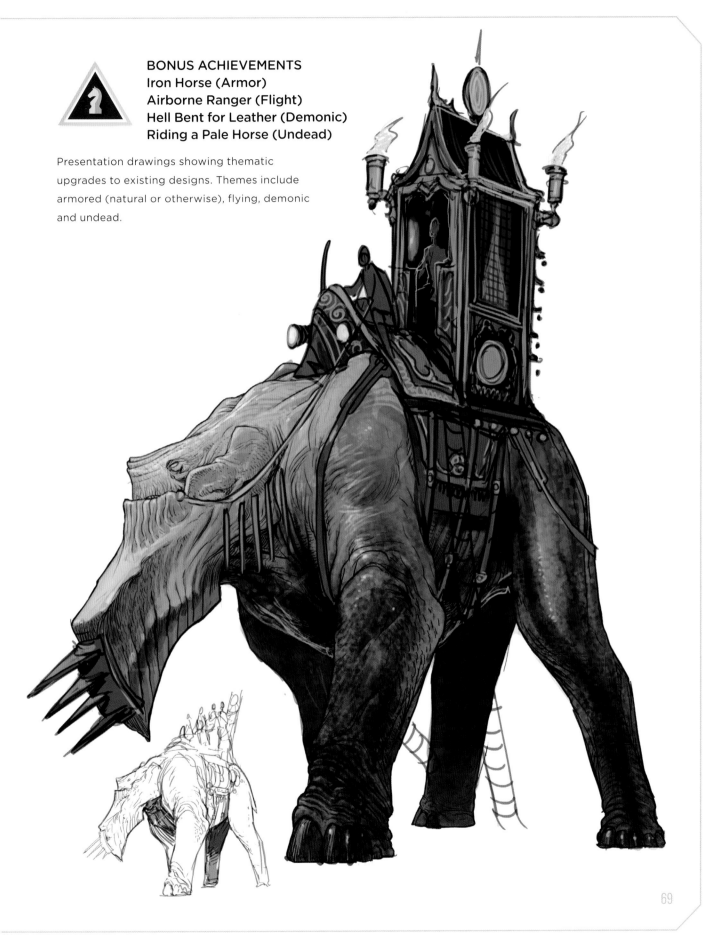

**LEVEL TWO**

*ANATOMY*

ACHIEVEMENTS

MINIMUM:

BONUS:

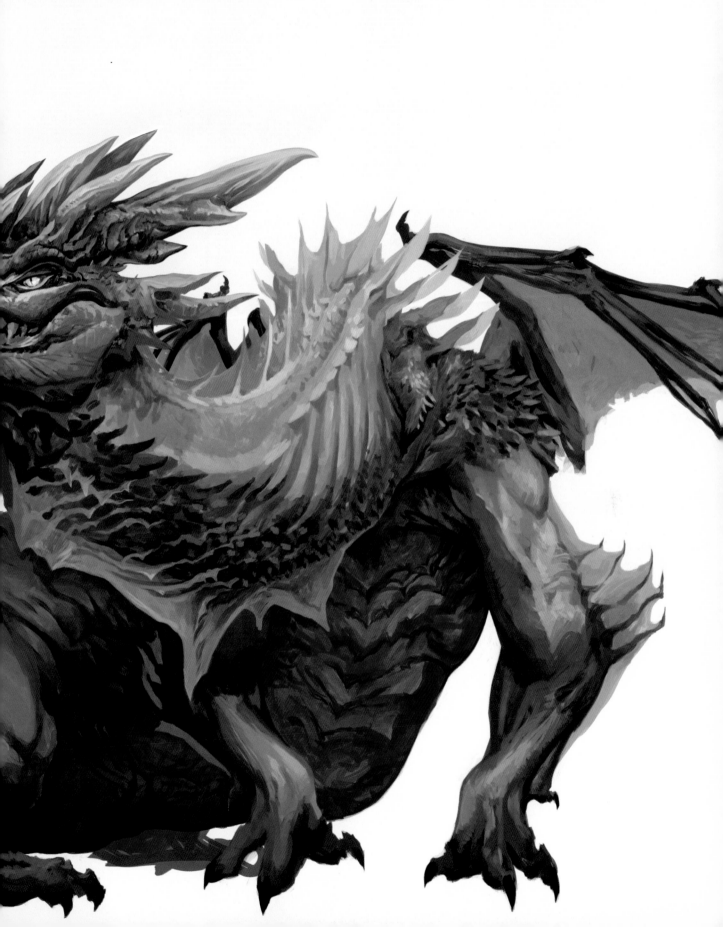

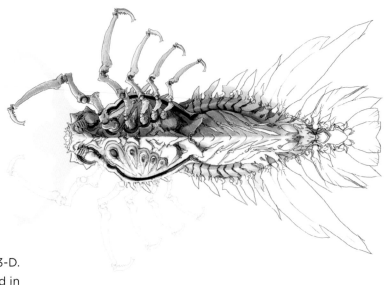

# ANATOMY:
## *PLANNING FOR CONSTRUCTION*

What kinds of drawings are used to describe anatomy? It's all good fun to be sketching away at your desk, inventing amazing characters, but before they can come to life, someone has to build them in 3-D.

Most likely your character will be sculpted in 3-D by another artist, even a team of artists. Or possibly, visual effects makeup people will be building a real-world costume for an actor or an animatronic robot.

In Level Two: Anatomy we will be making the technical drawings that these artists need to recreate your work in 3-D and to improve on your designs as they bring them to life.

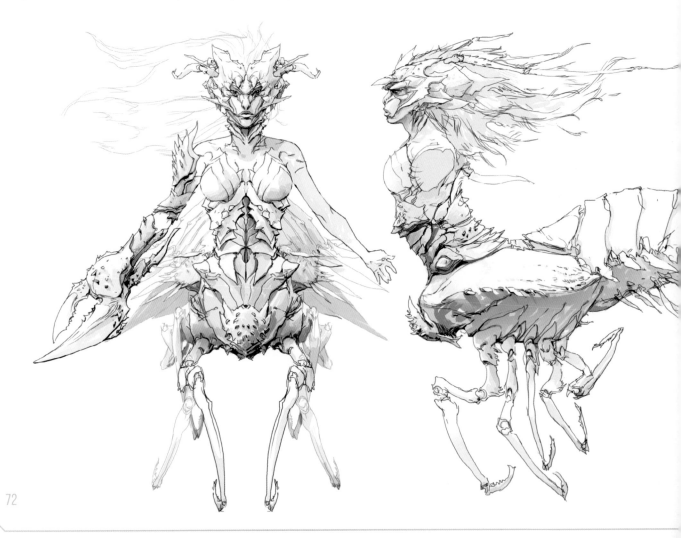

# ORTHOGRAPHIC VIEWS

Clean, descriptive orthographic views are the most important visuals you can give your 3-D sculptors. Typically, these are straight on views of the front, side and back of a character.

Often, first-stage brainstorming sketches might be a bit vague in some areas, especially if they were painted sketches. Following the sketches, more carefully drawn blueprints are your chance to resolve any fuzzy areas. Your goal is to answer as many questions as possible. The more info you can give to your art team now, the better the final results will be.

It's true that a sketch artist cannot imagine complex structures perfectly, but your goal should be a series of matching drawings in correct scale and alignment. You should be able to overlap any two views and see the structures line up.

Orthographic views just need to be informative. These are not works of art conveying emotion. They're construction diagrams. Typically they're just simple line drawings in black and white or with local color identifying materials. Sometimes on a big-budget project these might all be fully painted, but usually you'll finish only the most important view.

The character is best presented in a neutral pose, standing upright with limbs in an extended T or X position. This isn't natural, but it's descriptive. 3-D sculptors must be able to see the structure without any distortion. Occasionally limbs are removed for clarity. For instance, with a humanoid seen from the side, arms can be removed at the shoulder (and sometimes drawn to the side) to give an unobstructed view of the torso.

Care should be taken to keep the same scale and relative position between views. It's common to use guidelines that keep things like foot position, waist, shoulders, neck and head in alignment.

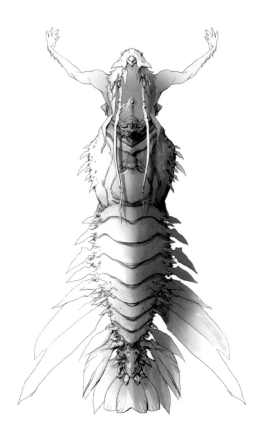

### SHOW MULTIPLE ANGLES
Nonhumanoid creatures sometimes need different camera angles. The view from the top (dorsal) and bottom (ventral) can be used to show important structures.

# SUPPLEMENTARY SKETCHES

There are always some things orthographic scale views can't completely show. You'll need to use judgment when another drawing is necessary. Think about when to add information like this:

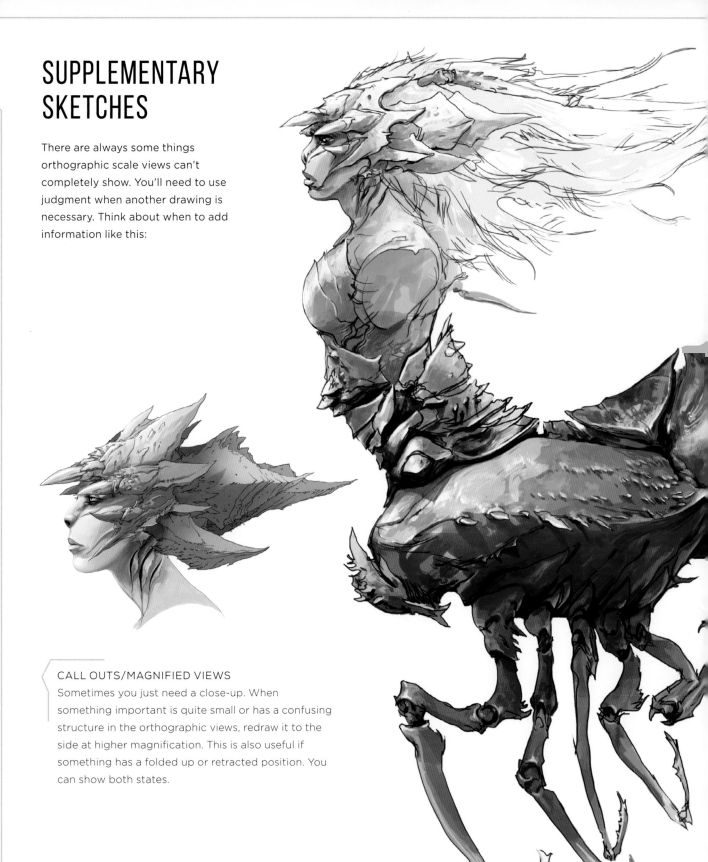

### CALL OUTS/MAGNIFIED VIEWS

Sometimes you just need a close-up. When something important is quite small or has a confusing structure in the orthographic views, redraw it to the side at higher magnification. This is also useful if something has a folded up or retracted position. You can show both states.

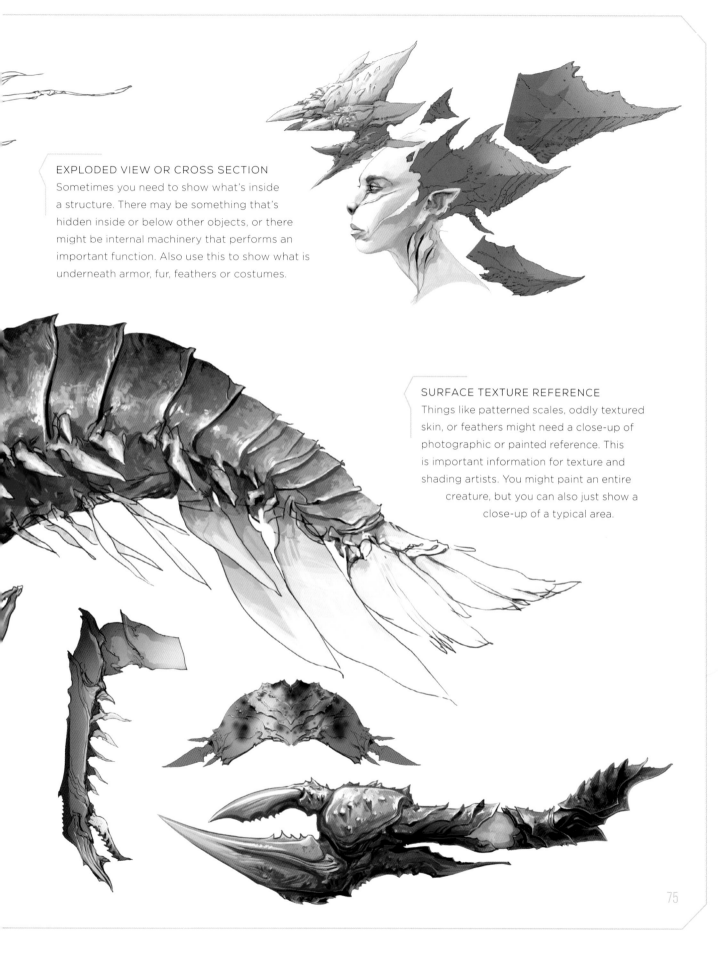

## EXPLODED VIEW OR CROSS SECTION

Sometimes you need to show what's inside a structure. There may be something that's hidden inside or below other objects, or there might be internal machinery that performs an important function. Also use this to show what is underneath armor, fur, feathers or costumes.

## SURFACE TEXTURE REFERENCE

Things like patterned scales, oddly textured skin, or feathers might need a close-up of photographic or painted reference. This is important information for texture and shading artists. You might paint an entire creature, but you can also just show a close-up of a typical area.

# VARIATIONS AND PROGRESSIONS

Sometimes a character design will have minor variations, things like costume changes over the course of a story, or changes over time, such as gaining power levels or displaying combat damage.

The creature may also appear in groups with slightly different characteristics. You can make the crowd scenes a bit less generic, or make military units appear less perfectly uniform by making simple variations on the basic anatomy.

Often in a video game, the solution is to design a progression where the character goes from a simple to a more complex version with a few steps in between. This way we can make each version slightly different by selectively removing and swapping parts.

It's like playing with a customized set of creature LEGO. The advantage is the team only has to build the character once, but the game can make different individuals by mixing and matching accessories.

Usually these design solutions don't need entirely new drawings; you can use layers digitally (or just tracing paper) to show how modular parts will fit over top of the shared anatomy.

It's probably easy to see how this works with body armor. It could just as easily be any kind of clothing. Create more variation by swapping heads and hairstyles, changing weapons or just changing skin colors and textures.

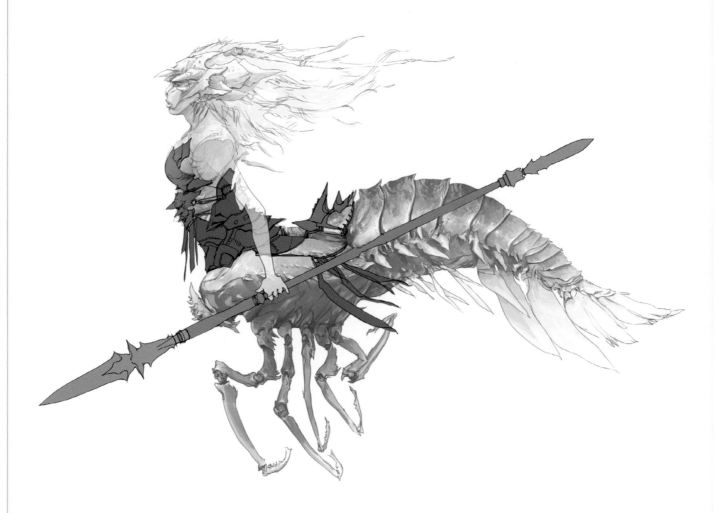

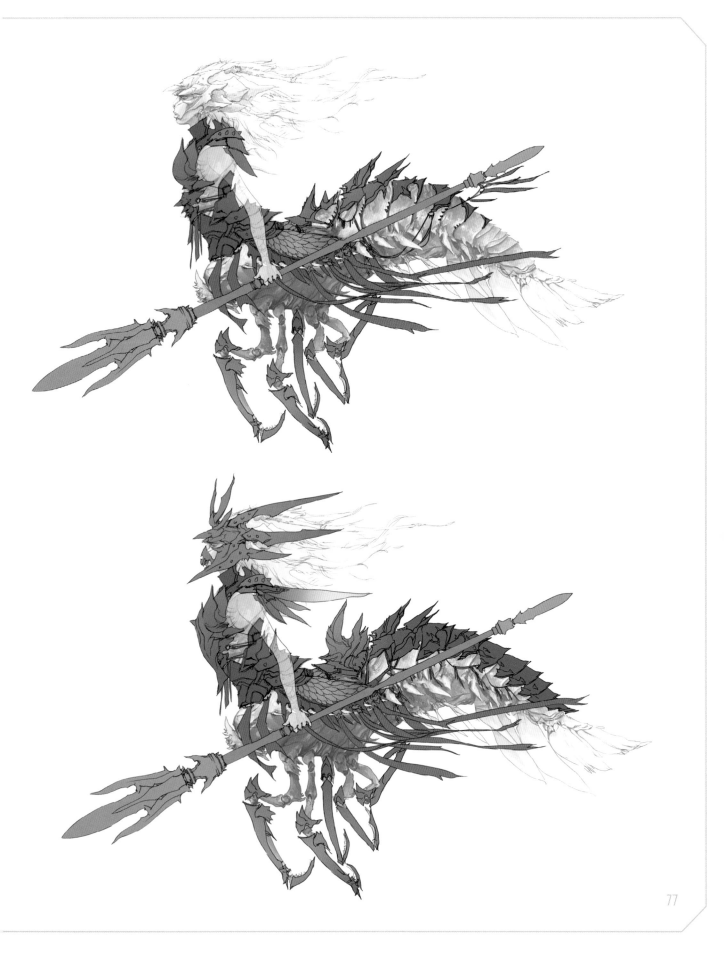

# (UN)NATURAL WEAPONS:
## *CLAWS, TENTACLES AND BREATH OF FIRE*

Your task is to design a creature with a minimum of three different kinds of natural weapons. By natural, I mean part of their anatomy, not a tool such as a sword or gun. The challenge here is how to best fit three interesting concepts (or more. The more you can work in, the better!) into a single coherent design.

How will the different natural weapons work together? How will they affect the creature's locomotion? How do the skeleton and musculature support these features?

Your creature might be a biologically convincing animal with claws, teeth and tusks. It could have a stinger and a cluster of barbed tentacular pseudopods around its grinding mouth parts. Or it could be a mystical creature with fire breath, flaming antlers and superheated hooves.

Have fun with the brainstorming. You'll find many interesting ideas by sketching them to life.

Always be thinking *what is the best way to show your invented natural weapons?* Would you make a magnified cutaway view that shows claws unsheathing (catlike) out of forelimbs? Maybe you need an X-ray view that shows interior organs manufacturing poison or acidic bile. Think of ways to demonstrate this kind of hidden anatomical detail while still making a descriptive drawing.

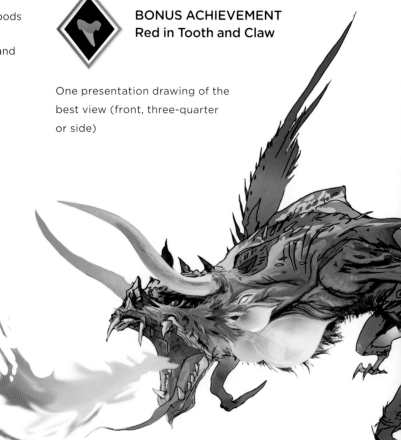

**BONUS ACHIEVEMENT**
**Red in Tooth and Claw**

One presentation drawing of the best view (front, three-quarter or side)

**ACHIEVEMENT**
**Unnatural Weapons**

- As many brainstorming sketches as required to find a great design
- One set of orthographic views (front, three-quarter and side) of your best 3-in-1 beast

**BONUS ACHIEVEMENT**
**Stings and Arrows**

Supporting images such as magnified views or cross sections describing the function of your weapons

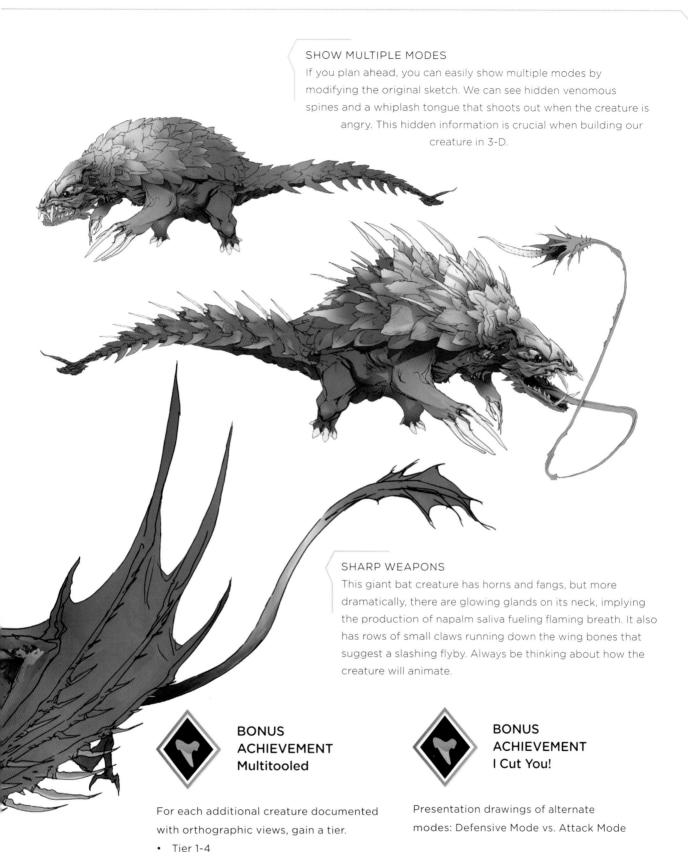

## SHOW MULTIPLE MODES

If you plan ahead, you can easily show multiple modes by modifying the original sketch. We can see hidden venomous spines and a whiplash tongue that shoots out when the creature is angry. This hidden information is crucial when building our creature in 3-D.

## SHARP WEAPONS

This giant bat creature has horns and fangs, but more dramatically, there are glowing glands on its neck, implying the production of napalm saliva fueling flaming breath. It also has rows of small claws running down the wing bones that suggest a slashing flyby. Always be thinking about how the creature will animate.

**BONUS ACHIEVEMENT**
Multitooled

For each additional creature documented with orthographic views, gain a tier.

- Tier 1-4

**BONUS ACHIEVEMENT**
I Cut You!

Presentation drawings of alternate modes: Defensive Mode vs. Attack Mode

# HYPER-EVOLUTION:
## ELOI AND MORLOCKS

In the 1895 science fiction classic *The Time Machine*, author H.G. Wells proposed that millions of years into the future humanity evolves into two different species: the Eloi, peaceful, hyper-evolved humans living in ecologically perfect coexistence with nature and the Morlocks, debased, bestial and degenerate cannibalistic mutants dwelling in caves.

In the book, the Morlocks are troglodytes; that is, creatures adapted to live in the total darkness of caves. They are pale, light sensitive and not reliant on vision to function. In some versions of the story they've been portrayed as brutish and violent; in others they are desperate survivors eking out a pathetic existence. It's up to you how you'll spin the story. Choose the intensity level of the designs, and which of these races you want to portray as good and bad guys. It might seem obvious, but it's possible to make different interpretations.

Do some research on real cave-dwelling species. That's how I found the word *troglofauna*, not to be confused with *stygofauna*, aquatic creatures who live in underground waters (a term named after the River Styx). See how much you can learn being a concept artist?

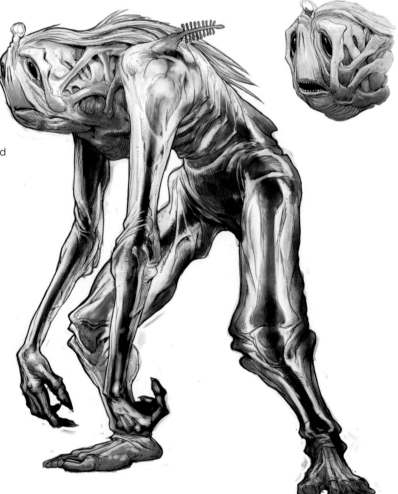

**ACHIEVEMENT**
Eloi Above

- As many brainstorming sketches as required to find your designs
- One set of orthographic views of your hyper-evolved human

**ACHIEVEMENT**
Morlocks Below

- As many brainstorming sketches as required to find your designs
- One set of orthographic views of your hyper-evolved human

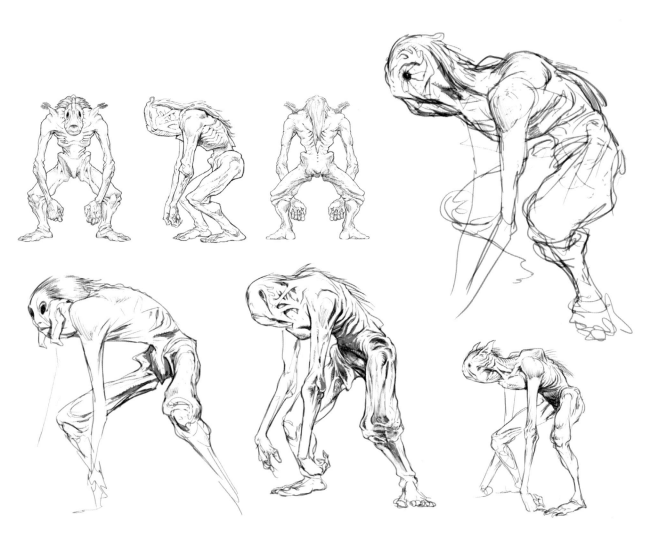

## MAKE A CLEAR ORTHOGRAPHIC SKETCH

The orthographic sketch might look less exciting than the presentation drawing, but it's necessary to explain important anatomical details. A drawing is always more clearly understood than a painting.

**BONUS ACHIEVEMENT**
**Racial Profile**

Presentation drawings of both races, best view (front, three-quarter or side)

• +2 color drawings

**BONUS ACHIEVEMENT**
**Time Waits for No One**

Presentation drawings of your time traveler and their time machine

**BONUS ACHIEVEMENT**
**Genetic Drift (+7 Morlock) Hyper-Evolved (+7 Eloi)**

Brainstorm a minimum of 7 sketches for each of the two races, detailing additional members of each race—opposite sexes, old folks and children. Sketch a unique individual, a tribal leader, a warrior and an average person. A monster is easy—individual personalities are harder!

# EXPERIMENTS OF DR. MOREAU:
## *HUMANOID HYBRIDS*

In the 1896 science fiction novel *The Island of Doctor Moreau*, H.G. Wells invented an isolated society of monstrous human/animal hybrids. The story deals with fears of modern society regressing into barbarism. This is just one of many works of fiction that included anthropomorphic animals (creatures fusing animal and human characteristics).

Your task is to design a set of human/animal hybrids that cover a wide range of emotional responses. Most of us will find one side of the scale easier than the other. If you always sketch serious characters, it will be a challenge to make something cute. If you're cartoony by nature, then you'll have to push yourself for dramatic realism.

It is important to have a focused portfolio so it's clear where your interests and skills lie, but eventually you'll be called to work against your nature. It's useful to have at least tried it a few times and have some tricks in reserve.

At minimum, attempt to deliver four unique human/animal designs with different emotional tones:

- Aggressive/scary/bestial
- Ugly/creepy/weird
- Cute/funny/waifish
- Heroic/inspirational/attractive

Which animals would best combine with humans to convey different aspects? Tigers are scarier than rabbits. Usually. Maybe you can make a scary rabbit-man?

Despite the range of tone required, aim for a consistent style of execution. On a real job, you couldn't switch from realistic to cartoony in order to achieve a different emotional tone. You must get the emotional effect you want within the same visual language.

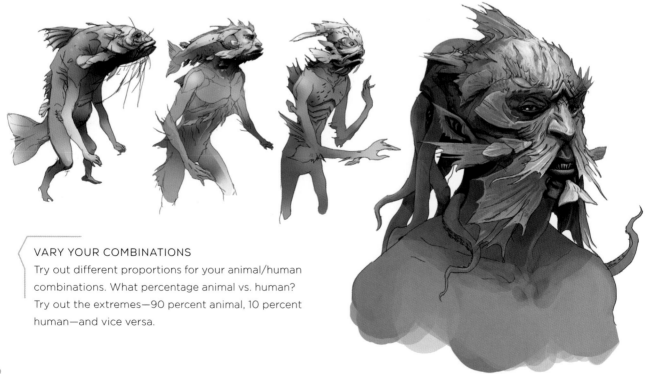

**VARY YOUR COMBINATIONS**
Try out different proportions for your animal/human combinations. What percentage animal vs. human? Try out the extremes—90 percent animal, 10 percent human—and vice versa.

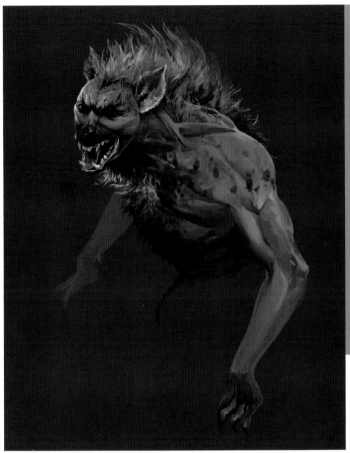

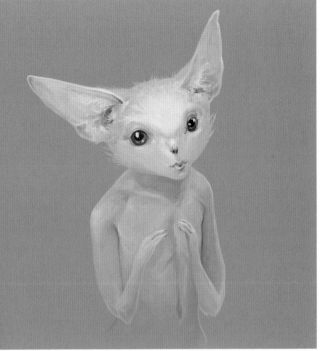

Choosing the right animals does most of the work for you, but factors such as color range, expression and posing can improve the effect.

**ACHIEVEMENT**
**Animal Instincts**

- Sketch a minimum of 12 different hybrids. They can be variations on the same cross-mix (this is harder) or different animals for each.
- Four presentation drawings covering all 4 emotional effects

**BONUS**
**ACHIEVEMENT**
**Hybrid Vigor**

For each hybrid creature documented with orthographic views, gain a tier.

- Tier 1-4

**BONUS**
**ACHIEVEMENT**
**Animal Crossing**

Additional presentation drawings, up to 7, 12 or 20 total hybrids

- Tier 1-3 (+3,+8,+16 drawings)

**BONUS**
**ACHIEVEMENT**
**Mad Doctor!**

Sketches and presentation drawings of your version of Dr. Moreau

# WEREWOLVES OF LONDON:
## *TRANSFORMATION SEQUENCE*

Your task is to design a werewolf and describe the transformation sequence. Naturally you don't have to limit yourself to a canine type of wolf. It can be any kind of were-creature you prefer, even something that isn't based on a real animal, as long as it starts as a normal human and physically transforms into a monster. It's probably best to start with brainstorming your target creature, developing interesting features that separate it from a natural animal.

Here's the real meat of the project. Once you have a goal in mind, the ultimate challenge here is to work out the anatomical transformation from normal human biped into your creature.

How does the anatomy of the human deform to fit your creature? Is the transformation quick and painless? Or a gruesome ordeal? What bones and musculature have to move or stretch, and in what order do the body parts change? Remember, try not to be strictly functional, but make it happen in an exciting way. Try

to factually answer the question: how do you get from A to B so that an animator would be able to make it really happen? Don't cut corners and jump steps in the transformation.

As you work, you may find you need to redesign your beast-form to line up better with the transformation sequence you're planning. That's OK. In fact, part of the challenge is to come up with the most interesting balance between final design and transformation steps, even if it means redoing your initial sketches.

Keep in mind, the traditional idea of a were-creature probably suggests a ravenous beast. But in this case, your design does not have to be negative in tone. You might be imagining a superheroic or divine transformation.

As with all of these projects, aim for a final tone and level of realism that fits your personal goals. Always be thinking about what kind of portfolio you are building and what sort of projects you're aiming for.

### RESEARCH DRAWINGS
Remember the value of research drawings: If you take the time to study some less obvious sources, you can move beyond the first solution. Here I took a look at humans, wolves, sabertooth tigers and something called a wolf-fish to come up with a composite skull.

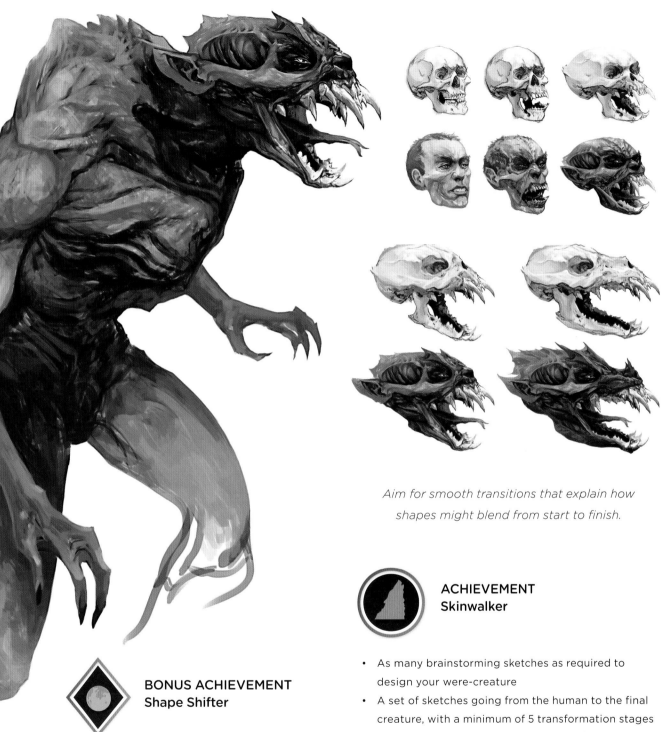

*Aim for smooth transitions that explain how shapes might blend from start to finish.*

### ACHIEVEMENT
### Skinwalker

- As many brainstorming sketches as required to design your were-creature
- A set of sketches going from the human to the final creature, with a minimum of 5 transformation stages
- A set of anatomical cutaway sketches showing skeletal and/or musculature changes required for the transformation

### BONUS ACHIEVEMENT
### Shape Shifter

Sets of orthographic drawings of your were-creature at key stages in the transformation

- Tier 1-3

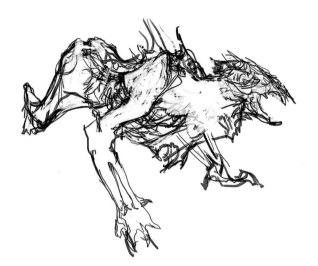

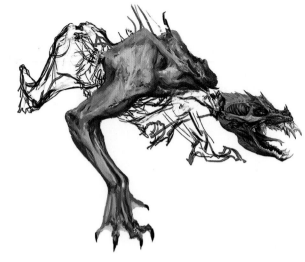

### 1 ROUGH SKETCH

If you know you're going to paint over a sketch completely, you can leave the drawing in a very rough state. If the goal is finished line art, trace it again and tighten up the details. But that's not necessary in every case. Why invest in a drawing you're going to make obsolete?

### 2 DEVELOP MUSCULATURE GROUP BY GROUP

Plan out a creature's musculature group by group, like sculpting clay over an armature. Inventing a creature's anatomy is just a matter of adapting what you know from humans, dogs or other terrestrial animals. Research drawings always help!

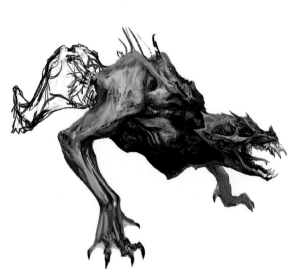

### 3 BLEND SHAPES AS YOU GO

Try not to have too many layers, it just gets confusing. As each section is completed, flatten it into the painting and blend it together. It's easier to make small changes to the silhouette when it's all in one layer. (I do keep the drawing underneath though.)

### 4 SMALL DETAILS

Save any extremely small details such as the spines on this creature's back, or on other creatures there might be scales or hair, for their own layer. These little details can often be copied/pasted or cloned if they're separate from the body.

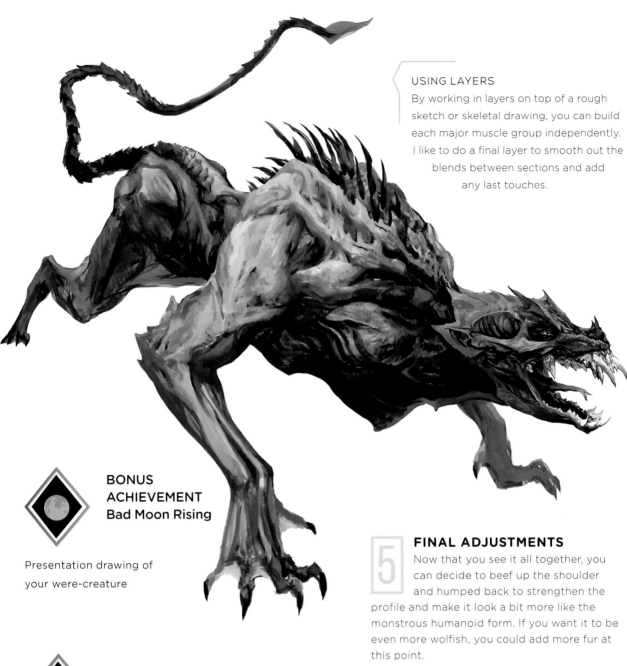

## USING LAYERS

By working in layers on top of a rough sketch or skeletal drawing, you can build each major muscle group independently. I like to do a final layer to smooth out the blends between sections and add any last touches.

## BONUS ACHIEVEMENT
### Bad Moon Rising

Presentation drawing of your were-creature

## 5 FINAL ADJUSTMENTS

Now that you see it all together, you can decide to beef up the shoulder and humped back to strengthen the profile and make it look a bit more like the monstrous humanoid form. If you want it to be even more wolfish, you could add more fur at this point.

## BONUS ACHIEVEMENT
### What Big Teeth You Have!

Additional before and after sketches of specific anatomical changes such as Hands-to-Claws or Face-to-Muzzle transformation. For each detail described, gain a tier.

- Tier 1-4

## BONUS ACHIEVEMENT
### Trouble on the Way

Presentation drawing of a mid-transformation stage

# MONSTER RANCHER:
## *CROSSBREEDING EXPERIMENT*

In this project you are a Monster Rancher intent on breeding the perfect fighting beast. Your goal is championship monsters for arena fighting. It's up to you if this will be brutal, bloody combat or lighthearted entertainment with plenty of zap-zap and pew-pew. Try to avoid humanoids. Crossbreeding people is icky. This is aimed at beast-type monsters.

For this project, first brainstorm two monsters as breeding stock, your first generation parents. Then ideate freely on designs for their crossbred offspring. What kind of creatures would result from your breeding experiment? What characteristics do you want to carry over from the parents or enhance by breeding?

The challenge of this project is showing what you can do with the materials you have. You cannot add any new ideas—only combine and exaggerate what exists in the parents to produce interesting children.

How will you work within this limitation? If you crossbreed a hellhound with a dragon, would you get a scaly bat-winged dog? Or a furry serpent with three dog heads? Can you improve a monster by breeding it with a fire-breather? Or would you rather introduce armored scales into your crossbreed? Your initial choices will make all the difference.

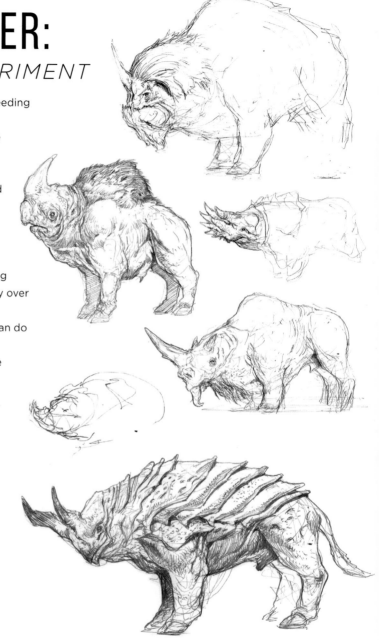

**ACHIEVEMENT**
**Monster Rancher**

- As many brainstorming sketches as required to choose your breeding pair
- Two presentation drawings (one of each parent)
- Minimum of 5 sketched variations of crossbred offspring
- One presentation drawing and an orthographic drawing set of the best offspring

### TRY OUT COMBINATIONS
Do whatever brainstorming you need to design a male monster. Then repeat to add a female parent. Strive to make them as different as possible so you can create interesting combinations.

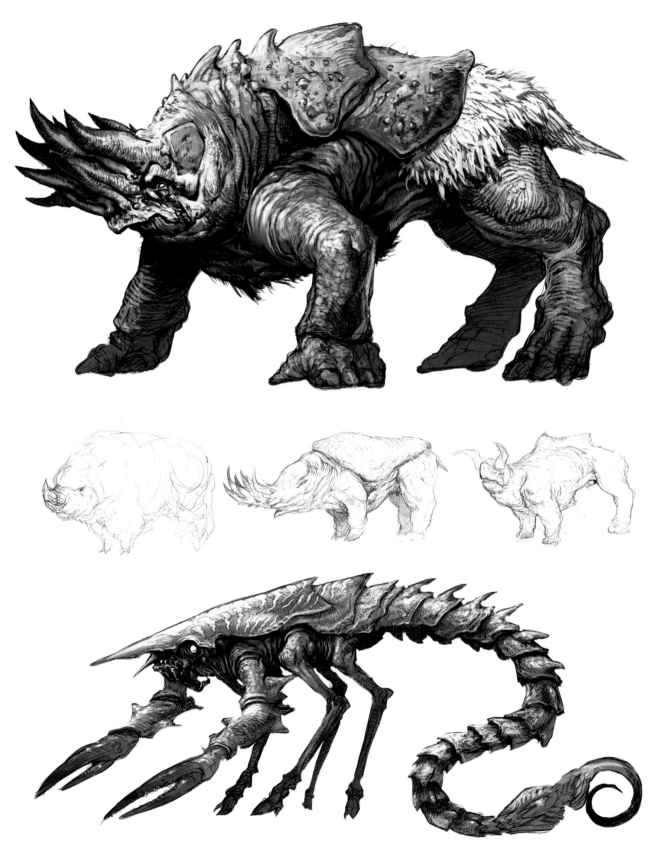

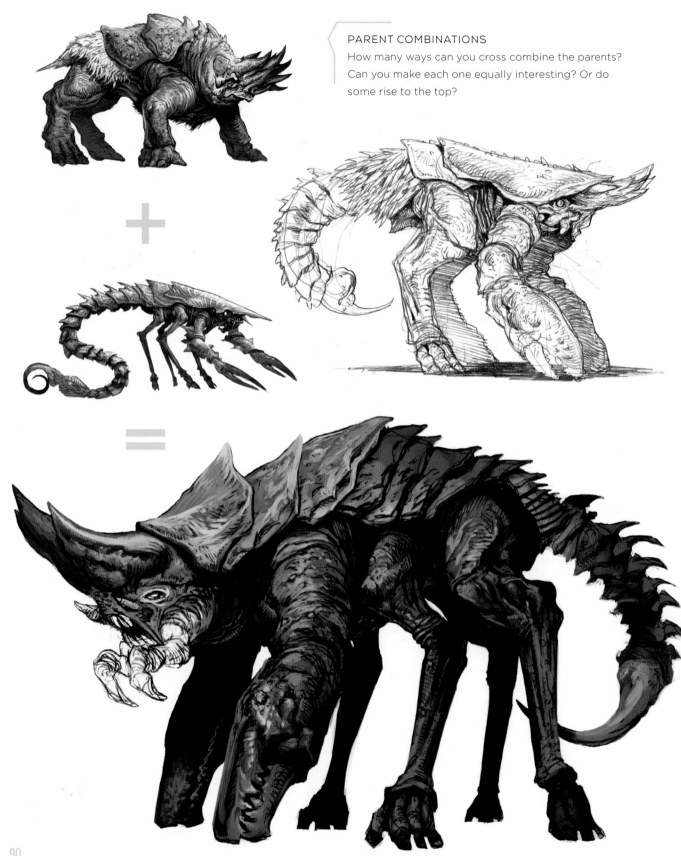

PARENT COMBINATIONS
How many ways can you cross combine the parents?
Can you make each one equally interesting? Or do
some rise to the top?

### BONUS ACHIEVEMENTS
### Kissing Cousins (Second Generation)
### Artificial Insemination (Third Generation)
### Red-Headed Stepchild (Fourth Generation)

Continue conceiving crossbreeds to second and third generations. Produce a minimum of 7 sketches combining children with children. Can you keep coming up with ideas for inbred offspring without adding new breeding stock?

### BONUS ACHIEVEMENT
### Best of Breed

Produce a presentation drawing and an orthographic set of the best in each generation. Gain a tier for each upgrade.

- Tier 1-3

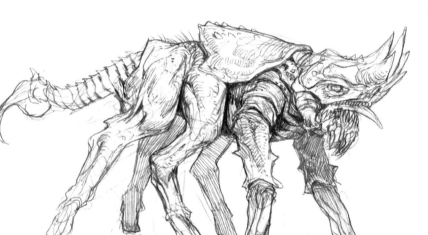

### GENETIC CONNECTIONS
You can keep making variations from these same parents or you can introduce a new breeding partner to create new traits over the generations. How far can you modify your creatures from the original breeding stock without losing the ancestral connection?

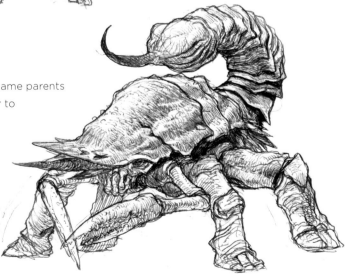

# LITTLE MONSTERS:
## *GROWTH AND DEVELOPMENT*

As creature designers, we all love monster movies, the kind of film where the concept design of the monster is just as important as the performance of the actors.

In many of these creature features there's a natural progression of suspense that follows the development of the monster. We've all seen movies with that template. The hapless adventurer breaks open a cache of mysterious alien pods, and quickly enough a creature is on the loose. Often the monster starts out at a disadvantage, but as the victims fall, the alien grows bigger and more bizarre until the final climactic battle when we see the creature in all its terrible glory.

The challenge here for the designer is to make a convincing development sequence from an immature form through various stages of growth until the final mature form.

Alternately, if you're less inclined towards horrible beasts, you might try a more positive spin on this project. Many cultures live hand in hand with domesticated beasts, be they mounts, guardians or working animals. The life cycle of these creatures could be part of the world building behind a fictional setting.

In many role-playing games, it's common for players to build up towards more powerful creatures. You might want to pit the players against baby dragons before introducing the ancient wyrms. A fantastic take on a creature gives you more range for variation between young and old versions.

This could also work in a different storytelling context. A hero sometimes has a mythical animal companion or sidekick. Perhaps they've grown up together from child to adult. These might appear in the story as flashbacks or prequels.

Any way you want to spin it, that's the challenge. Design three to five stages of development from feeble infant to fully mature form. It's up to you to set the scope of things. Does your creature go from a cute cuddly thing you can hold on your lap to a giant city-destroying beast? Or is your goal a biologically convincing development cycle with many subtle changes?

**ACHIEVEMENT**
**Attested Development**

- A set of 3 sketched anatomical stages: infant, youth and mature
- Supporting drawings: cross sections or close-up detail drawings as necessary to define what is unique about each developmental phase
- A presentation drawing of your favorite phase

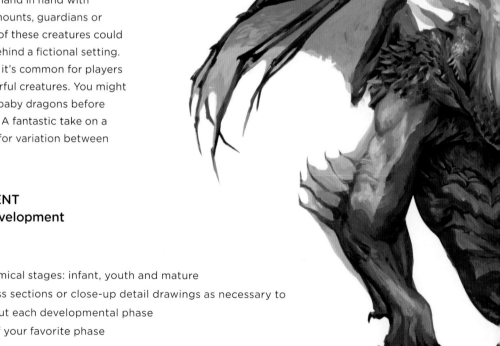

## BONUS ACHIEVEMENT
### Age Appropriate

Expand your sequence to 5 stages of development. Potentially include advanced old age and even fetal development. Or split the youth phase into teen and young adult.

## BONUS ACHIEVEMENT
### Progress Pics

For each full set of orthographic drawings of any developmental phase, gain a tier.

- Tier 1-5

## BONUS ACHIEVEMENT
### Ageless Wisdom

Project your mature form into a mythical future. What kind of mythical stature might a truly ancient creature achieve? Can you push this into near immortality? For each leap into the future, gain a tier.

- Tier 1-3

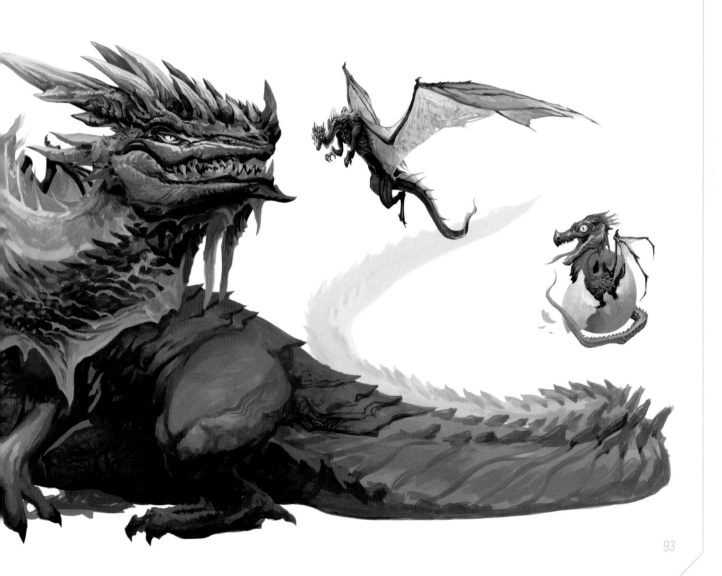

# DIRE BEASTS:
## *EXTREME ANATOMY*

This project is about pushing designs beyond your *best-idea-at-the-time*. There are going to be times when you've invented something pretty darn cool, which, if executed well, could probably do the job just fine. The design is approved and put into production, and you think you won't ever touch it again. But on occasion, once we see things actually under construction, they reveal themselves to be only good, not great.

So what happens when your best design is sent back for more work? How do you go back and push it further? After all, you did your best the first time!

Sometimes you need to take the core concept and double down on the exaggeration. Find whatever aspect is the heart of the idea and push that part of the design further.

### TAKE IT TO THE NEXT LEVEL

If you're designing a warrior with a sword, what does he look like with a *huge* sword? What if his sword is on *fire*? What if he controls a *whirling cloud* of swords with the power of his mind? There is always room in your concept to take it to the next level of fantastic imagination.

It's also possible you have the opposite problem. You've created such an exaggerated, heroic, amazing character that any further enhancement makes it ridiculous. It goes beyond impressive to unbelievable. At this point you need to refine rather than exaggerate.

Can you take the core concept and make it more smoothly integrated with real world anatomy? Can you give it more sophisticated surface texture? Often the key here is digging deeper, doing more research and finding better quality reference material. Find real world details to add to the concept until your exaggerated creature looks like it could actually exist.

### REWORK AN EXISTING DESIGN

So given this challenge, here's an exercise. Take any one of your previous successful designs. Creatures from *Skin and Bones* or *Big Game Trophy Heads* are good candidates, but many previous exercises have creatures that can work.

Pretend your existing design has been rejected at the eleventh hour, and you've been asked to overhaul the concept without losing what was already good about it.

Focus on what was the most important part of your existing design and rework it. Push the concept further. See how many times you can up the ante. Can you push the exaggeration of an idea three times? Five times?

Once you've seen how much you can improve an already good idea, you might find yourself going back and second-guessing a lot of what you thought was final work.

This is a key part of building your portfolio. In any body of work, there is always something that is the weakest link. Find that one thing, improve it and you automatically improve your entire presentation as a whole. You are always judged by the weakest piece you show, not by your best. Art directors have to be concerned about what you'll deliver under pressure. So let's take the opportunity to rework a good piece and push it to great!

**ACHIEVEMENT**
**Break on Through**

- Select a previously acceptable design and brainstorm ways to push the core concept further
- Minimum of 3 presentation drawings of your improved ideas

**BONUS ACHIEVEMENT**
**Ideation Iteration**

Can you push an idea a second time? A third? Before it jumps the shark? For each iteration, gain another tier.
- Tier 1-4

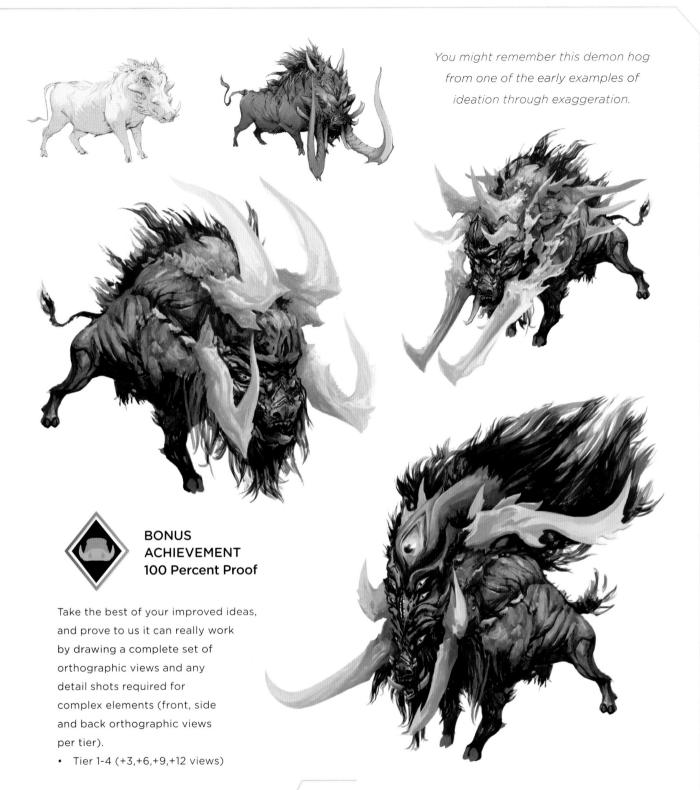

*You might remember this demon hog from one of the early examples of ideation through exaggeration.*

## BONUS ACHIEVEMENT
## 100 Percent Proof

Take the best of your improved ideas, and prove to us it can really work by drawing a complete set of orthographic views and any detail shots required for complex elements (front, side and back orthographic views per tier).

- Tier 1-4 (+3,+6,+9,+12 views)

### PUSH YOUR CONCEPT TO THE EXTREME
By repeatedly pushing the exaggeration, trying to one-up yourself with each iteration, you can stretch the concept from an imposing animal to a truly demonic interpretation of the idea.

# PARASITE EVOLUTION:
## *GROSS ANATOMY*

There is an entire subgenre of horror and dark fantasy built upon the idea of body dysmorphia. We all have things we dislike about the meat-prisons that contain our minds. In some people this fear of imperfection or the concern with reaching impossible standards becomes a paralyzing obsession.

We also share another common fear—infirmity, the failure of our bodies, either by the looming threat of old age and senility, or the fear of a paralyzing accident or mental illness.

Gruesome stories about the decay of our physical selves, demonic possession, alien infestations or weird mutations help us express these parts of our psyche. It's certainly something that calls for a concept artist to skirt a close line next to some disturbing ideas.

### DEVELOP A PARASITE

Your challenge in this project is to design an alien parasite that lives within a human host. The first goal is to design the free-roaming form of the parasite itself so that it might be animated in all its wriggling glory. But we also need to consider the stages of development that will occur inside the human host.

You'll have to decide what level of intensity is suitable for your portfolio. How far can you push this idea before it's beyond your personal limit? Designing for entertainment media in this day and age is not always for the faint of heart. What sort of projects do you want to try for?

If you really push for a high-intensity negative creature, the parasite may eventually transform the human host entirely, becoming a monstrous thing and/or propagating itself through a disgusting form of reproduction. Things can escalate to the *kill-it-with-fire* stage very quickly. And that's what we want in a creature feature! The audience is looking for catharsis and, perhaps with some pity for the victim, although mostly they seek relief that their problems are pale in comparison.

But if you want to dial it back, you can work towards a low-intensity negative design; perhaps there's a lighthearted angle. It might even have a comical appearance. Maybe your host has a strange growth or attachment that could be easily removed or cured; possibly a bug riding on the head, or people turning into mushroom men. If you can imply the condition is curable, the story can turn out OK in the end.

It's possible to even put a positive spin on it, that somehow this creature could give its host super powers such as regenerative properties or enhanced senses, something like the *Spider-Man* story but with more spiders.

Whichever way you go, the exercise should focus on how it works anatomically. How does it grow and mutate inside or outside the human form?

**ACHIEVEMENT**
**Down with the Sickness**

- As many brainstorming sketches as required to find your parasite/host ideas
- A set of orthographic views of the original, free-roaming form of the parasite
- Rough sketches in a sequence detailing a minimum of 4 of the phases of infiltration: infection, parasitism, advanced state and final consumption of the host

**BONUS ACHIEVEMENT**
**Not Even My Final Form!**

Upgrade your rough sketches of the infiltration cycle to presentation drawings.

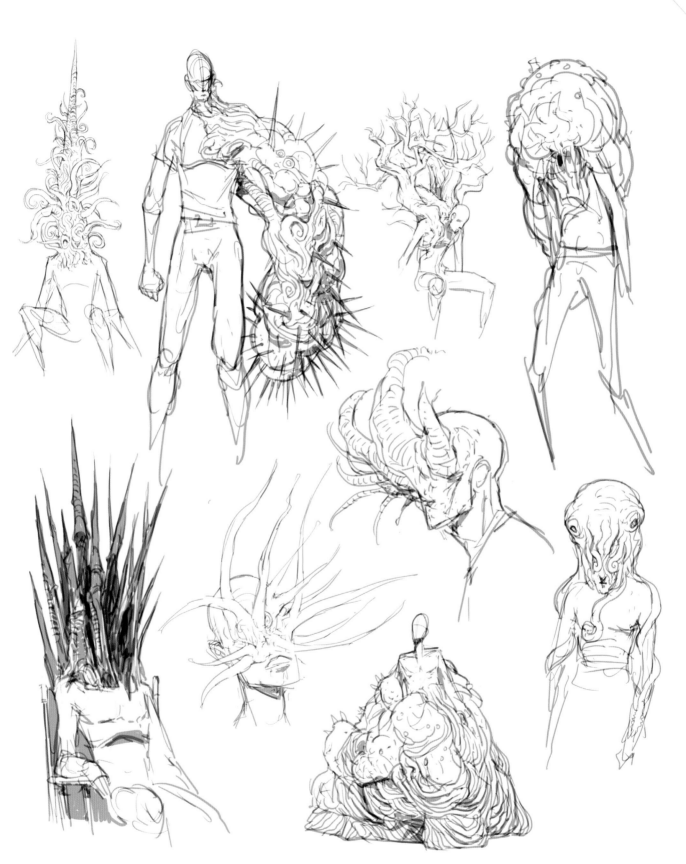

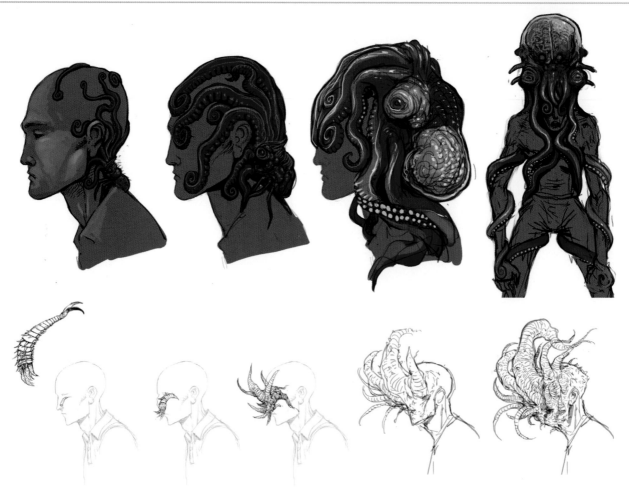

*Very simple drawings can tell the whole story. Visualizing ideas is easy for a concept artist, yet incredibly valuable for the project as a whole.*

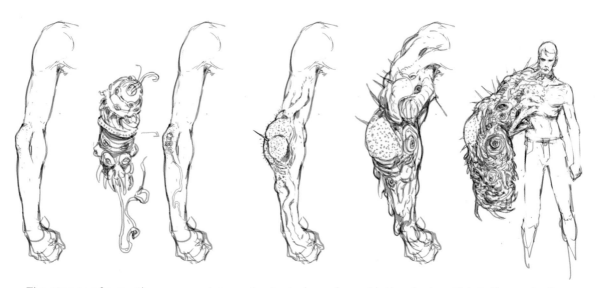

*The stages of growth are a great opportunity to have fun with the design. This is the sort of storytelling imagination that is most rewarding for a designer.*

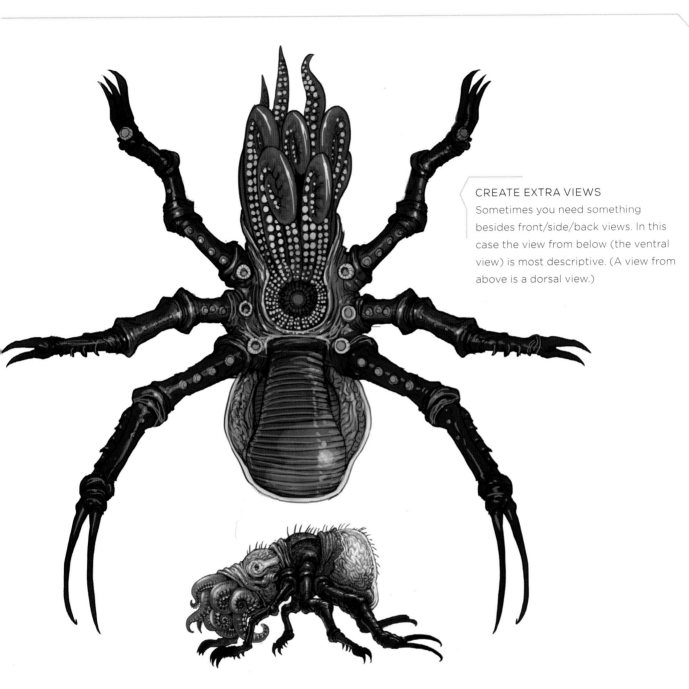

**CREATE EXTRA VIEWS**
Sometimes you need something besides front/side/back views. In this case the view from below (the ventral view) is most descriptive. (A view from above is a dorsal view.)

**BONUS ACHIEVEMENT**
**Worms Go In, Worms Go Out**

Presentation drawings of the fifth phase: reproduction. How does the parasite life-form spread its young?

**BONUS ACHIEVEMENT**
**Looks Infected, Bro**

Continue to invent new parasites and sketch 4 new infection drawings. For each new concept set, gain another tier.

- Tier 1-4

# STRANGE ATTRACTORS:
## *DARK BEAUTY, HEAVENLY PERFECTION*

It can seem like creature design is always about making hideous monsters: deforming, mutating, adding fangs, warts and wrinkles.

It's a good day in the studio when we get asked to sketch a creature that is strange and otherworldly, but at the same time alluring, perhaps even erotic. In this project your challenge is to design a beautiful creature that might serve as a romantic-interest character, a seductive adversary or an idealized heroic figure.

This might seem like a simple assignment, drawing a pretty girl or handsome lad, but being able to make a character attractive is a crucial skill for an entertainment artist. It takes plenty of practice to draw an attractive figure. Don't underestimate how difficult it is. Everyone has their own mental image of beauty. Success or failure is often a matter of small subtleties in the drawings or unspoken cultural cues.

Don't forget, designs can be male, female or something else entirely. Your creature does not have to be entirely humanoid.

As always, choose the level of realism that matches your portfolio. The way you portray attractive characters is crucial to positioning your work. Generally these types of characters get the lion's share of attention when marketing your game or film.

One further element—though this is an anatomy challenge—in reality, this kind of project requires you to invent a suitable costume. Your character can't be naked in most stories. At least not all the time.

Occasionally some creatures might dodge this requirement by being robots or aliens or something that can be innocently naked. But it's rare for a character who spends any significant time on screen to have no clothing or equipment at all. Therefore, you'll need to consider your character's costume at the same time as you design their physical form, much in the same way we've drawn skeletons and muscles in layers.

**ACHIEVEMENT**
**Strange Attractors**

- A set of orthographic views of your character's anatomy
- A second set of orthographic views of your creature in costume
- A presentation drawing of the final costumed design

**BONUS ACHIEVEMENT**
**Gender Bender**

A presentation drawing of a version of your creature as the opposite sex. Merman to your mermaid or vice versa

**BONUS ACHIEVEMENT**
**Haughty Couture**

3+ presentation drawings of your creature in different costumes. How would they appear in different situations? Ready for war, at home relaxing, at a formal occasion, in seasonal costume?

- Tier 1-3 (+3,+7,+12 costumes)

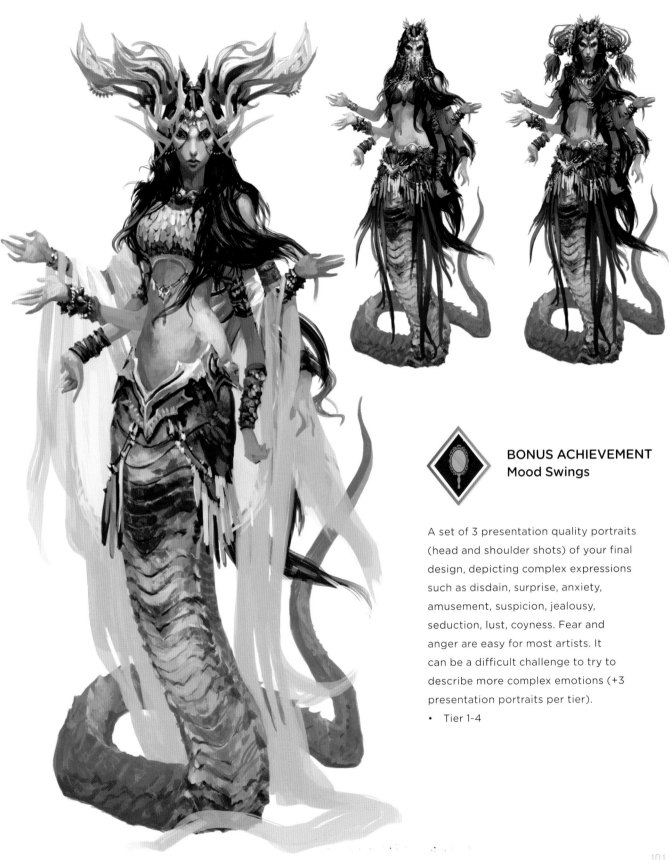

## BONUS ACHIEVEMENT
### Mood Swings

A set of 3 presentation quality portraits (head and shoulder shots) of your final design, depicting complex expressions such as disdain, surprise, anxiety, amusement, suspicion, jealousy, seduction, lust, coyness. Fear and anger are easy for most artists. It can be a difficult challenge to try to describe more complex emotions (+3 presentation portraits per tier).

- Tier 1-4

# LEVEL THREE
## *ANIMATION*

### ACHIEVEMENTS

**MINIMUM:**

**BONUS:**

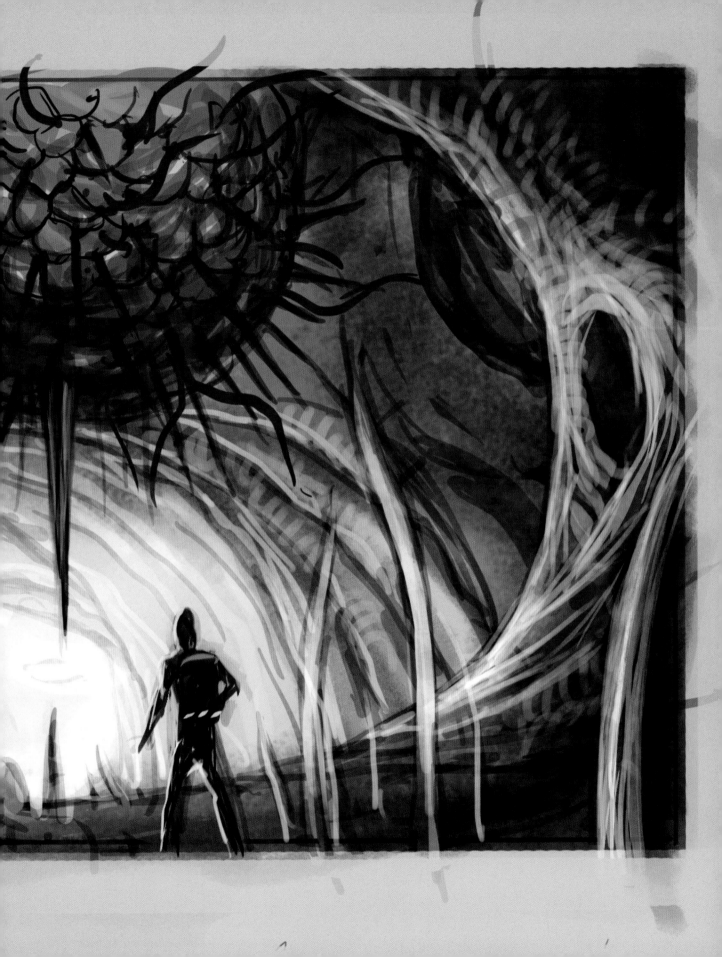

# ANIMATION:
## *SHOWING YOUR CHARACTERS IN MOTION*

Why do we describe animation with still images? In Level Three: Animation, the exercises introduce the use of sequential drawings that show your characters in motion.

You might think this is more of a task for an animator than a concept artist. But with today's 3-D art environment, animators don't have anything to work with until a model has been built. It will always be faster and easier to previsualize a character with a few drawings instead of going ahead and building something just to find out if it's really going to work.

We can also use storyboards or pose sheets to preempt future problems that nobody has yet anticipated. Once a design is visualized on paper, we all get a much better idea what we are dealing with. Two people can read the same script and imagine different things.

When a modeler sees for themselves what kind of range of motion you're planning, they're already thinking about how to build the character's joints. The riggers can see what kind of skeleton the creature will need. We can also confirm our costume design will work with the action poses we've planned.

Sometimes you can tell just by looking at the drawings if you've created a wardrobe malfunction. Something that looks great on a character standing upright might not work in full motion. Typically we run into problems with animating complicated shoulder joints. But it can be little things, like changing the shape of a boot heel from flat to stiletto, that may affect an entire set of walking and running animations.

Sometimes it's surprising what kinds of interactions aren't easy to implement. Just think of how many games don't have riding bikes or swimming or even proper ladder climbing. No behavior exists in a video game world until it's been simulated in code. These sketches are a good way to plan what's possible.

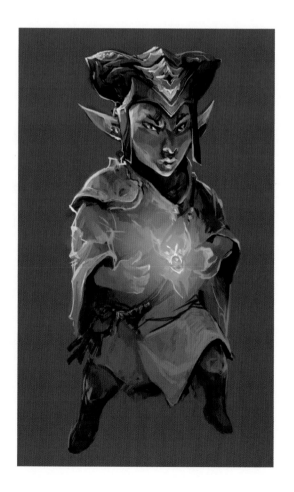

# VISUAL EFFECTS STORYBOARDS

A simple set of drawings can raise important questions about visual effects. In some sense, all that matters to the concept artist is drawing things that look great.

But when the programmers and designers get a look at your ideas, they can begin a discussion about what kind of rendering technology is involved.

How will the effects team create your designs? Do they need help from the modeling team, or can it be done with the game engine or rendering software? Does the team need new systems to do justice to your idea?

Sometimes the decision might be that the drawing looks awesome, but maybe we should pull back on these ideas before we overload the rendering pipeline.

Special effects are notorious for slowing down frame rate in video games. Players hate this; it makes the game feel choppy and unresponsive. In film and animation, the issue is often rendering time. If a scene has hundreds of thousands of frames, it can be a problem if it's taking over an hour per frame to render.

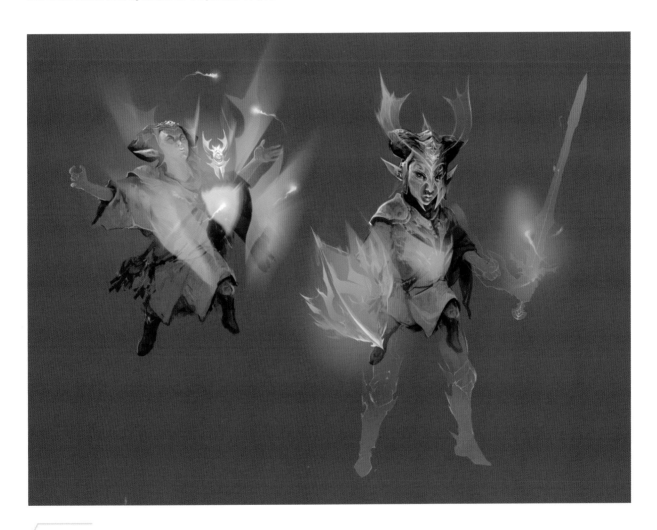

### VISUAL EFFECTS CAN CHANGE CHARACTER DESIGN
This little wizard is casting a spell that summons mystic arms and armor. Looks cool! But this changes his animation entirely. He's taller now, with longer limbs, which changes his existing movements and joint positions. Plus he now needs to have sword-fighting animations that he might not have had before. Every idea can have unintended consequences that are revealed in the sketching process.

# POSE SHEETS

One of the easiest ways to convey attitude is to sketch the character in a typical pose. Think about a slouching bandit vs. the ramrod posture of a knight. But we've probably done this back in the orthographics phase. Still, a character sketch or orthographic views are limited by the need to show as much of the character as possible. You can't have them hunched or twisted in an unusual way if you're trying to clearly show all the structural details.

For storytelling purposes it can be useful to show a range of more active poses: how they look on the attack, when they're hurt, running vs. jumping, etc.

You're essentially drawing cartooning key frames. Back in the day, single poses of animation were hand-drawn by lead animators to serve as guides for armies of in-betweeners.

This is another opportunity to show special effects associated with attacks or unique postures, as well as motion that might be simulated by physics—hair, cloth or things like chains and ropes.

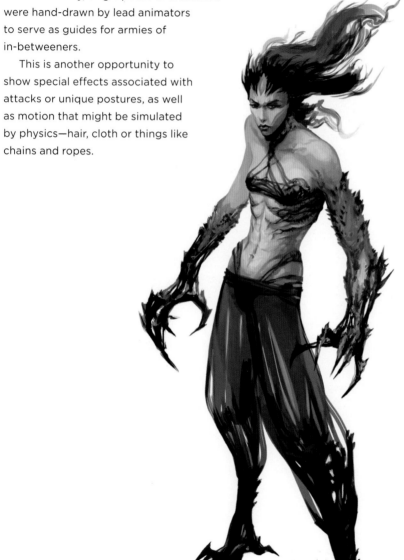
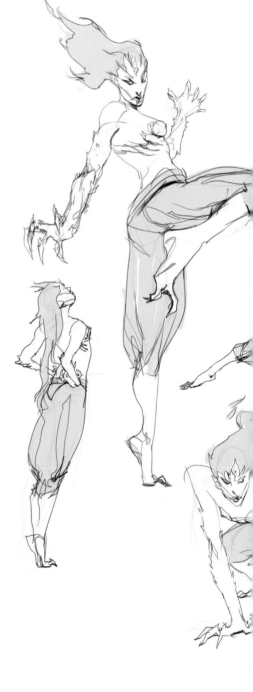

## POSE SHEETS SHOW PERSONALITY

This demon-ninja-vampire is the kind of character who's best defined by animation. There's nothing revolutionary about her design or anatomy—only a pose sheet can show off the character properly.

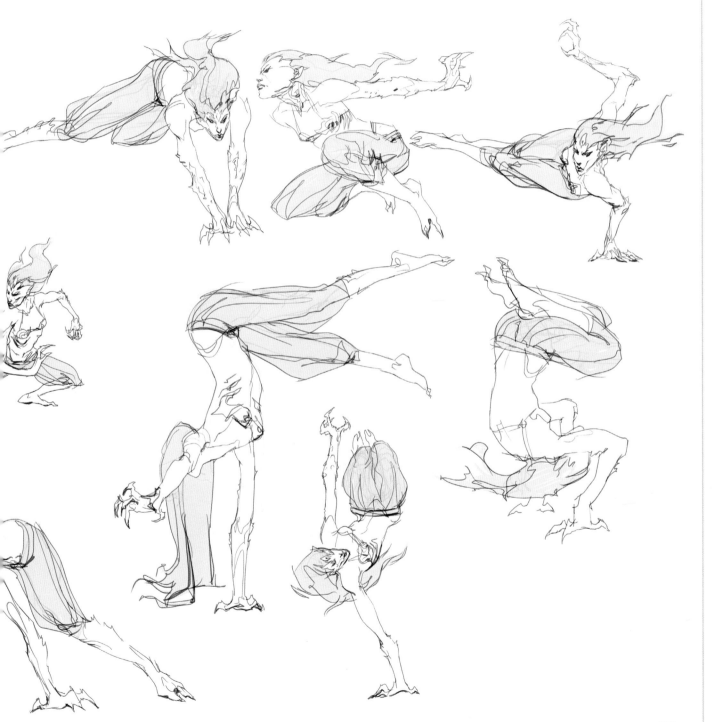

# STORYBOARDS

Sometimes specific gameplay elements or plot points need to be shown as sequences of images—or storyboards. These sequential images are usually meant to explain a creature's abilities—any special moves that are part of their animation set. Many games feature a lot of combat and movement puzzles, meaning some of these animated moves will be seen over and over again, and therefore need to be finely tuned.

In other cases you have something complex to describe; possibly a creature changes in shape over time. Maybe it grows in power or has a spectacular death sequence. In games it's common for creatures to have spells or superpowers or be able to appear out of nowhere. It's up to you to find the visual solutions for whatever the gameplay designers have in mind.

You may only be making quick sketches, but with a few well-placed drawings, your vision can strongly influence the tone of a character, sometimes even changing how the game plays or improving specific details in the script. Seeing something in action is always more convincing than reading it on the page. The concept artist is in the best position to add ideas into the mix.

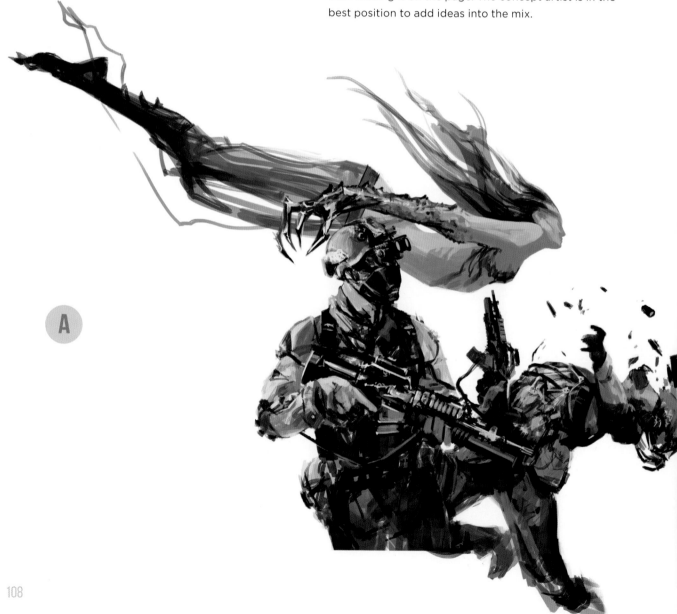

A

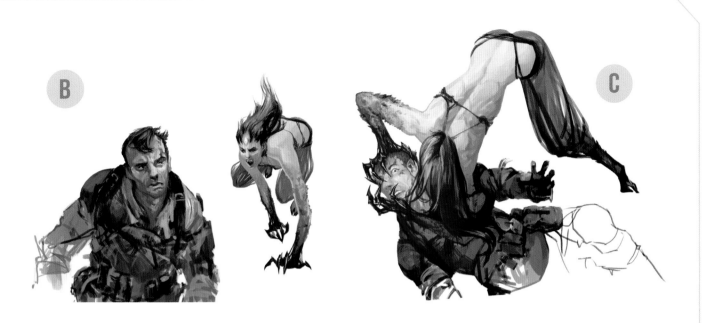

## CREATING A SEQUENCE OF EVENTS

I'm thinking: How does our demon-ninja-vampire take on a well-equipped super-soldier? What if she strips off her enemy's helmet first, then goes back for the kill?

Always try to find a visual solution to game play mechanics that also conveys your character's personality. Often, if a concept artist can pitch a great visual, it'll get written into the game or film.

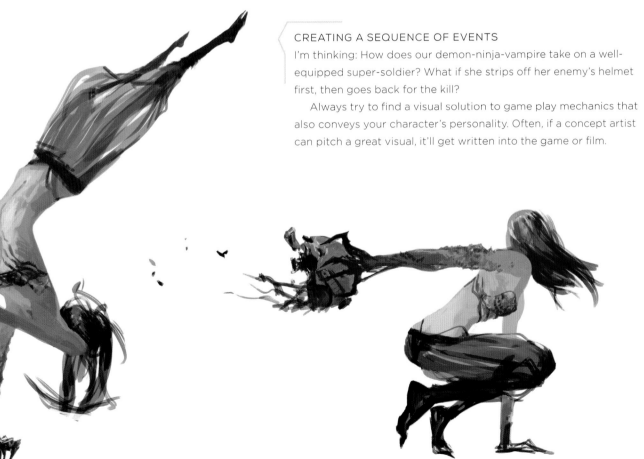

# EXPRESSION SHEETS

Concept artists are frequently designing nonhuman characters. That's what we're here for! We are making things that don't exist look convincingly real. As designers, we always need to consider how the story is told through our creatures, how we can make our monsters feel more alive.

Even when a creature doesn't have a human face, it is often required to emote. Creatures need to *act*—to advance the plot or to project an emotion to the audience. Sometimes they don't need much, just an angry roar and a pained dead or damaged face. But

sometimes we need to show reactions to the players' dialogue or even to convey humor or pathos.

An expression sheet is simply a set of drawings illustrating how the character shows emotion. How does your character look when angry as compared to sad, happy, hurt, hungry, etc.?

Expression sheets don't have to include just facial expression. They can include special effects, color changes or strange bits of anatomy.

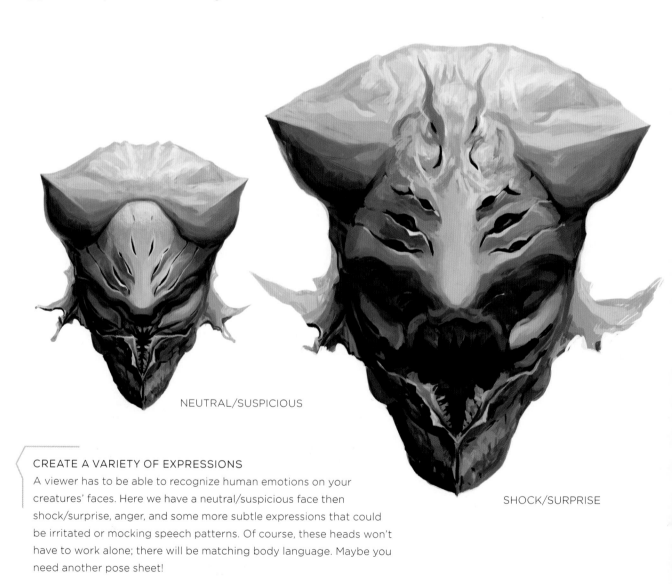

NEUTRAL/SUSPICIOUS

SHOCK/SURPRISE

### CREATE A VARIETY OF EXPRESSIONS

A viewer has to be able to recognize human emotions on your creatures' faces. Here we have a neutral/suspicious face then shock/surprise, anger, and some more subtle expressions that could be irritated or mocking speech patterns. Of course, these heads won't have to work alone; there will be matching body language. Maybe you need another pose sheet!

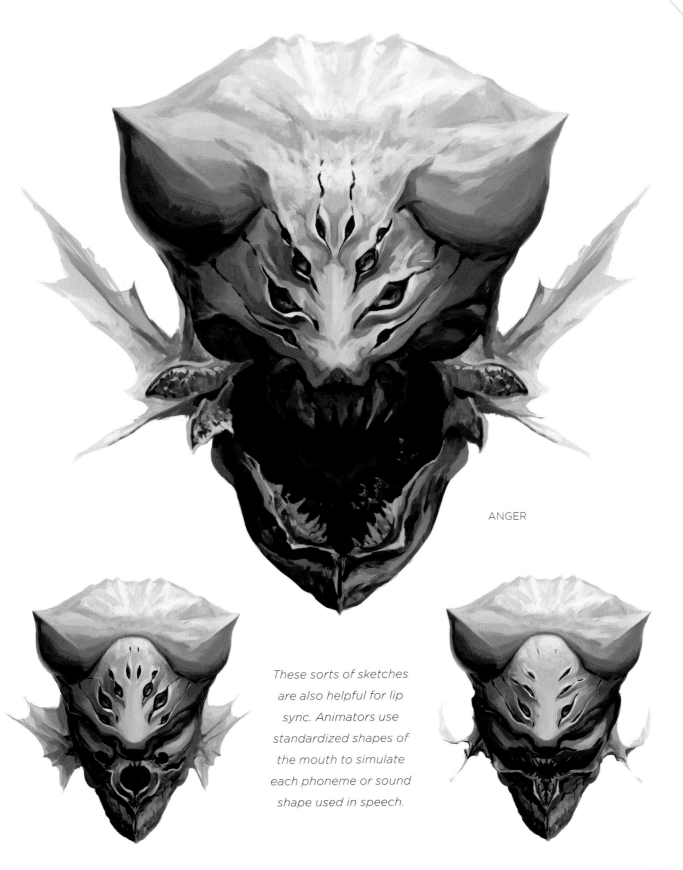

ANGER

*These sorts of sketches are also helpful for lip sync. Animators use standardized shapes of the mouth to simulate each phoneme or sound shape used in speech.*

# AMAZING RACE:
## *DO THE LOCOMOTION*

Off to the races! In the real world we have some varieties of animal racing (horses come to mind) but people will watch anything race—from cockroaches to greyhounds and even chariots.

In this project we'll design a set of alien racing animals. The goal is to explore kinds of locomotion. You might want to start with researching the movement of the kind of animal you have in mind and design your creature backwards from there.

Running creatures are easy, but there are creatures that hop-fly-run like chickens. Snakes can actually move pretty fast. Octopi have jet propulsion and can, in fact,

run short distances on land. An alligator's gait is very different from a frilled lizard with its two-legged run.

Also consider what kind of completely alien things you can come up with. What about a point-to-point teleporter? Or a creature that can roll at high speeds?

You can decide if you want these creatures to have jockeys (human or alien riders) like in horse racing, or be on their own, like a greyhound race.

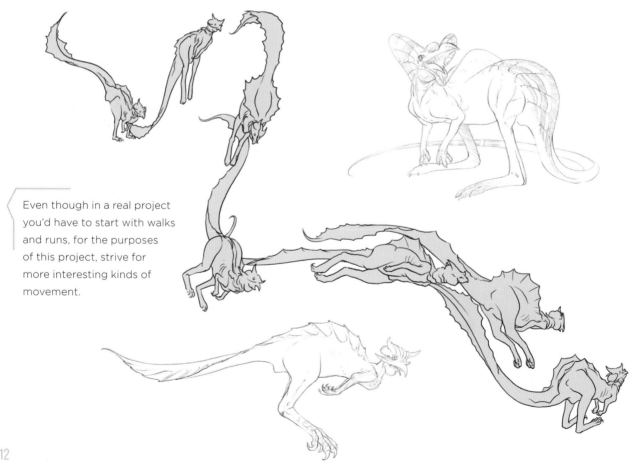

Even though in a real project you'd have to start with walks and runs, for the purposes of this project, strive for more interesting kinds of movement.

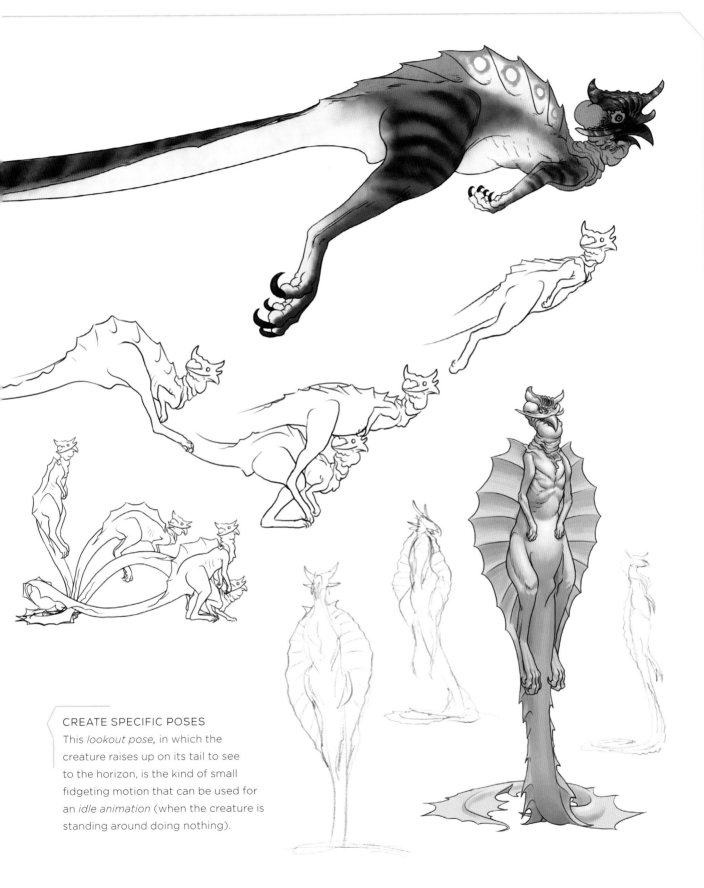

### CREATE SPECIFIC POSES
This *lookout pose*, in which the creature raises up on its tail to see to the horizon, is the kind of small fidgeting motion that can be used for an *idle animation* (when the creature is standing around doing nothing).

## TEST YOUR COLOR SCHEMES

Just a reminder: If you keep your color separate from the line art, it's simple to make hue/saturation variations. If you flatten your files, it becomes much harder to try these types of color tests.

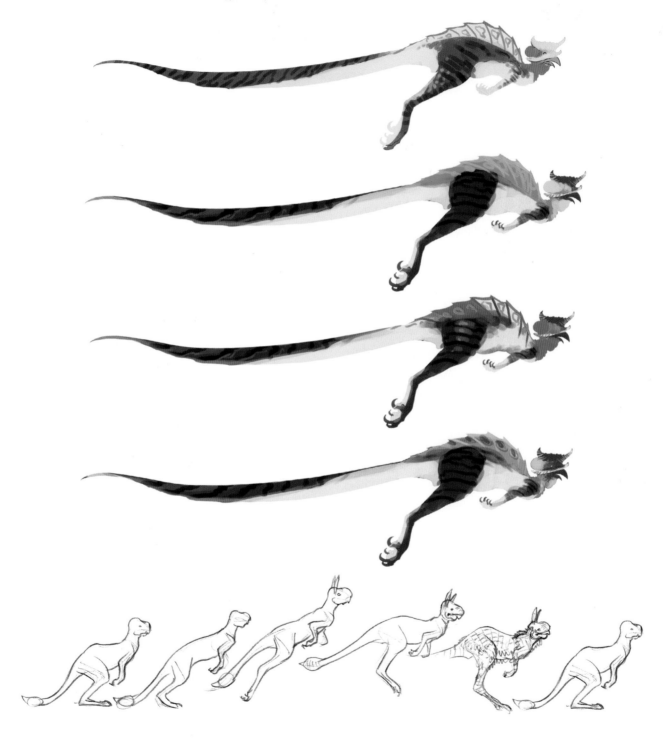

## ACHIEVEMENT
### Fleet Footed

- Sketch a minimum of 7 different racing beasts. Aim for a variety of locomotion
- One presentation drawing of your best design
- A storyboard sequence (3–5 frames) demonstrating your creature's run cycle

## BONUS ACHIEVEMENT
### (Non)Stop Motion

Upgrade one racer concept with a pose sheet describing a set of 5 motions such as sharp turn, sudden stop, leap-dodge, crash-fall, evasive move, sneak attack. For each upgraded design, add a tier.

- Tier 1-4

## BONUS ACHIEVEMENT
### Marathon Man

For each additional presentation drawing of a new creature and locomotion storyboard, gain a new tier.

- Tier 1-5

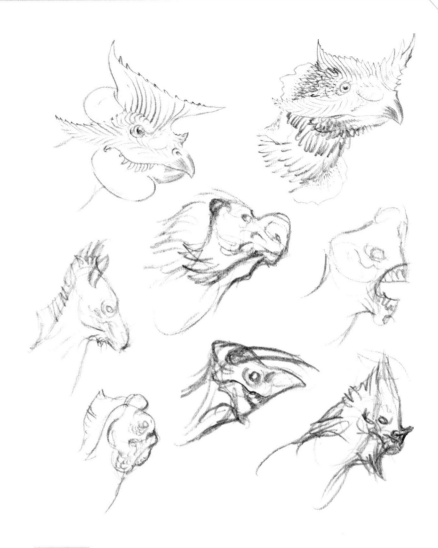

### DEVELOP DETAILS ON THE HEAD

While every aspect of a creature design matters, it's only natural to pay more attention to the head. Every reaction shot or emotion is going to be based on a facial expression. The chosen head provided opportunities for the animation with the air sacks around the neck. Did you know many birds have inflatable air sacs? Research is everything!

## BONUS ACHIEVEMENT
### Pole Position

Upgrade a racing beast's presentation drawing to include a jockey.

# ANGELS, DEVILS AND HARPIES:
## *FANTASY FLIGHTS*

One of the more difficult anatomical challenges to deal with is that of humanoid creatures with wings. It's always a challenge to create a design that seems believable. Your task is to brainstorm designs for a biologically-possible flying creature, be it an angel or devil, a Harpy or even Pegasus.

Researching birds and bats is going to be key, so consider spending some time drawing real-world anatomy in order to find what you need. Whatever you choose, don't be tempted to simply glue on wings as extra limbs!

Consider how you will logically combine the anatomy of a person's or creature's shoulders and back with the extra bones and muscles required for natural flight. You might research an entirely different way to solve this problem. Can you look to other animals such as bats or flying squirrels for ideas?

Try to answer questions such as: How large would wings need to be to actually provide lift for a person-sized bird? How do the wings fold up at rest? How does the integration with a person's torso work? Do they have arms as well as wings? If your wings have feathered plumage, how far does that extend beyond the rest of the body? And are there animalistic characteristics to the head and hands? Don't neglect costumes and equipment. It's a challenge to design clothing that works with wings.

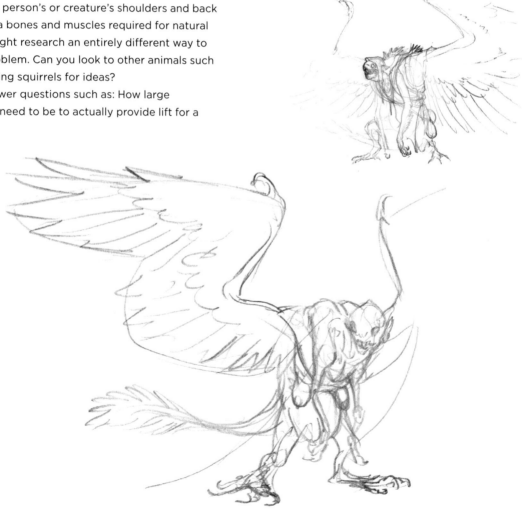

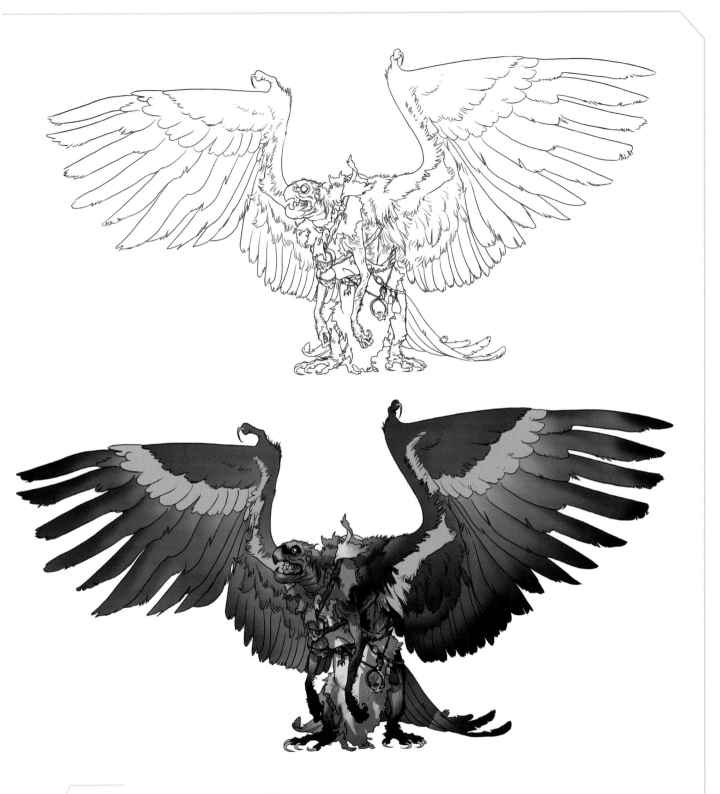

### SHOWING PERSONALITY WITH DETAILS

Our final design for a winged Harpy uses classic tricks to convey personality. The vulture-like skin and color scheme focuses your attention toward her evil expression. The ragged costume decorated with skulls says a lot about her nasty habits. You can gain a lot of background information from this one drawing.

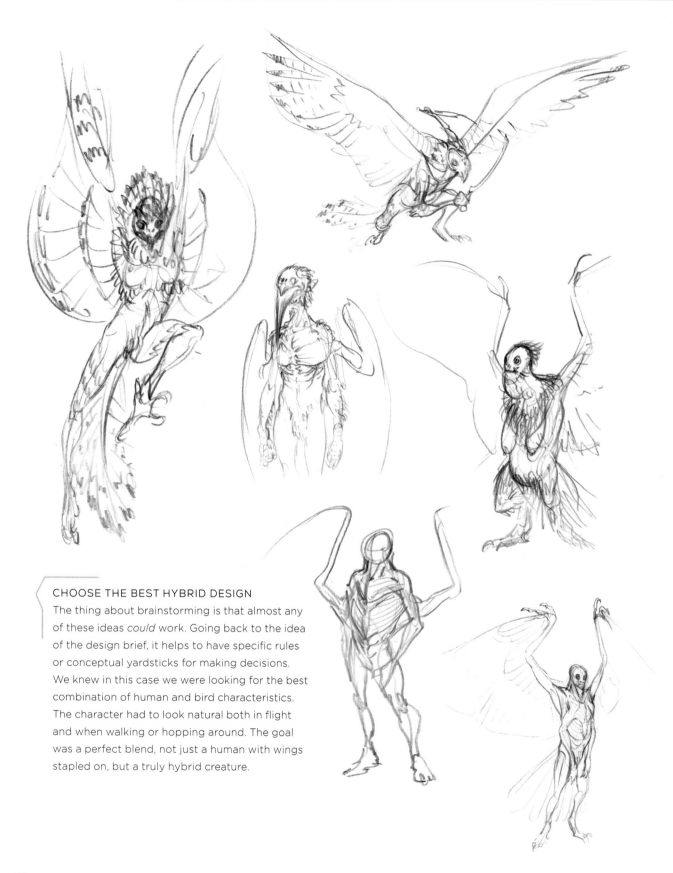

### CHOOSE THE BEST HYBRID DESIGN
The thing about brainstorming is that almost any of these ideas *could* work. Going back to the idea of the design brief, it helps to have specific rules or conceptual yardsticks for making decisions. We knew in this case we were looking for the best combination of human and bird characteristics. The character had to look natural both in flight and when walking or hopping around. The goal was a perfect blend, not just a human with wings stapled on, but a truly hybrid creature.

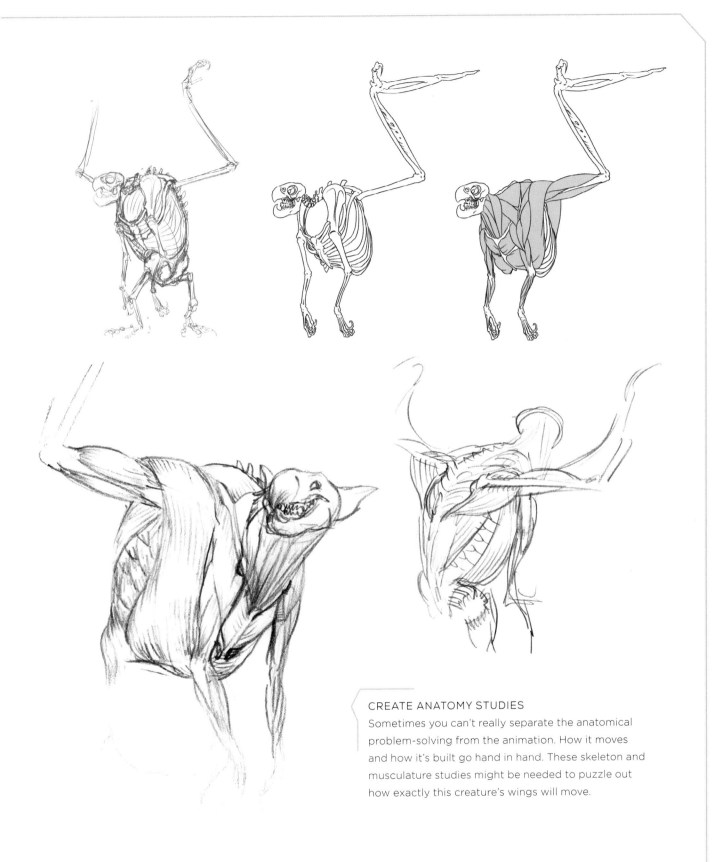

### CREATE ANATOMY STUDIES

Sometimes you can't really separate the anatomical problem-solving from the animation. How it moves and how it's built go hand in hand. These skeleton and musculature studies might be needed to puzzle out how exactly this creature's wings will move.

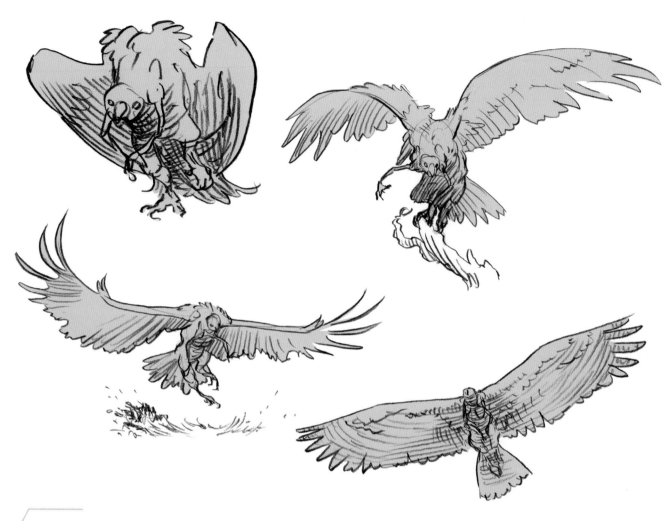

## STUDY REAL CREATURES

You may have to go right back to the basics and study real-world references for your characters. Your fantastic creatures are always going to be more fun if they're convincing.

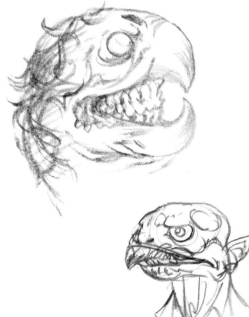

## BRAINSTORM THE PERFECT HEAD DESIGN

A creature's head or face is always a key part of the project. Facial expressions are the biggest factor in defining a character's personality. Some of these sketches had a light-hearted look or an off-beat weirdness, but the vulture head with its staring eyes and bared human teeth was the variant that rose immediately to the top.

## ACHIEVEMENT
### Wingardium Leviosa

- An orthographic set showing the anatomical structure of your creature's wings
- Any magnified views or call-outs required to explain plumage or webbing
- A presentation drawing of the wings from the most descriptive angle, with overlays and cutaways if required
- A presentation drawing of the front view to show costume and character
- A pose sheet showing wings at rest, in flight, lift-off, landing, acrobatic movements

## BONUS ACHIEVEMENT
### Fancy Plumage

Birds, from parrots to seagulls, have a wide range of plumage. Create a racial variant of your character with different plumage and a different costume (and weapons if you desire).

## BONUS ACHIEVEMENT
### Winged Victory

Now that you've developed a winged character, can you come up with an entirely different solution? If you did feathery angel wings, now let's see demon bat wings. Or can you invent something else entirely? For each new presentation drawing and a flight pose sheet, gain a tier.

- Tier 1-3

## BONUS ACHIEVEMENT
### Fight or Flight

Secondary pose sheet showing 3–5 examples of your winged character in mid-air combat. This is harder than it might sound if flight is meant to be realistic. Birds don't just hover!

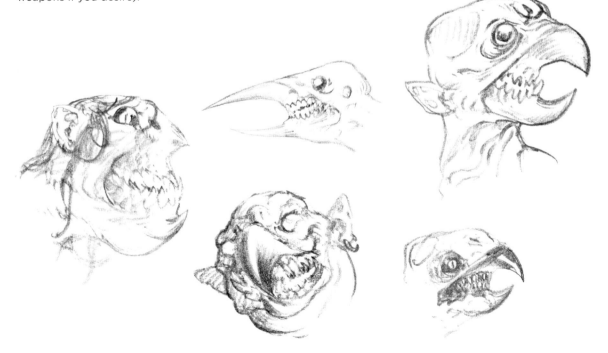

# APEX PREDATOR:
## *HUNTING STRATEGIES*

Your task is to design a predator with a unique method of hunting. You'll also need an idea for at least one kind of prey. (This can, of course, be people. Humans make great prey.)

Try to think up something more exciting than the traditional eat-your-face-off tooth and claw attacks. The weirder the better.

Nature offers us a wide variety of inspiration for hunting methods. There are spiders that set traps and snails that shoot darts (well, that is for procreation not predation, but it's a good idea). How about acidic vomit, deadly spores, excreted land mines or hallucinogenic vapor? Is your predator a gigantic threatening beast or a deceptively cute critter? Don't rule out the possibility of predators hunting in packs.

It may help if you first decide where your creature lives: desert, jungle or polar ice? Does it soar in the 500 km/hour winds of a gas planet? The setting can inform the creature's hunting strategy.

In order to make the mechanics of your hunting strategy crystal clear, the final goal is a storyboard of your creature overcoming its hapless prey. In the real world you'll be inspiring a whole bunch of animations, special effects, sound cues and camera work, all with a few drawings.

### PICK YOUR FAVORITE DESIGN
As always, it may require a series of sketches to arrive at a concept you love. After coming up with these creatures that lure in their prey with false flowers or razor blade branches, it's only one more step to imagine a creature that mesmerizes humans with a hypnotic lure.

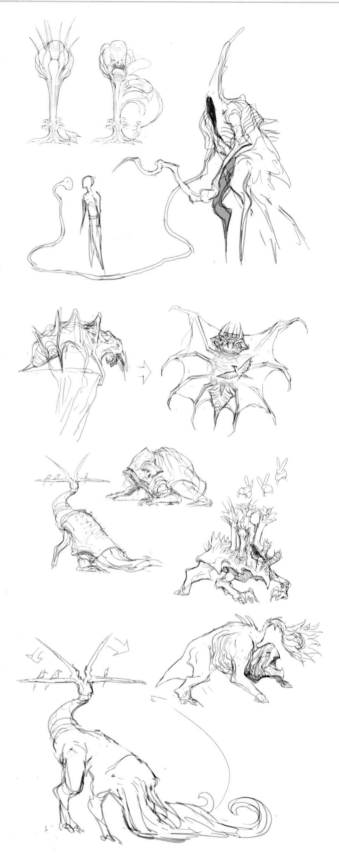

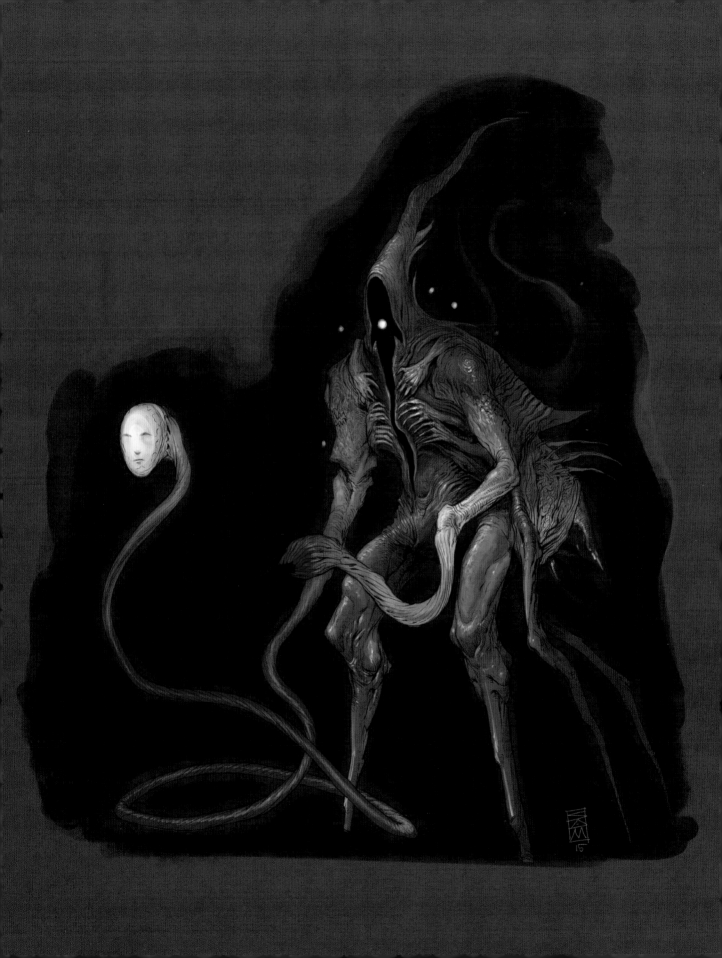

1

SLEEP WALKER SEES A WARM, FRIENDLY FACE IN THE
MIST. IT CALLS TO HIM...

2

SLEEP-WALKER APPROACHES "FACE"- THINKING IT IS SOME-
ONE HE LOVES, UNAWARE THAT SOMETHING IS NOT RIGHT...

4

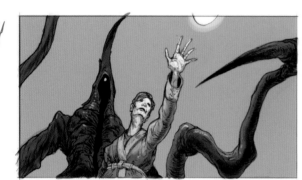

THE SOMNAMBULON EMERGES FROM THE MIST, "STINGER"
RISES OVER ITS INEVITABLE VICTIM...

5

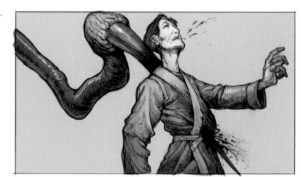

AS THE "STINGER" IMPALES THE SLEEPWALKER, THE MONSTER
SPEAKS: "AWAKEN, SLEEP-WALKER!!"

7

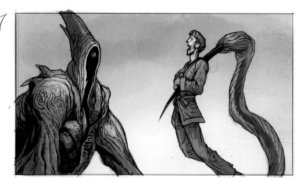

MORE HORRIBLE SCREAMING AS SLEEPWALKER SEES
THE MONSTER FACE-TO-FACE

8

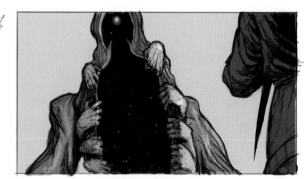

THE SOMNAMBULON'S "MOUTH" OPENS UP INTO A VAGUE HUMAN
SHAPE, IT BRINGS THE MAN CLOSER & CLOSER

### DEVELOP A STORYBOARD

A storyboard like this can make a huge difference explaining the creature design. There
are clever details—such as the creepy hands gripping the monster's robelike body—which
might be missed otherwise.

**3**

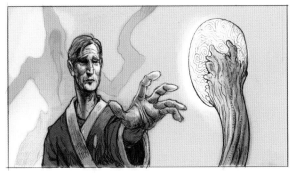

SLEEP-WALKER REACHES OUT TO TOUCH THE "FACE"
AN OMINOUS SHADOW LOOMS BEHIND
SLEEP-WALKER: "KATHERINE? IS THAT YOU?"

**6**

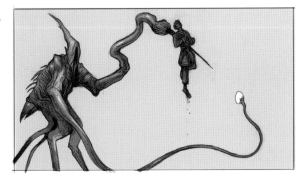

SLEEPWALKER SCREAMS IN PAIN & HORROR AS HE IS
LIFTED INTO THE AIR

**9**

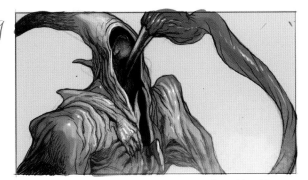

THE SLEEPWALKER IS "SWALLOWED" WHOLE

END SCENE

## ACHIEVEMENT
## Night of the Hunter

- As many brainstorming sketches as required to make a set of orthographic views of your predator
- A presentation drawing of your predator and your prey
- Any magnified views or cross sections required to describe your predator's abilities
- A storyboard of your creature's hunting technique

## BONUS ACHIEVEMENT
## Chow Time

Sketch ideas for more interesting prey—creatures that fly, leap or burrow. Take one of your ideas to completion by making a presentation drawing of the prey and a storyboard of a new hunting technique designed just for them. For each idea taken to completion, gain a tier (+1 presentation drawing, +1 storyboard (3-5 frames per tier).

- Tier 1-3

## BONUS ACHIEVEMENT
## Clever Rabbit!

Upgrade your animation ideas with a storyboard showing a clever prey creature escaping alive. For each escape sequence, gain a new tier.

- Tier 1-3

# BOTANICALS GONE BAD:
## *DAY OF THE TRIFFIDS*

In this project our challenge is to document the life cycle of an invasive alien plant species. Come up with whatever you can on the theme of a rapidly spreading plant species that might take over the world. I would suggest a negative perspective: a dangerous infestation overwhelming society. Perhaps it is a form of terraforming, a relentless alien jungle seeded by an invading species.

The goal is a series of anatomical designs that demonstrate the plant's life cycle followed by a storyboard sequence demonstrating its growth sequence.

You can choose the scale you're depicting. Are these plants overgrowing small villages, or is it an urban area, or even a continental scale?

Good questions you might want to answer: How does its propagation progress? Is the plant independently mobile like Tolkien's Ents? Does it grow tremendously in size or remain human scale? What is the method of reproduction? Underground root growth and suckers? Windblown spores or seeds? Is it a spreading vine or fungal infection? Do humans and animals carry the seeds? Is it a carnivorous plant?

The storyboards in a case like this might not be sequential as in frame-by-frame cinematic action. They might be more like selected documentary images, like a photo essay or slide show describing the gradual process of overgrowing a planet.

**ACHIEVEMENT**
**Botanicals Gone Bad**

- A set of 4 presentation drawings of your creature at key stages of life: seedling, sprouting, mature growth, reproduction
- Magnified views or cross sections as required
- Minimum of 5 presentation drawings showing the spread of your plant-based infestation around the world

**BONUS ACHIEVEMENT**
**Rose by Any Other Name**

Supporting sketches showing human society fighting back (winning or losing, your choice) (+1 presentation drawing per tier)
- Tier 1-3

**BONUS ACHIEVEMENT**
**Hothouse Flower**

Supporting sketches showing your plant's abilities: any special effects such as flowering or fruiting. Any unusual behavior (floating spores, exploding seeds, burrowing roots), any special interaction with humans
- Tier 1-3 (+3,+6,+12 concepts)

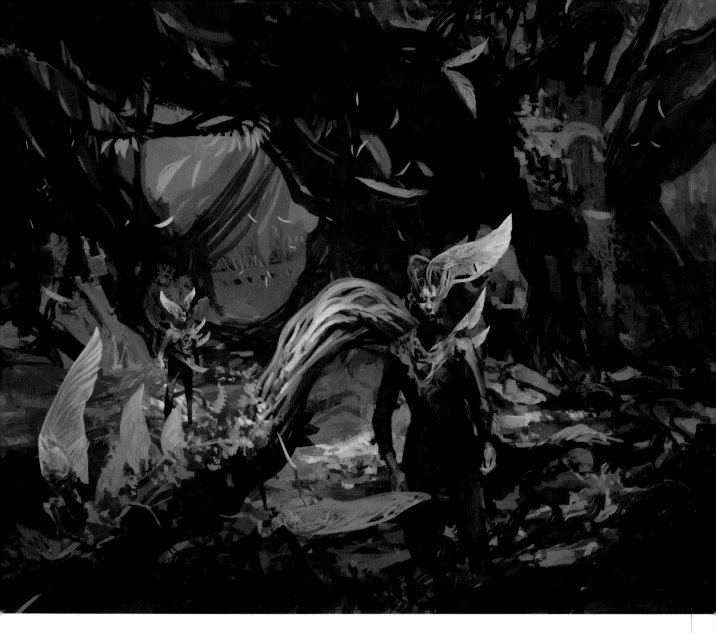

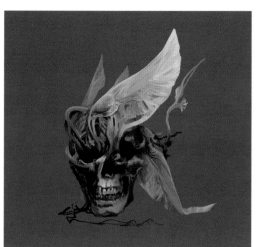

### DRAW INDIVIDUAL ELEMENTS
Sometimes it's possible to make a single image into a storyboard. In this sketch we can see stages of wind-borne propagation, independently mobile seedpods, and human victims as unwilling hosts to the unstoppable alien vines.

# GIGANTIC CITY DESTROYER:
## *SUPER-SIZED DESTRUCTION*

Science fiction films have had their share of giant-sized city destroyers. From *Godzilla* to the recent *Pacific Rim*, there are plenty of examples of monsters so huge they can level cities. In comics, I'm a fan of Geof Darrow's *Big Guy and Rusty the Boy Robot,* which feature a fantastic update to the Godzilla creature design.

You have a twofold task in this exercise. Design a gigantic city-destroying monster *and* visualize what sort of fantastic powers it has at its disposal. Drawing special effects usually involves storyboards of powers in use and the dramatic results.

Does it have a shock-wave shout? Laser beam eyes? Can you be more outrageous than that? Looking at nature, you might find numerous ideas you can exploit. What if your creature deposits explosive eggs? The sea cucumber famously vomits up its own intestines, giving a predator a distracting snack while it escapes. Your creature might disgorge a lake of acid mucus. Your imagination has no limits!

Just consider: What are the methods of destruction at your creature's disposal and what sort of anatomy is required to sell those ideas?

Keep in mind that if you want to sell the feeling of scale, very small details are necessary to convey the impact of relative scale.

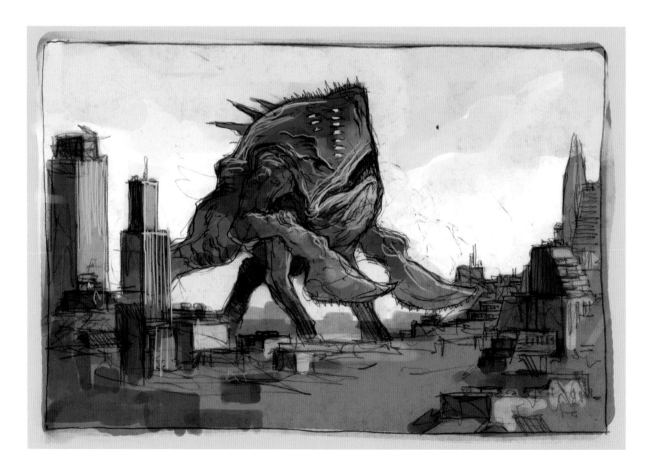

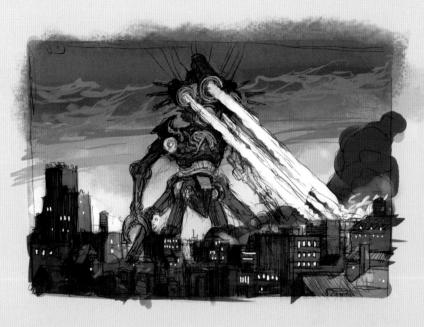

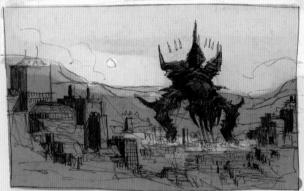

## COMBINE STORYBOARDS AND BOUNDARY CHECKING

Variations on a theme: Once you have an underlying concept—in this case a giant alien machine/monster with eye beam weapons—there are still many specific variations worth considering. Sometimes you can combine storyboarding with the brainstorming practice of boundary checking.

### ACHIEVEMENT
**Appetite for Destruction**

- As many brainstorming sketches as required to make a set of orthographic drawings of your destroyer
- Minimum of one presentation drawing of your destroyer
- A storyboard of your creature's destructive powers. You will want to indicate the background environment for scale and storytelling

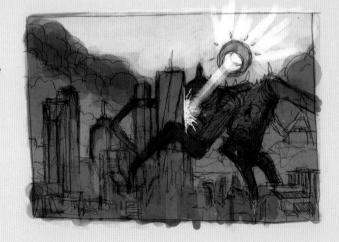

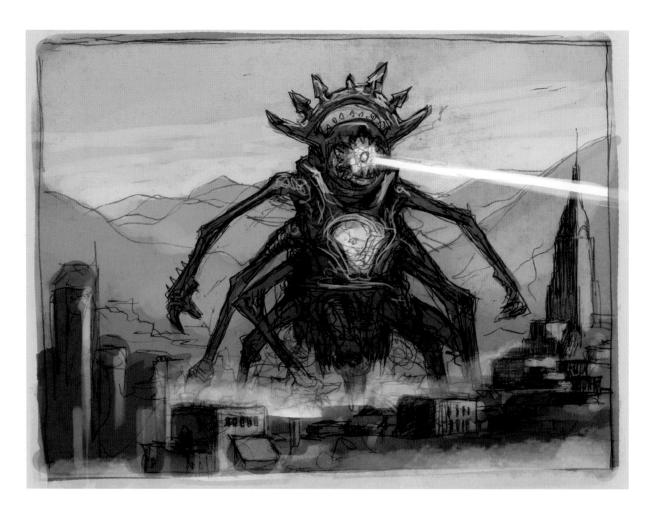

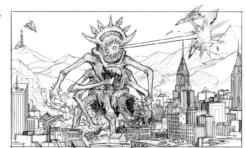

THE PULSAR BEAST USES ITS MULTIPLE ARMS TO SHOVEL DEBRIS INTO ITS CORE, WHICH PROCESSES IT INTO ENERGY.

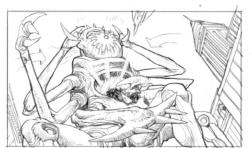

ONCE THE BEAST'S CORE HAS CREATED ENOUGH ENERGY, ITS HEAD PULSES RED. USING ITS TOP SET OF ARMS, IT GRASPS THE HORNS ON EITHER SIDE OF ITS HEAD.

### USE STORYBOARDS TO SHOW ACTION

Remember, in a real project, you will have already drawn your design with orthographic views, so you don't need the storyboard frames to be miniature works of art. They can be simple line drawings meant only to show the action.

3

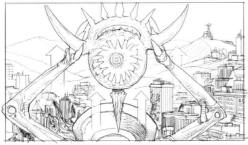

THE BEAST LIFTS ITS HEAD OFF ITS BODY, THE HEAD HAS A HUGE SPIKE UNDERNEATH IT.

4

THE BEAST DRIVES THE SPIKE & HEAD INTO THE GROUND AT ITS FEET.

5

THE HEAD CREATES A STRONG TRACTOR BEAM AS IT WINDS UP FOR ITS SONIC PULSE OF DESTRUCTION.

6

THE BEAST'S HEAD THEN EMITS A **MASSIVE**, DESTRUCTIVE PULSE-BOOM THAT LEVELS 5 BLOCKS OF THE CITY IN EVERY DIRECTION.

## BONUS ACHIEVEMENT
### The Harder They Fall

Additional presentation quality storyboard describing the death of your creature. After all, the humans always win. We will eventually need to see your monster defeated. This is a climactic moment, make it amazing.

## BONUS ACHIEVEMENT
### Warts and All

Monster Shots: Close-ups are so important with a creature that is huge in scale. Give detail shots of your monster's head, hands or weapons, and key details on the body (weak spots? weird organs?). For each set of 3 drawings, gain a tier.

- Tier 1-3 (+3,+6,+9 close-ups)

## BONUS ACHIEVEMENT
### Urban Renewal

Additional sketched storyboards describing other special abilities and/or special situations. Ideas include secret powers revealed, collateral damage, monster regeneration, human military response. For each set of 3 storyboards, gain a tier.

- Tier 1-3 (+3,+6,+9 boards)

# ENTER THE OCTAGON:
## KUNG FU FIGHTING

This project is all about the action. Your goal is to design a martial art and a character that represents your style. The character may be a human but doesn't have to be. Your fighting style can have any cultural inspiration or be based on a culture you invent from scratch.

You may choose to design a humanoid with interesting anatomical features that inform new fighting techniques, or you might research (or invent) a unique martial arts weapon and base the fighting style on that.

Your challenge is to sketch storyboards of your character in action. What are their signature moves? What sequence of poses conveys the action? How would they handle multiple opponents or enemies of different sizes?

These storyboards might be cinematic, showing key moments of an interaction from the best possible angle, or they might be from a fixed camera angle, showing how video game play might look to the player as it happens.

**ACHIEVEMENT**
**Fists of Fury**

- As many brainstorming sketches as required
- A presentation drawing of your martial arts fighter
- Magnified views of weapons (unless style is bare handed)
- A pose sheet that documents a unique fighting style. Minimum 5 drawings. Aim for a matched set of poses that create visual character. Kung fu looks very different from pro wrestling. Ideas: ready pose, strike, power strike, block, multiple strike

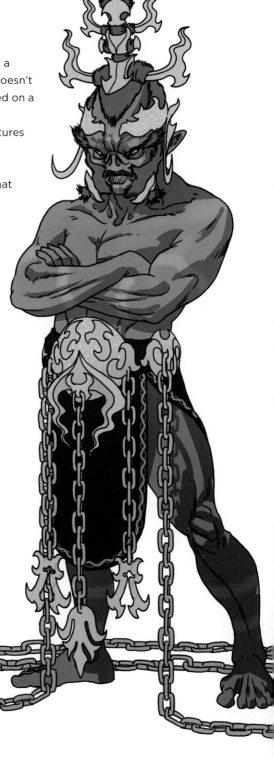

## BONUS ACHIEVEMENT
## Fatality!

Additional storyboards of super moves—how your character dispatches their enemy. Emphasize fantastic visual style and special effects rather than real-world martial arts. For each set of 3 new moves, gain a tier.

- Tier 1-3 (+3,+6,+9 boards)

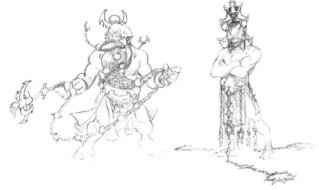

## BONUS ACHIEVEMENT
## A Few Fists More

Each additional storyboard expanding your martial arts style with +5 more moves

- Tier 1-3

### CHOOSE THE BEST CONCEPT FOR THE PROJECT
One idea often leads to another. The first sketch of a gladiator in chains led to the idea that the chains themselves could be the theme of the character's fighting style. Other variations were tried and discarded. The idea of a dwarf using his own beard as a weapon? It's funny, but maybe too funny for the theme of the project.

## BONUS ACHIEVEMENT
## Five Fingers of Death

Brainstorm 5+ sketches of opponents for your fighter(s). Enemy Ninjas, Zombie Villagers, Mountain Ogres—variety is the key, while remaining on style for your martial-arts world. (+5 sketches per tier)

- Tier 1-4

### REJECT IDEAS
Of course there were other ideas along the way. Some of these roughs were moving towards more of a wrestler character. They were discarded in favor of the visual appeal of the whirling chains.

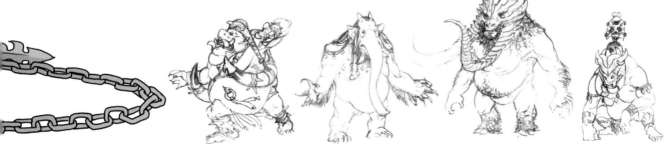

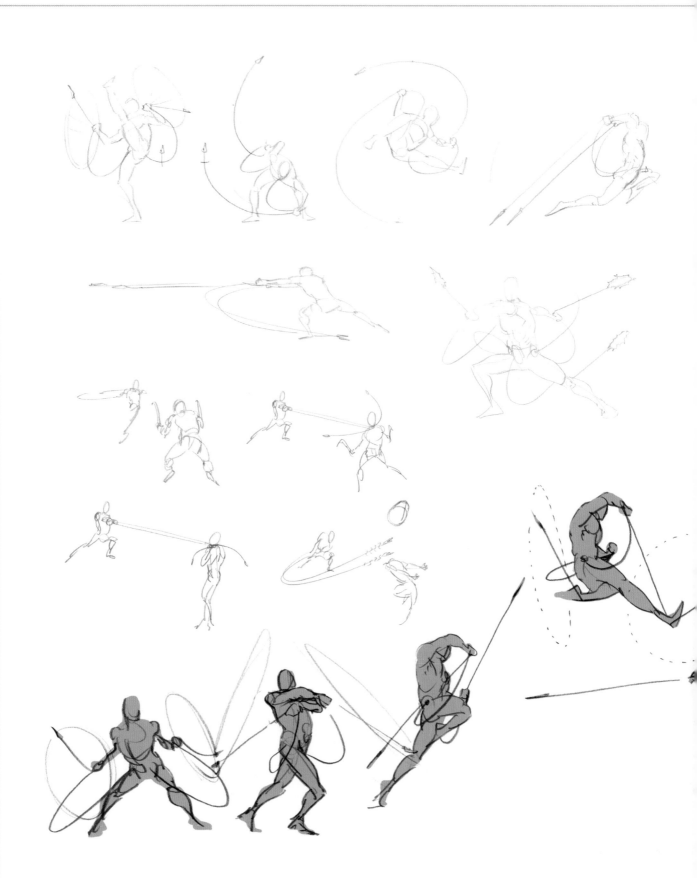

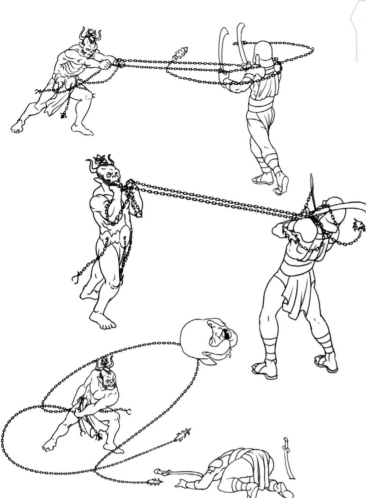

## SKETCH VARIOUS ROUGH MOVEMENTS

Once the drawings reveal a direction, we are able to dive deeper, rapidly brainstorming variations on the chain weapon theme. This is when time spent drawing the live human model will pay off. You can often find drop-in life drawing at your local college. These small storyboards should be very rough drawings. They're just enough to visualize an idea in your head—not overdrawn. If they like the ideas, your team's animators will make these look awesome. One of these might become the basis for an illustration, but not every frame needs to be rendered.

**BONUS ACHIEVEMENT**
**Ready, Set, Fight!**

A set of orthographic views of your fighter

**BONUS ACHIEVEMENT**
**Sidekick**

Brainstorming sketches and a presentation drawing of a sidekick for your fighter. Could be a bumbling student, a wise teacher, an animal companion, a lover, a rival. Anything goes.

- Tier 1-3 (+1,+3,+9 characters)

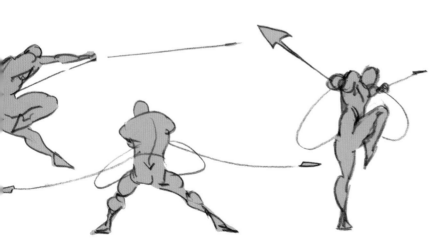

# THE HARDER THEY FALL:
## DEFEAT THE BOSS

Video games are well known for the trope of the *Boss Fight*. That is, an exceptionally challenging opponent, usually something out of the ordinary to the normal course of gameplay, which requires exceptional skill and often some puzzle-solving in order to defeat.

Sometimes in these situations there is an environmental component—hazards in the combat arena that affect movement (places the player can't safely go—your classic pits of lava or laser beam traps). Or there may be something preventing you from damaging the bad guy (shields, force fields, armor, etc.). Explaining the situation might call for unusual supporting diagrams: cutaway or sequential drawings showing protected vs. vulnerable states. You might need to sketch maps of the fighting arena or storyboard sequences describing specific strategies the player might take.

There may be minions that need to be drawn—smaller creatures designed to distract, annoy and possibly backstab a player during the fight. This is a common strategy to make a boss more difficult. Throw in some dangerous critters to distract the player.

Your task is to take on all aspects of this common design problem and make the drawings and storyboards to show how it fits together.

The design of the creature will go hand in hand with the strategy the player needs to defeat it.

If the battle will have multiple stages as you wear down your gigantic opponent, you may wish to treat each stage of the battle as its own creature design.

**ACHIEVEMENT**
**The Big Boss!**

- As many brainstorming sketches as required
- A presentation drawing of your boss monster
- Any magnified views or cross sections required to explain the boss's anatomy
- A set of presentation drawings showing the boss's attack and defense modes. What are its abilities?

**BONUS ACHIEVEMENT**
**The Protagonist**

Sketch up some ideas for the player in this game. You can sketch a generic figure in the storyboards, but it's good to have a close-up of the hero. Minimum 5 sketches and a presentation drawing. For each unique version, gain a tier. (+5 sketches, +1 drawing per tier)

- Tier 1-3

**BONUS ACHIEVEMENT**
**The Hits Keep on Coming**

A presentation quality storyboard of your player getting killed—how many ways to die? Gain a tier for each graphic defeat. (+1 storyboard per tier)

- Tier 1-3

**BONUS ACHIEVEMENT**
**Victory Dance**

A storyboard depicting your boss's final death sequence. What does victory look like?

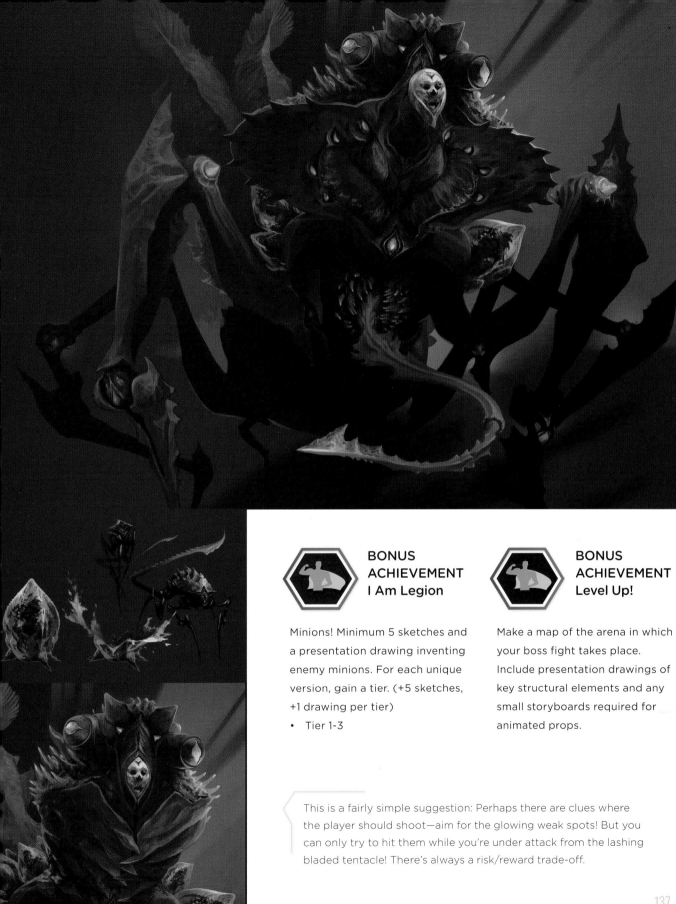

## BONUS ACHIEVEMENT
### I Am Legion

Minions! Minimum 5 sketches and a presentation drawing inventing enemy minions. For each unique version, gain a tier. (+5 sketches, +1 drawing per tier)

• Tier 1-3

## BONUS ACHIEVEMENT
### Level Up!

Make a map of the arena in which your boss fight takes place. Include presentation drawings of key structural elements and any small storyboards required for animated props.

This is a fairly simple suggestion: Perhaps there are clues where the player should shoot—aim for the glowing weak spots! But you can only try to hit them while you're under attack from the lashing bladed tentacle! There's always a risk/reward trade-off.

# JONAH AND THE WHALE:
## *BELLY OF THE BEAST*

There is a biblical fable in which Jonah is swallowed by a whale for three days, emerging whole and newly committed to his faith. We will be using this legendary creature as a setup for a fantastic journey. Your task is first to design the whale, a gigantic creature through which a character can travel from mouth to exit.

When thinking about truly huge creatures—vastly larger than a human character—they become more of an environmental setting than an actual beast. At this tremendous scale, humans can't even perceive them as a single creature. They're more like a living mountain range or a city.

While inside the giant creature, your Jonah might encounter dangerous parasites, other swallowed characters, or, what if the whale is gestating young?

Consider the possibilities of the living environment of the whale's organs. The internal passages of the giant beast might be twisty organic tubes (perhaps occasionally flooded with unknown fluids) or vast vaulted chambers of bone and flesh. There may be bizarre organs that offer light and sustenance for swallowed survivors.

The outside of the creature might be a landscape of its own. A living mountain range or a forest of organic growths populated with creepy-crawlies. Think about microscopic imaging of our own bodies or how giant barnacles are common on real whales. Or consider an ecosystem of smaller creatures, like theremora, a fish that clings to the bodies of sharks, feeding on parasites and cleaning the host's skin. What could you do with these kinds of biological concepts?

Keep in mind, your creature does not have to be a marine mammal. This is just a starting point for ideation. Feel free to reframe this assignment as any kind of creature in any setting.

The goal with this project's theme is to push your thinking beyond the ordinary. It's a perfect setting for inventing weird creatures with little relation to real world animals. Try to invent alien life-forms that are a living part of an equally alien environment.

This idea might seem incredibly unlikely, but you never know what projects will come along. If you can show work with this scope of imagination, you'll stand out from yet another portfolio full of warriors and super soldiers.

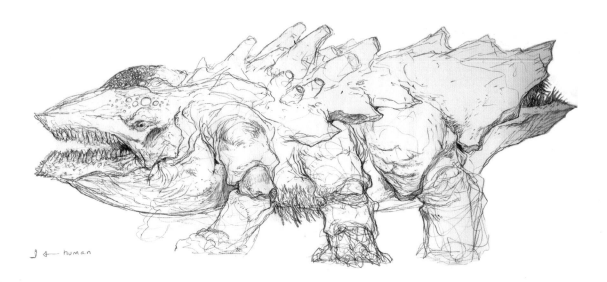

human

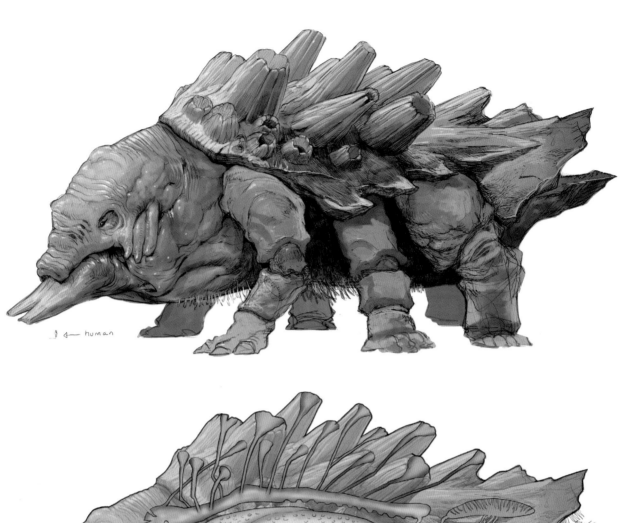

## MAP OUT INTERIOR DETAILS

This is a kind of brainstorming in its own way. A chart like this is a bit silly, but it should spark some ideas and it's an establishing shot. It provides a context—an overall view—for where your storyboard frames are located.

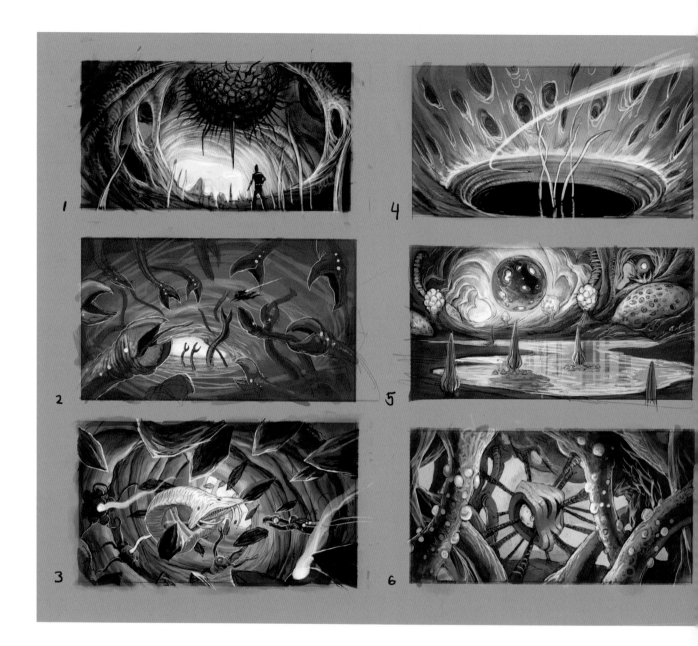

### STORYBOARDS CAN AFFECT THE SCRIPT

In the real world you might expect to be working from a script. But you'd be surprised the number of times you have nothing more than "now some cool stuff happens on the way to the final battle." Visual designers have the chance to put their own creative spin on things. Your ten-minute sketch can sometimes change the whole direction of the plot!

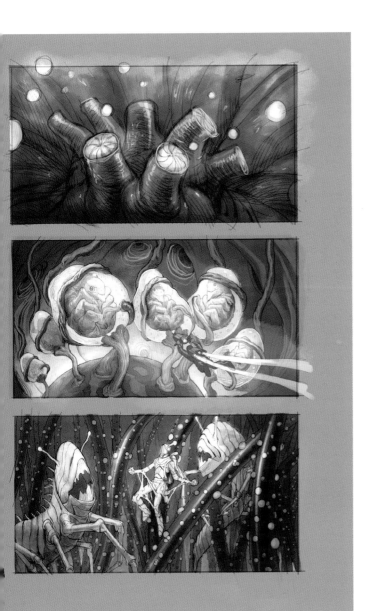

## ACHIEVEMENT
### Belly of the Beast

- A presentation-quality storyboard (minimum 5 frames) of the journey through the belly of the beast
- A presentation quality rendering of your creature from the outside
- A presentation quality cutaway drawing of the interior of your creature

## BONUS ACHIEVEMENT
### Nobody Rides for Free

Additional sketches of creatures encountered inside the beast (+5 sketches per tier)

- Tier 1-3 (+5,+10,+15 sketches)

## BONUS ACHIEVEMENT
### The Hitcher (Jonah)

### The Hitcher (Jonah)
Design Jonah. Sketch multiple versions, before being in the beast and inside the belly of the beast

## BONUS ACHIEVEMENT
### Director's Cut

Additional presentation quality storyboard frames (minimum 5 additional) from the story of Jonah's passage

# GALACTIC COUNCIL:
## *ALIEN ACTORS*

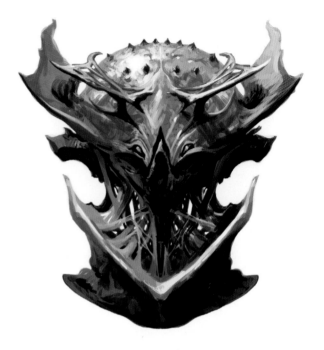

In this project your goal is to invent a nonhuman character that can successfully portray emotions. Brainstorm up a truly alien character that you can render as a head and shoulders shot. This might be a mythical beast or a science fiction alien, but it should be a character that would have a speaking role in the script (even if it does not have a mouth).

For this assignment you can make it even more challenging by avoiding humanoid faces as much as possible. Seek out alien, nonhuman shapes, something that could not possibly have a human skull. This is meant to be a character that is rendered in CG, not an actor in a costume.

The real challenge in this project is to take your design and document a series of expressions. Demonstrate how a nonhuman creature can relay its feelings on screen.

You will need to exaggerate expressions we know from humans but translate them into your alien form. Consider what tricks you might use besides movement of facial parts. Overall head and neck posture, skin coloration or visual effects could all come into play to create the illusion of emotion.

Try these expression suggestions: anger, fear, amusement, surprise, hate, joy, suspicion, disgust, sorrow.

**BONUS ACHIEVEMENT**
**Thank the Academy**

Upgrade your 5+ expression portraits to presentation quality. Include effects, color changes or other subtleties.

**ACHIEVEMENT**
**Got the Feels, Man**

- As many brainstorming sketches as required
- A presentation portrait (head and shoulders) of your alien in a neutral pose
- A minimum of 5 expressive portraits documenting different emotions

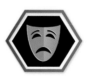

**BONUS ACHIEVEMENT**
**Galactic Council**

Keep going with different aliens. For each new alien race you design with a set of 5 emotions, gain a tier.

- Tier 1-5

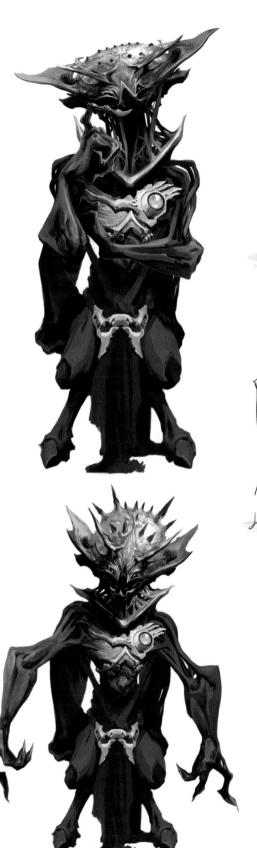

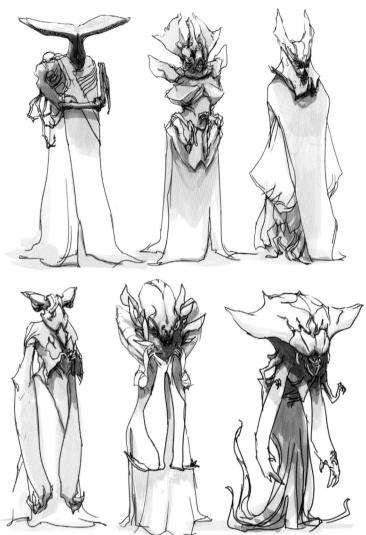

## ALWAYS SKETCH

Don't forget, even in these later assignments, everything should begin with brainstorming sketches before you settle on your favorite character.

 **BONUS ACHIEVEMENT**
**Extended Metaphor**

Upgrade your design with a sketched orthographic set and a presentation drawing of the alien's full body. Gain a tier for each expression taken to a full pose.

- Tier 1-5

# LEVEL FOUR
## *ILLUSTRATION*

ACHIEVEMENTS

MINIMUM:

BONUS:

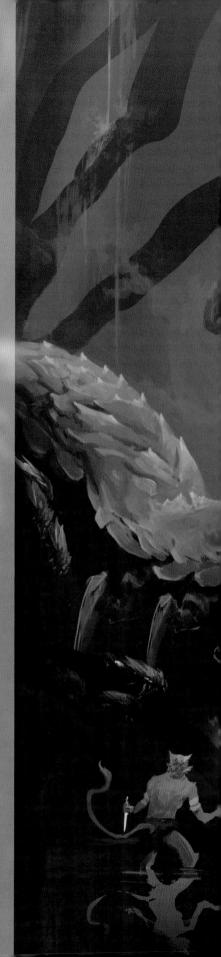

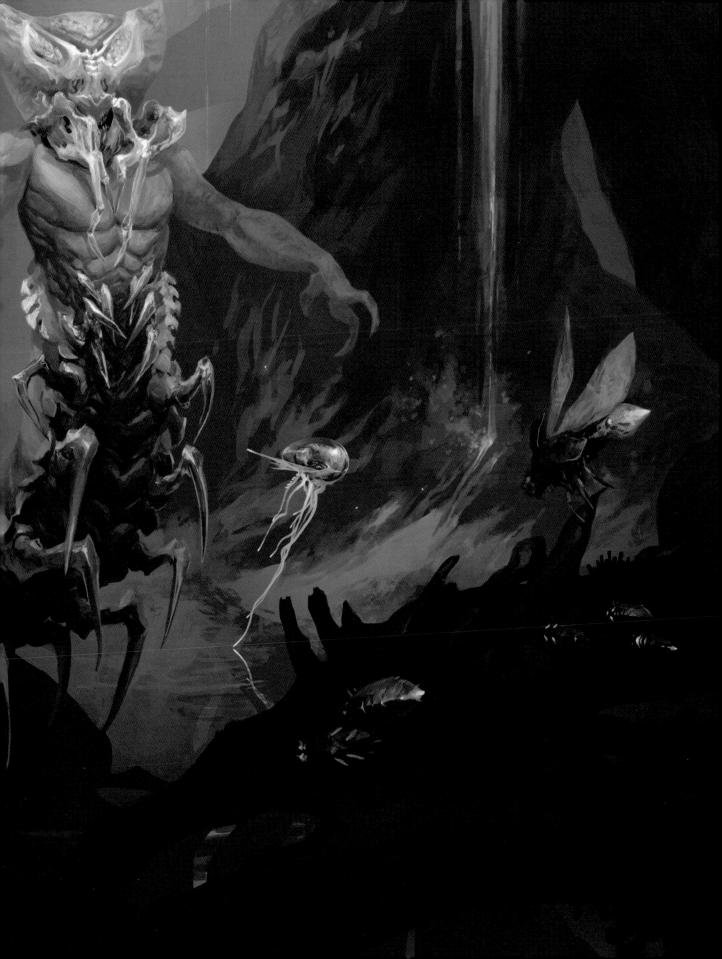

# ILLUSTRATION:
## *THE FINAL PRESENTATION*

It's important to understand that a concept artist is not really an artist in the usual sense of that term. The distinction between painter/illustrator and concept artist is often confused, as we use many of the same drawing and painting skills. But we must always remember our ulterior motive: to previsualize an idea so that it may be held up to judgment. We exist to give producers and directors something they can objectively appraise.

To that end, after all the brainstorming, orthographic blueprints and explanatory storyboards, we will probably be wrapping up our presentation with a finished illustration that will become our final sales pitch to the producers.

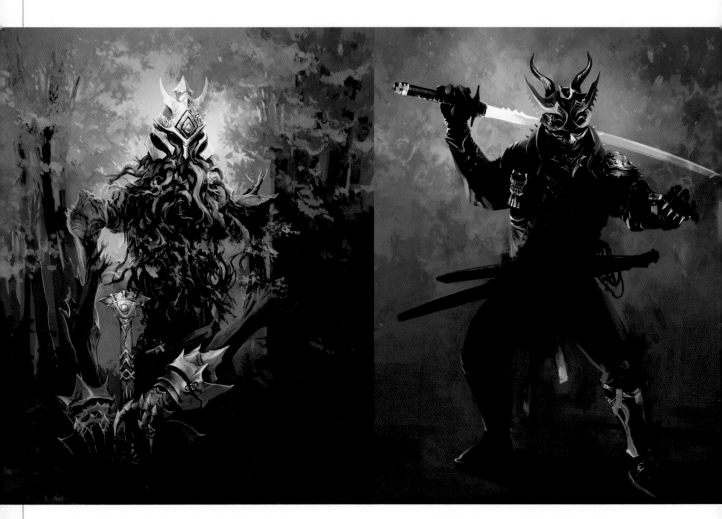

*The smallest hint at a background is sometimes enough. Use silhouette shapes and color to imply the right setting for your character.*

*Dramatic lighting can take the most basic design and imbue it with a sense of mystery.*

# PAINTINGS SELL YOUR IDEAS

I've been emphasizing brainstorming sketches and digitally colored drawings so far—what I've been calling "presentation drawings"—because it's the sweet spot of the skill needed from the artist, the time investment to make the art as a blueprint.

That's all a concept artist usually wants: more ideas, communicated faster. Drawings do that with efficiency. If I didn't have any bosses, investors or marketing departments, I'd never do anything except drawings. That's all the 3-D modeler who actually makes the game wants to see.

But if you've got the budget and time for it—or if the time has come for an important decision from on high—a tonal painting is more compelling than a tinted drawing.

You can work over presentation drawings. The more rendering you put into your drawing, the more it starts to look painterly. Given enough effort, they'll look the same in the end. But it's not a time-efficient way to make a painting. Why complete a painstaking drawing if your intent is to obliterate it with a paint-over?

## PAINTINGS ALWAYS WIN

When we paint, we can think in terms of solid forms and lighting rather than the valuable-but-obsessive focus on intricate detail in a drawing. Fundamentally, it is the lighting that is going to make a painting look three-dimensionally real.

As well, a tonal image is more naturally suited to depict atmospheric effects like smoke and mist, glowing light sources, transparent effects, wet or shiny surfaces, even the climate of your scene—is it raining or snowing? A painting can use lost edges and selective focus in a way that a drawing cannot.

If you then add a simple background, even if it is just a simplistic impression of an environment, you further enhance the impact of mood and story.

Given sufficient time for the artist to work, a painting will always win out when evaluated side by side with a drawing. It's just human nature. Tonal images are closer to how our eyes work. The combination of solid shapes and soft edges, atmosphere and mood created by the color palette, and the use of light and shadow ultimately sell the idea in an emotional way.

## CREATE EMOTION

Nobody (your producers and directors included) can intellectually separate the quality of the concept (how good the design is) from the emotional quality of the painting (how it makes you feel).

Ironically, at the end of the day, while a drawing is faster to make, easier to read and more informative for the team, a painting might be what it takes to get a design approved.

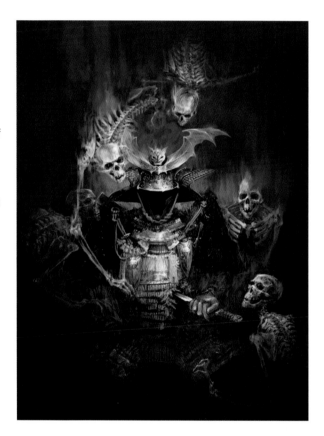

### CREATING SPECIAL EFFECTS
Special effects like smoke and fire transparencies are not easy to describe in a drawing. You really need to bring them to life with value and color.

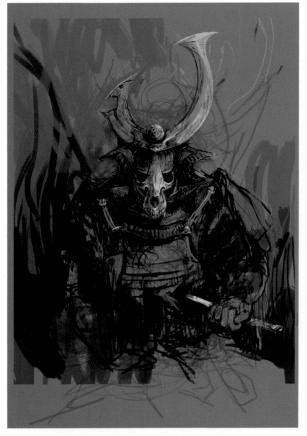

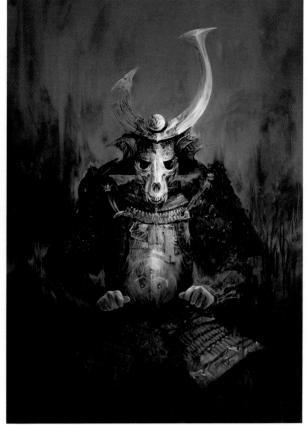

### 1 CREATE THE ROUGH BASE

Start with rough speed paintings while you develop your ideas. Just as with brainstorming, not every design is a winner, so don't invest more energy than necessary to find out.

### 2 DEVELOP THE FIGURE AND DETAILS

When you're ready to develop the details, begin sharpening the important areas by casting highlights and small shadows into the scene. You don't need the same level of sharpness everywhere. Focus on conveying the character; let any unimportant details merge into the background. You can always make supplemental drawings later. The illustration has to have the right mood. It's not a blueprint, so don't overwork it.

### 3 SPECIAL EFFECTS

Keep special effects on their own layers. Too many layers get confusing, but you want the flexibility to tweak the intensity of lighting effects or transparencies (such as smoke), especially if you're using blending modes such as Color Dodge.

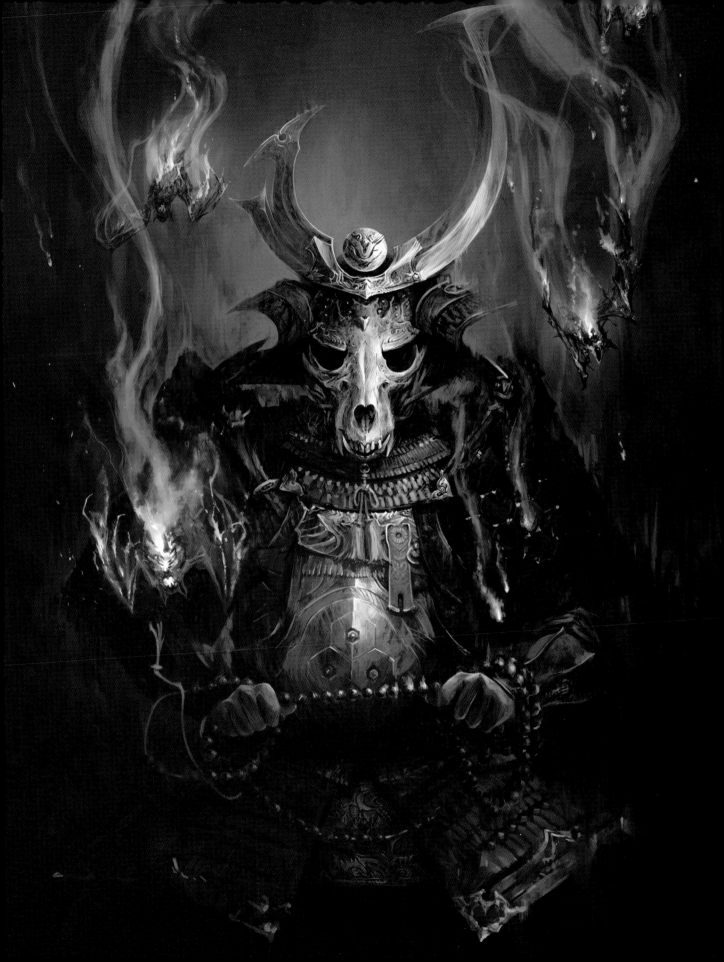

# PHOTO COLLAGE

Something you might want to consider is the use of photo collage. This is an option that's becoming a popular time-saving trick. Artists will digitally collage fragments of reference photography, masking out unwanted parts of photos, and stretching or transforming the pixels they like over the top of a drawing or base photo.

You can see here how skin textures and anatomical details from fish and lizards have been combined to create a lot of detail quickly. Be careful if you try this. You don't want to become a slave to the photos you happen to have available. You can accidentally find yourself limiting your ideas or getting stuck with mismatched lighting and perspective. I don't think this is a replacement for inventing ideas, but it's one way to cheat a bit and get some detail for free.

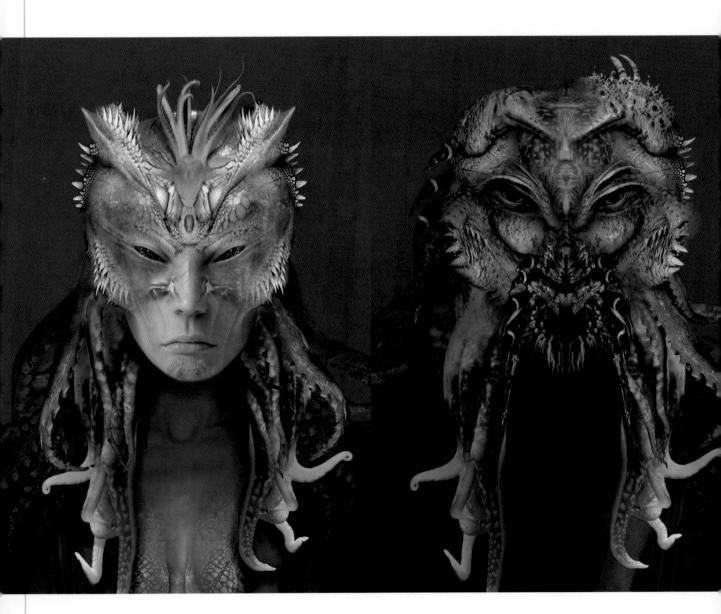

# SPEED PAINTING IS ABOUT SILHOUETTES

Of course you can guess by now, I feel it's more important to paint ideas quickly than to capture every tiny realistic detail. The modeling team will take care of that when the time comes.

To paint efficiently, start with big shapes first, what might be called *massing in*. In many ways, it's the opposite of tinting a drawing. Instead of starting with every detail defined in the drawing, we can build a very general shape first. Concentrate on trying to make larger forms look solid by painting planes of light and cast shadows.

Avoid detail for as long as possible until you can see the structural shape. If you're selective about the amount of detail you build on top of the shape, you can resolve things quickly. Focus tighter detail on important bits, and the viewer's imagination fills in details that aren't there.

Again, this isn't helpful to the modeler at all, is it? You will still need to make orthographic drawings for them. This is a kind of sketch artist's trickery that can suggest a mood or imply a character without painting more than necessary.

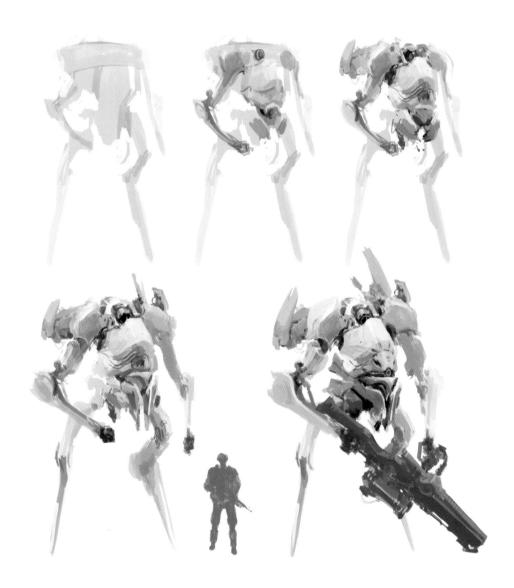

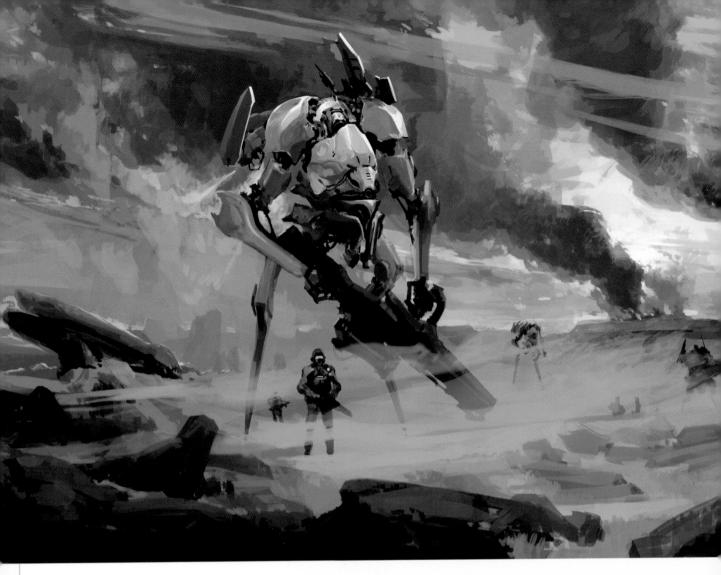

# SELL THE STORY
# AND THE SETTING

As a character designer, the environment is not technically part of your job, but it's too useful a tool to ignore. Inserting your creatures and characters into a background can make a huge difference in the presentation. Even the most basic suggestion of a landscape and a few clues to a story going on, and suddenly your character comes to life.

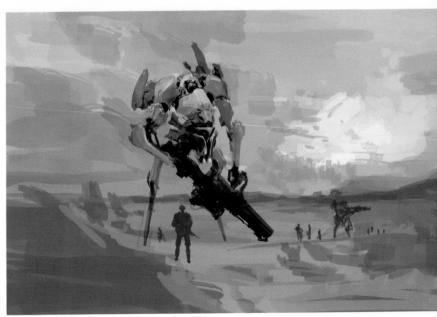

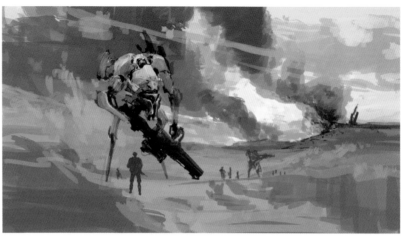

### DEVELOP THE COMPOSITION

Work larger to smaller, adjusting the big compositional shapes before going in to create smaller details. It will save you time to go slower than to go faster. If you dive into detail first, you always end up erasing it when you make compositional changes.

### CREATE LAYERS

When building up your environment, work in layers for the foreground, midground and background. You can make changes to each layer without disturbing the others.

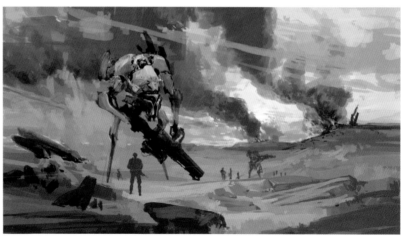

### ADD DETAILS

You can draw focus to your main character by clustering the sharpest details and the highest contrasts close to the character's head. Fade off detail toward the edges of the image. Other areas can be important, but they should never be as sharp or as contrasted as the primary focus. There can be only one!

# IT'S ELEMENTAL, MY DEAR WATSON!
## *ELEMENTAL THEMES*

As we begin these projects exploring illustration vs. straight-up design, let's begin with an exercise on materials and surface qualities. This is a great example of something you would need to render in tonal values, instead of drawing in detail. Our goal is to design a matching set of characters representing the elements *earth*, *wind*, *fire* and *water*. How would you personify each element? What kind of anatomy do they suggest? Keep in mind, these characters don't have to be humanoid. They might be animalistic or monstrous creatures.

You can use the classic alchemical elements or design your own quartet of natural phenomena. Invent new elemental properties, such as *crystal*, *life force* or *mana*. Whatever it is, the overarching goal is a concentrated study of characters with nontraditional surface qualities and textures. Challenge yourself to paint the ephemeral qualities of light, temperature and transparency.

## FANTASY OR SCIENCE?

You might take a classic fantasy approach and consider these as mystical personifications of natural forces—literally a figure made of fire. Alternately, consider a scientific approach where technological mastery gives a creature elemental abilities—their bodies sheathed in ice or wrapped in levitating wind. Whatever approach you choose, further challenge yourself to make a matching set. These creatures should look like they are from the same fictional world.

The main goal of this challenge is how you'll render your designs in a convincing way. It will require research into the visual properties of each element: how fire and water transmit light, have sheen or reflection. How they cast or bounce light on the environment. How transparent objects can be suggested by clues such as distorting the background.

**BONUS ACHIEVEMENT**
Master O'Disaster

Provide a design for the wizard or scientist creating these creatures. Fill in the story, be it high fantasy, science fiction or whatever you can come up with.

**ACHIEVEMENT**
Elementary My Dear!

- As many research drawings of materials and surfaces as required
- A minimum of 4 illustrations of your Elemental creatures emphasizing their visual effects

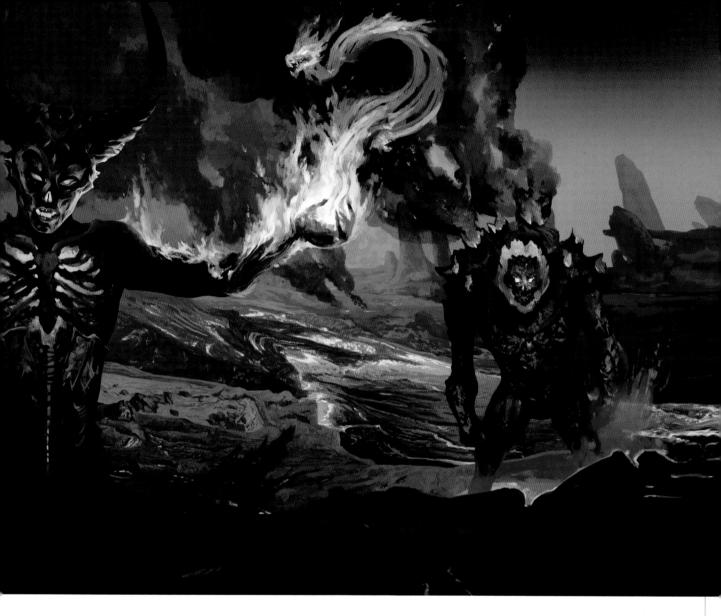

**BONUS ACHIEVEMENT**
**Flame on, Little Friends!**

Expand the understanding of your creature with a set of illustrations of its powers in action. Provide a minimum of 3 abilities in a set. Can it shoot jets of flame or make weapons of ice? These may take the form of fight scenes. Gain a tier for each set of Elemental Power storyboards.

- Tier 1-4

**BONUS ACHIEVEMENT**
**Appearance Is Everything**

Create supporting storyboards showing how your elementals manifest. Is your water elemental poured from a magic jar? Does it grow from a droplet or appear as a cresting wave? Work out a solution for the summoning animation of your creature. Gain a tier for each element described.

- Tier 1-4

# MOBY DICK:
## *REBOOTED CLASSIC*

The 1851 novel *Moby Dick* by Herman Melville is a story of Captain Ahab's obsession with hunting and killing a giant sperm whale. Ahab is seeking revenge for a previous encounter in which the whale destroyed his ship and severed his leg. Ahab's obsession eventually results in the loss of his second ship, his crew (except Ishmael) and his own life.

Your task in this project is to redesign a monstrous interpretation of the great white whale. Push the character design in your personal direction—negative or positive, realistic or fantastic.

### CREATE A FULL SCENE

The real challenge for the assignment is this: After you have completed the design, produce a final illustration showing your great whale as it would appear at the emotional climax of this classic man vs. nature conflict. Will the viewer first encounter the beast when underwater? Do you choose to show it breaching—launching itself out of the ocean? Or perhaps the encounter is in the middle of a raging storm?

We need more than just an orthographic drawing to convey the emotion of encountering this beast on the wide open ocean. It must be seen as Ahab's great nemesis.

Feel free to consider alternative retellings of the tale. Does this somehow take place in a desert environment? Is the whale a sandworm? Is it set in space or the upper atmosphere of a Jovian planet? Any kind of alternate universe retelling is up to you.

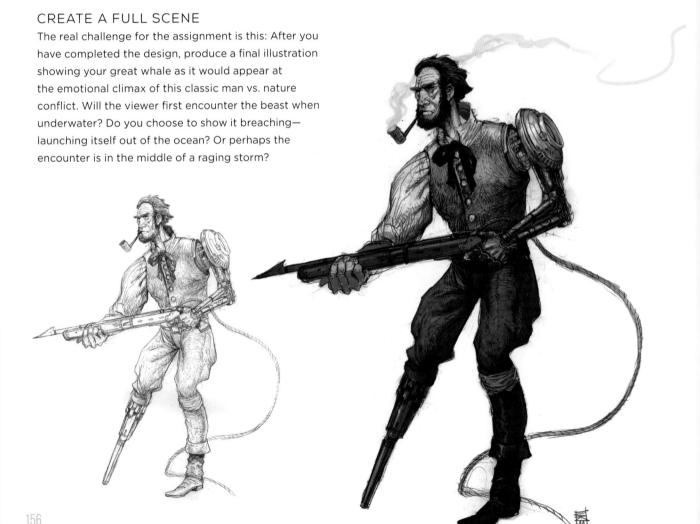

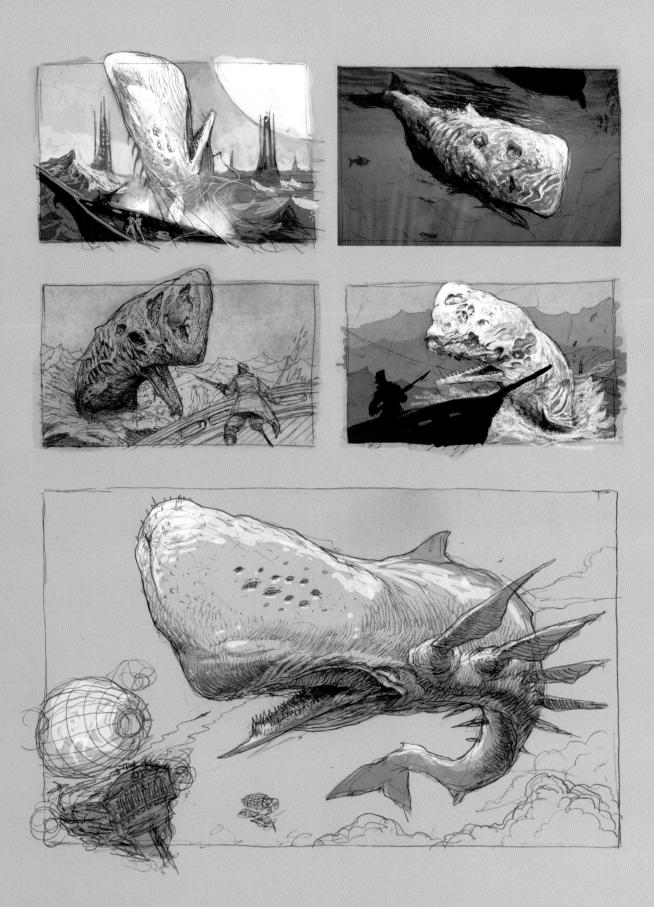

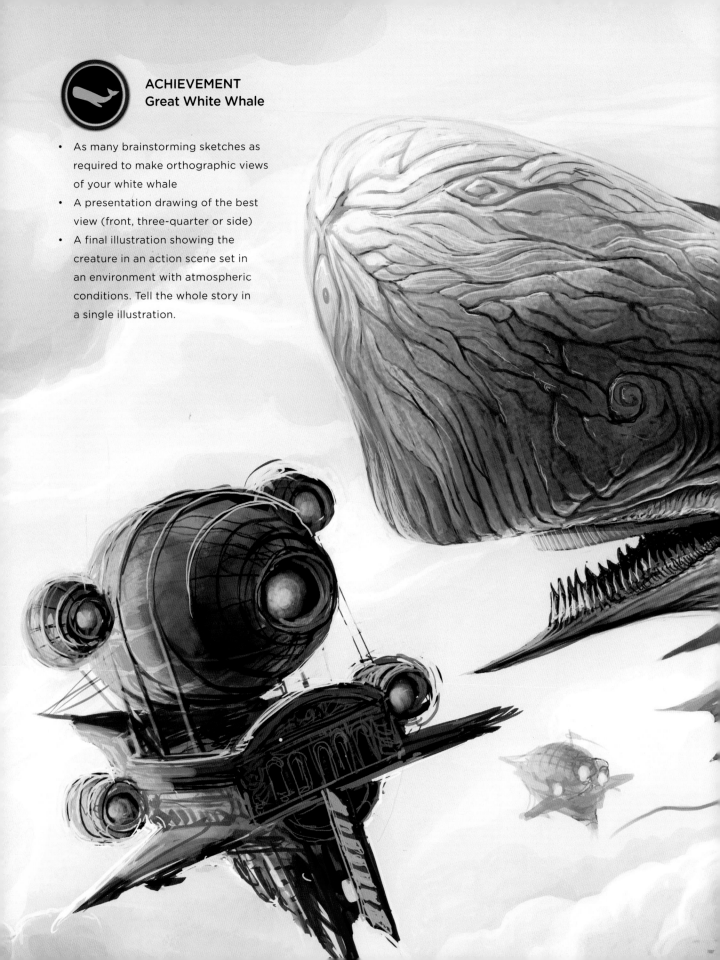

## ACHIEVEMENT
## Great White Whale

- As many brainstorming sketches as required to make orthographic views of your white whale
- A presentation drawing of the best view (front, three-quarter or side)
- A final illustration showing the creature in an action scene set in an environment with atmospheric conditions. Tell the whole story in a single illustration.

## BONUS ACHIEVEMENT
### Man on a Mission

Design your version of Captain Ahab. Provide a set of sketched orthographic views and a presentation drawing.

## BONUS ACHIEVEMENT
### Classics Illustrated

Any 3 presentation quality portraits (head and shoulders) of your vision for characters from *Moby Dick*: Ishmael, Starbuck, Queequeg, Stubb, Tashtego, Flask, Daggoo, Pip, Fedallah (descriptions are available on Wikipedia or I suppose you could read the book).

- Tier 1-3

## BONUS ACHIEVEMENT
### Able Seamen

For each finished illustration of a character rendered in action on a background, gain a tier.

- Tier 1-3

# BOTANICALS GONE WILD:
## ANTHROPOMORPHIC PLANTS

Your task in this project is to explore the concept of intelligent humanoid plant creatures.

The challenge is to take all the complexity of an exotic plant found in nature and rework it into a character with personality and emotions. The quality of the finished drawing will go a long way to make this convincing.

Your designs may be based on any species of plant or a combination of species. Consider cacti, carnivorous plants, fungi or exotic tropicals. Research into plant and flower forms is going to be key. There is incredible variety in nature, and you'll have to depict it properly.

### CREATE INTELLIGENT CHARACTERS
Your audience needs to grasp at first glance that these walking plants are self-aware. You must create a character that can engage with the audience. This means it needs a head and face, even if it's disguised. There has to be a way to imbue your design with personality and convey emotion.

Going further, can you solve this challenge more than once. If you were to do an entire project with plant creatures, how would you make different personalities come to life?

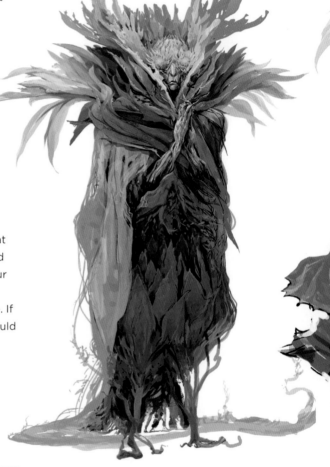

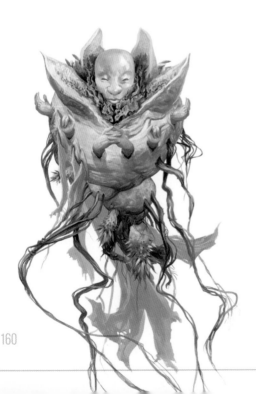

### DON'T MAKE THEM TOO HUMAN
Try to preserve the sense that these creatures are growing into their shapes. Avoid making them so humanoid that they appear to be normal people in plant clothing.

### TRY STRANGE IDEAS
An intelligent plant is already a weird idea. Why not go crazy with it? Consider ideas that might seem too bizarre for a traditional creature.

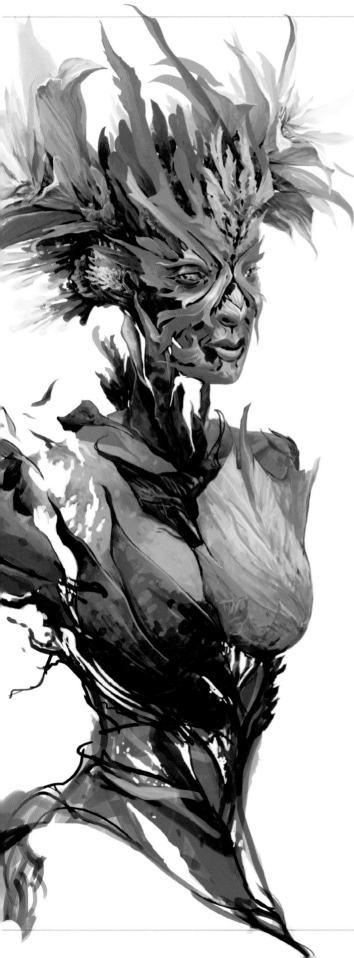

## ACHIEVEMENT
### Botanicals Gone Wild

- As much reference and research drawing as is required
- A minimum of 7 sketched variations of intelligent plant creatures
- One final illustration of your favorite design, painted to a high degree of realism

## BONUS ACHIEVEMENT
### Green Thumb

Additional sketches, up to 10, 13 or 19 total designs for intelligent plant creatures

- Tier 1-3 (+3,+6,+12 sketches)

## BONUS ACHIEVEMENT
### XenoBotanist

Upgrade 3+ more designs to finished illustrations. Gain a tier for each additional +3 upgraded renderings.

- Tier 1-4 (+3,+6,+9,+12 illustrations)

## BONUS ACHIEVEMENT
### Four Seasons

Take an appropriate botanical design and make illustrations of seasonal variations: spring, summer, fall and winter. Give each its own personality. Gain a tier for each additional seasonal set of 4 seasons.

- Tier 1-4

# PICTURES WORTH A THOUSAND WORDS:
## TELLING A STORY

What good is a character nobody cares about? I'm sure you've seen some wicked designs in films or games that just fall flat. There may be nothing wrong with the concept, but the personality is underdeveloped. I would say it's not reaching your emotions. Villains need to properly inspire fear, heroes need you to cheer for them, and sometimes that means first you must sympathize with them.

In this assignment your challenge is to take a single character and put them into a series of completely different moods. It will probably work best to use a humanoid character.

This might seem at first the same as any other storyboard, but you should strive for more than just stage directions or fight choreography. This time it is about the impact of color and tone combined with how the characters are posed. You're creating illustrations that tell the deeper story, not an animator's chart of mouth and eyebrow positions as you've done before.

### CREATE EMOTION WITHOUT CHANGING DESIGN

Keep in mind this is also not a matter of changing the underlying design. In fact, the costume or anatomy should remain the same, or at least changes should remain logically possible. An actor cannot change their body, but together the actor and director can create the mood with lighting, weather, camera angle, pose, and of course, facial expression. Even the use of props might come into play: a king with his crown worn proudly or with it broken in defeat. Pull out all the stops to make the viewer feel for the character.

Strive to make these emotional situations as different as possible: joy vs. despondency, triumph vs. humiliation. Put us through a roller coaster of emotions.

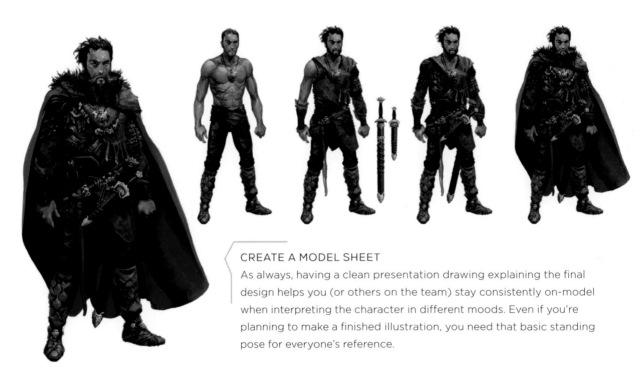

### CREATE A MODEL SHEET
As always, having a clean presentation drawing explaining the final design helps you (or others on the team) stay consistently on-model when interpreting the character in different moods. Even if you're planning to make a finished illustration, you need that basic standing pose for everyone's reference.

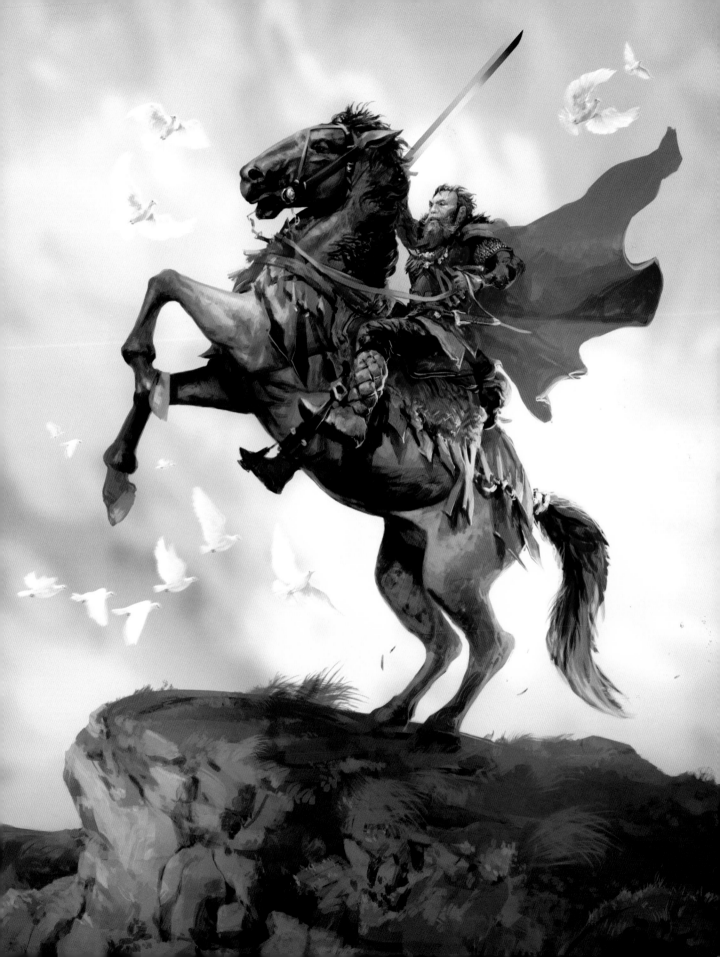

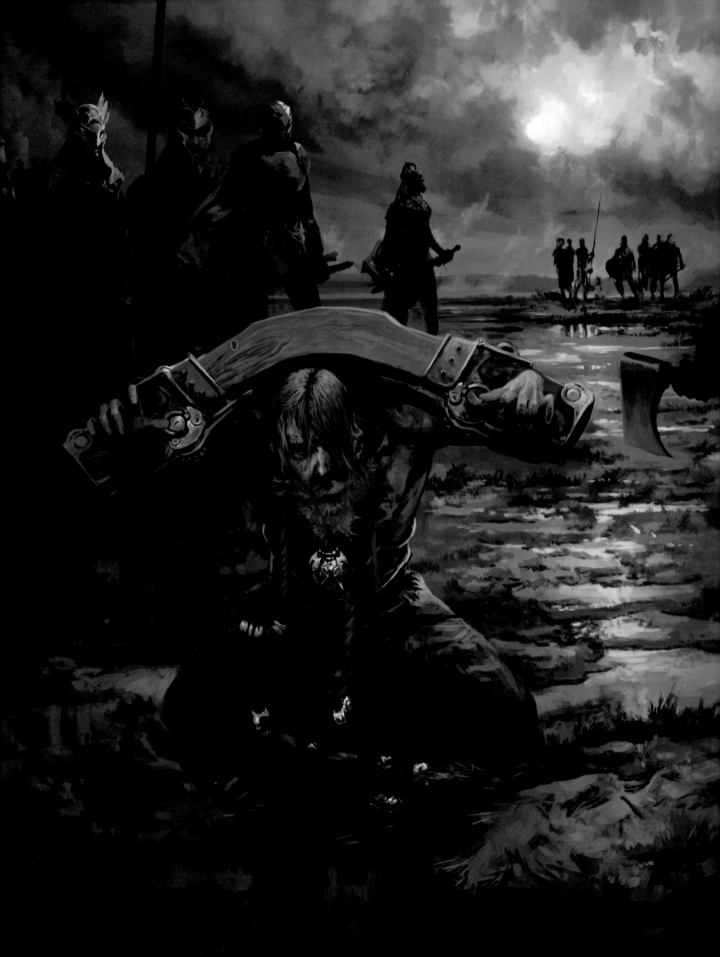

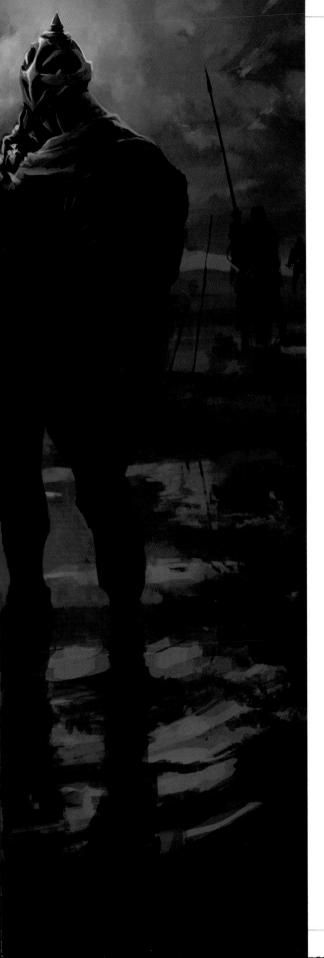

## CREATE A NEW EMOTIONAL SCENE

Before, we saw our hero in triumph, now in abject defeat. Remember, the character must be recognizable as the same person, even if their situation is completely different.

### ACHIEVEMENT
### Worth a Thousand Words

- Presentation sketches describing your character's physique and costume
- A neutral head-and-shoulders portrait of your character
- A pair of emotional renderings of your character with as wide a range of mood as possible

### BONUS ACHIEVEMENT
### Through the Wringer

Continue pitching emotional situations. Some suggestions include the agony of defeat, grim determination, broken spirit, adventure awaits! (optimism), brooding melodrama, loss and despair, drunken revelry, clinical analysis, worrying illness. How many can you come up with? For each new emotive rendering, gain a tier.

- Tier 1-5

### BONUS ACHIEVEMENT
### Masterpiece Theater

Expand your favorite emotional rendering into a cinematic narrative. Put the character into an environment; add background characters and other star actors. Make this a complete narrative of the climax of a story: your hero in grief over the death of a friend on the battlefield or your king in a celebratory wedding coronation. This is the kind of single masterwork painting that can sell an entire project.

# INVASIVE SPECIES:
## ADAPTATION TO ENVIRONMENT

There are many reasons for the design of a creature to be influenced by its environment. Creatures that we find in the desert tend to have a different look from those in arctic or jungle environments. Climate and terrain affect how these creatures have evolved.

Your goal in this assignment is to produce a creature and modify it based on different hostile environments.

For instance, if it would be at home in a temperate environment, how would evolution in an arctic zone change your creature's anatomy? Fur is a natural choice, but possibly there are other options. How would it look adapted to the desiccation of the desert or a swampy terrain?

By this time you've done a lot of creatures. Perhaps you can upgrade a previous creature or one of your hybrid humanoids from the *Experiments of Dr. Moreau* or the aliens from *Racial Profiling*.

### CREATE A FINISHED ILLUSTRATION

Of course, a set of simple design variations is not enough any longer. We're going to make this more interesting by painting finished illustrations showing your climate-adapted creatures in the worst possible conditions. What is the worst the local climate can throw at them?
- Sandstorm in a rocky desert
- Blizzard on a jagged glacier
- Miasmic swamp full of vapors and bugs
- Tropical rainforest in a torrential downpour
- Volcanic area—a smoky wasteland with drifting sparks, falling rock and ash

Strive to make these dramatic examples using atmospheric lighting and dramatic weather effects. These don't have to be earth climates. See if you can invent mystic realms or alien settings.

Consider adding a storytelling element. Show your creature about to pounce on a victim or on the march, maybe during a skirmish.

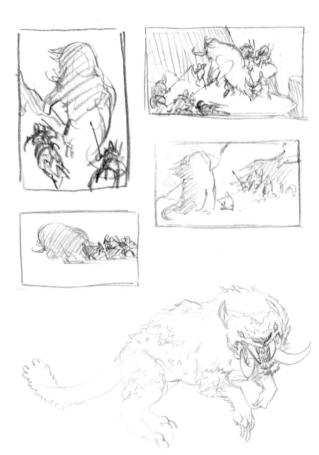

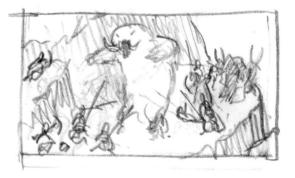

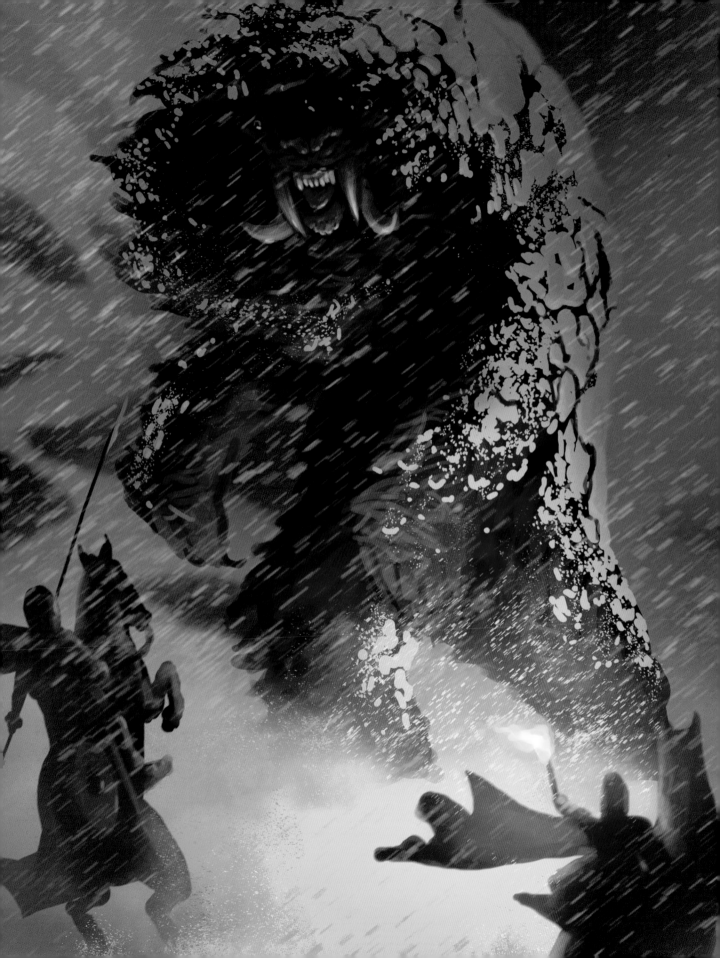

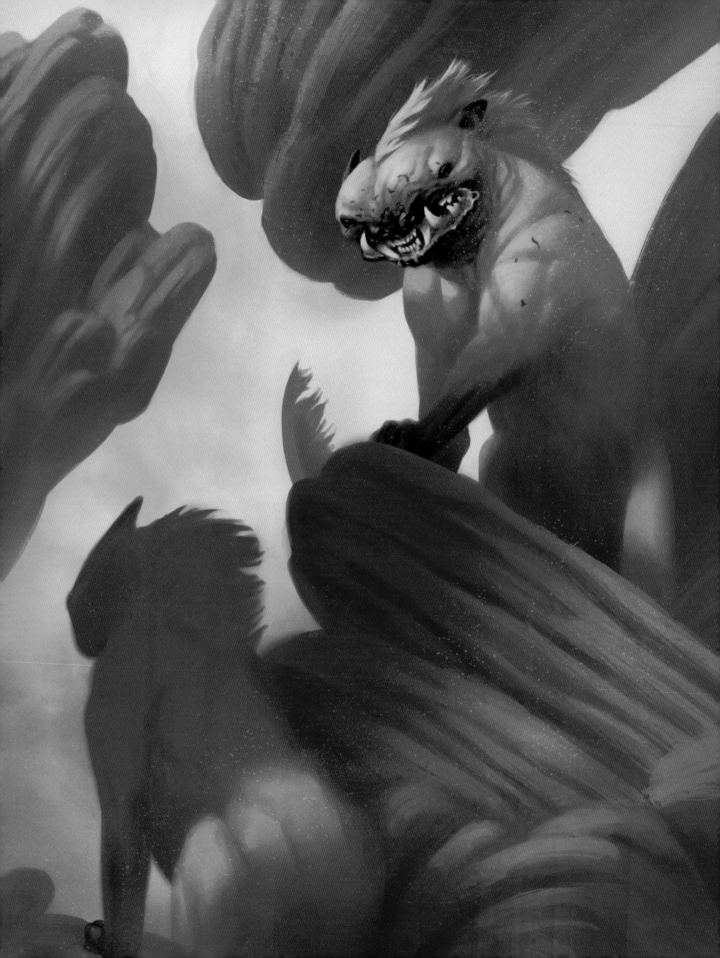

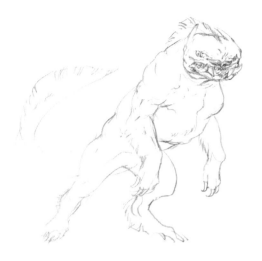

## ACHIEVEMENT
### Invasive Species

- A minimum of 12 sketches of creatures and possible adaptations
- A minimum of 3 presentation drawings of your final creature, with any magnified views or cross sections as required, showing survival adaptations. How do they breathe under water or live on an ice planet?
- A final illustration showing your chosen design painted into their environment with appropriate atmospheric conditions

## BONUS
## ACHIEVEMENT
### Climate Control

For each new illustration of your creature adapted to a new and different environment, gain a tier (+1 creature variation shown in context).

- Tier 1-4

## BONUS
## ACHIEVEMENT
### (Un)Natural History

Upgrade your entire ecosystem. Go back to *Predator and Prey: The Food Chain* and transpose those creatures into one of your fantastical environments. Create a *National Geographic*-type illustration where you show all of your creatures in a predation chain within a single illustration. For every 3 predators and prey you put into your illustration, gain a tier.

- Tier 1-3 (+3,+6,+9 upgraded and illustrated)

> DRAW THUMBNAIL SKETCHES
> Sometimes you want to make a series of very small compositional sketches in order to plan out the camera angle and setting. These are good for problem-solving, but you'd never show these to your directors. If you needed to get approval for the scene, you'd have to take a presentation drawing to get useful evaluation.

# CREATURES AT WAR:
## *MILITARY MONSTERS*

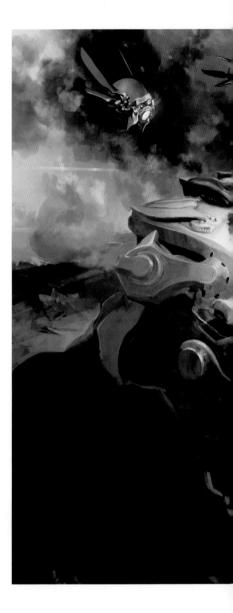

This project goes hand in hand with the next project: *Invaders From Beyond*. What if there was a science-fiction Earth in which all of our technological needs were based on biotechnology rather than machinery? We no longer build robots or computers. We have cybernetic engineered life-forms to serve those needs.

To put this in an action-adventure context, what if our society's advanced military-industrial complex had developed out of this advanced engineering?

### ADVANCED TECHNOLOGY

Modern infantries have smoke grenades, night vision and laser-guided missiles. Think about the idea of the power armor we have come to love in our science fiction. Right now we are working on strength-augmenting exoskeletons. Science fiction is becoming reality.

Taking it further, modern tanks and helicopters have reactive armor and antimissile defenses. We have weapons of great destructive power, bombers, stealth fighters and supercarriers. But we also have subtle things such as camera drones.

What would we create if we developed advanced bioweapons? Your solutions might be realistic—they may look like machines but be made of organic materials. They might be clones or nanotechnology, or they may be wholly imaginary creations more akin to dragons than tanks.

Don't pass up the opportunity to imply psychological factors. War is hell. We are talking about pure aggression, imposing one nation's will on another by force of arms. This is nasty stuff. It's very likely you want the look of these beasts of war to reflect that dark, negative tone.

**ACHIEVEMENT**
**Monster and Commander**

- As many brainstorming sketches as required
- A minimum of 5 presentation drawings of biotech weapons
- A final illustration showing this biotech in action. Make this a large, full-color finished piece demonstrating the look of the final project. Capture the shock and awe of modern warfare with massive explosions, smoke and fire, sizzling acid, spewing plasma, anything goes.

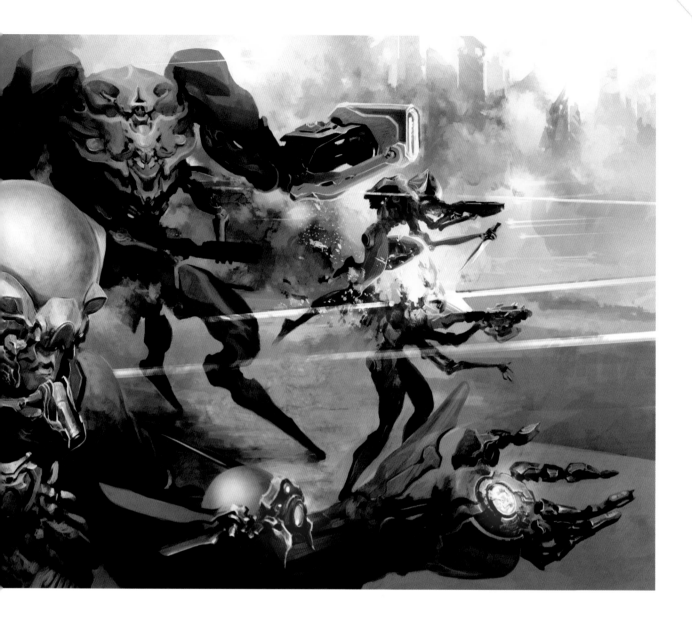

### BONUS ACHIEVEMENT
### Warmonger

Continue to expand your ideas. Sketch a minimum of 5 versions of a new living weapon. Choose the best of those sketches to upgrade to a final presentation drawing. For each new biomechanical design, gain a tier. (+5 sketches, +1 drawing per tier)

- Tier 1-5

### BONUS ACHIEVEMENT
### Military Industrialist

Go back and rework your finished illustration. For each new biotech weapon included in your final illustration, gain a tier. Your final painting should be a portfolio on its own!

- Tier 1-5

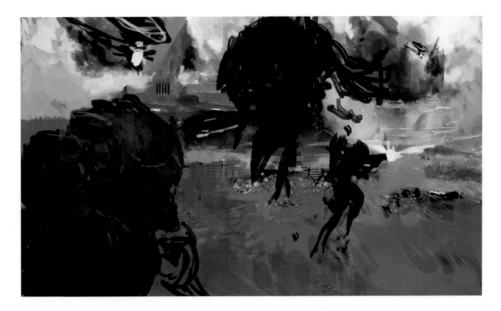

## 1 START WITH BIG SHAPES

The greatest difference between a painted illustration versus a presentation drawing is working massed tone. Unlike a drawing, roughed-in masses won't look like anything at first, but they will start to build a pattern of silhouette shapes that is more three-dimensional than a linear sketch.

Use a separate layer for each character silhouette so you can move, scale or edit each figure independently and still paint the background behind.

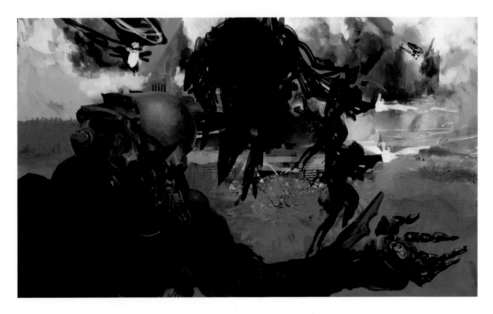

## 2 HOLD OFF THE DETAIL AS LONG AS POSSIBLE

If you zoom down to the details too soon, you might find yourself investing time in an area that gets covered up later. Try to set the composition first. Determine the relationship of how characters overlap, their relative size and where light and dark edges meet. Once you have that locked down, you can start adding surface detail.

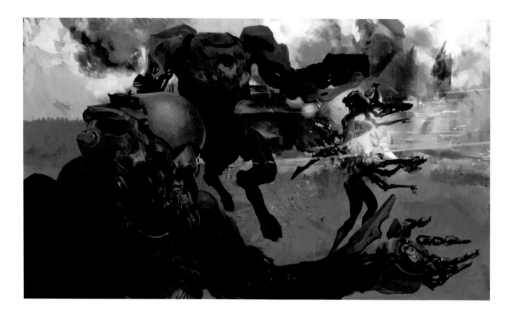

### 3 FOCUS ON THE HEAD

Typically, you want to focus detail on a character's head and chest. The design should draw the eye towards the face. If it's equally detailed all over, it can be confusing where viewers should be looking.

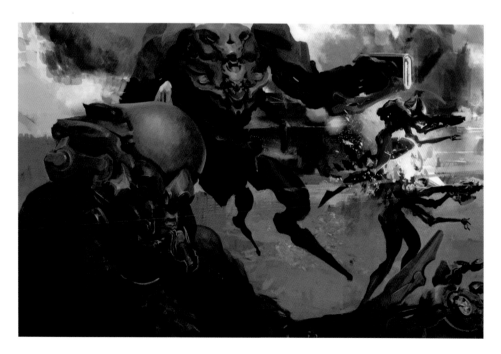

### 4 PRIORITIZE YOUR EFFORTS

A character illustration needs just enough background to tell the story. What's the least you can get away with? Suggest the chaos and smoke of the battlefield with a hint of the futuristic setting in the distance, but don't invest a lifetime in painting it. A glimpse of a destroyed city is pushed up into the corner and hidden behind smoke, so it's there subconsciously but doesn't distract from the characters.

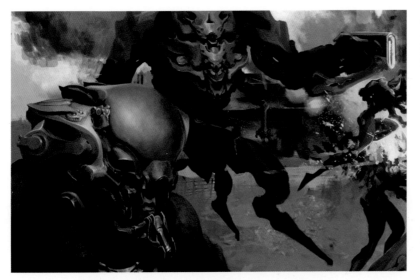

## 5 REFINE THE CHARACTERS

Comparing the first blocked-in shapes with the final finished image, you can see the composition was there from the beginning. The midground characters are backlit against flames, drawing focus to the big mech's weapon and the leaping figure.

With this kind of action plan, a lot can be done with silhouettes—saving most of your time and energy for the main character.

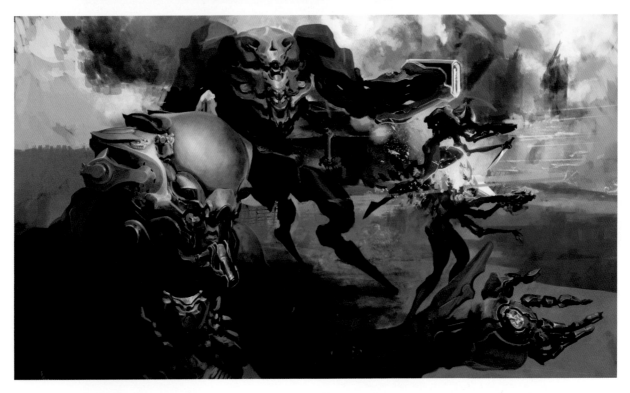

## 6 LIGHTING EFFECTS

As the painting takes shape, pay attention to the special effects. Paint energy beams and glowing light sources on Color Dodge layers (artificially brightening everything below).

Spotlight the main figure using a Curves Adjustment Layer, which allows you to play with value and contrast. Use the Quick Mask channel on any adjustment layer to paint in a mask that hides where your adjustment shows. Essentially, you can make a value change, then erase that adjustment, only allowing it to show up where you need it.

Use curves to tweak the foreground, midground and background zones in the painting to each have their own value range. In this case the layers become bluer and have less contrast as you move back in space.

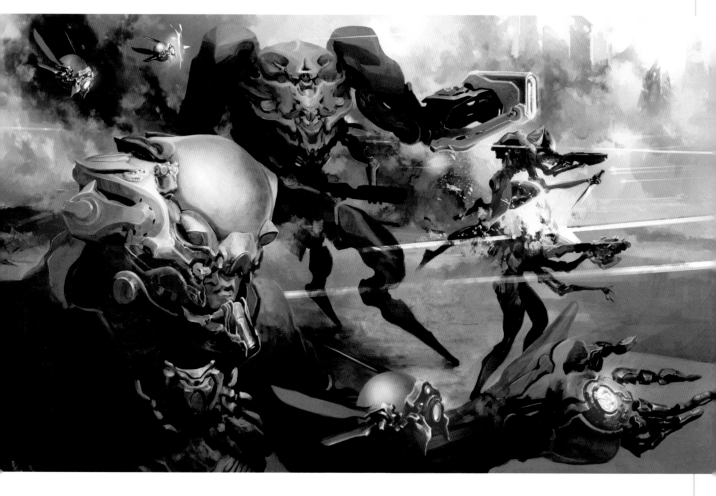

### FINAL DETAILS

The most eye-catching element is the main character's shiny helmet. It has the sharpest detail in the image but is also the highest contrast in the whole painting.

The head has been placed at the rule of thirds compositionally—not in the dead center, but at one-third over. This gives you a focal point with a clear directional composition. Everything in the image is pointing to imaginary enemies off screen. They should get a matching painting!

# CREATURES AT WAR:
## *INVADERS FROM BEYOND*

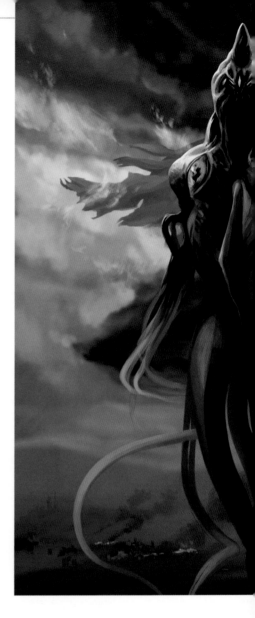

This project goes hand in hand with the previous project: *Military Monsters*. Having introduced the idea of an advanced technological military based on bioengineering, we can now turn to the subject of the enemy.

Your new task is to imagine an alien culture. They may be aliens arrived from space, extradimensional energy beings or a mystical race—demons, wraiths or elder gods.

You must design enemy forces capable of clashing with the advanced cyborg military you have already invented. Ideally you've come up with incredible war machines for the human forces. That will make it all the more challenging to invent alien invaders that pose a nightmare threat.

### CREATING ALIEN INVADERS

Would they have gigantic insectoid beasts of war? Or have huge space squid floating over the battle shedding living attack drones? Push your imagination beyond your human biotechnology to completely alien ideas. Think about asymmetry and highly organic forms, things that could not possibly be human in origin.

You might want to go back to the brainstorming exercise *Racial Profiling* and see if you can push any of your previous ideas to be worthy enemies for your futuristic military.

It's possible that your alien ideas will provoke new ideas for human troops. You can work these two exercises back and forth, continuing to up the ante.

**ACHIEVEMENT**
**All Your Base Belong to Us**

- As many brainstorming sketches as required
- A minimum of 5 presentation drawings of monstrous alien war beasts
- A final illustration from the alien invader's viewpoint, capturing the final battle for human existence

**BONUS ACHIEVEMENT**
**Space Invaders**

Continue to expand your ideas. Sketch a minimum of 5 versions of a new alien war beast. Choose the best sketch to upgrade to a final presentation drawing. For each new alien war beast, gain a tier. (+5 sketches, +1 drawing per tier)

- Tier 1-5

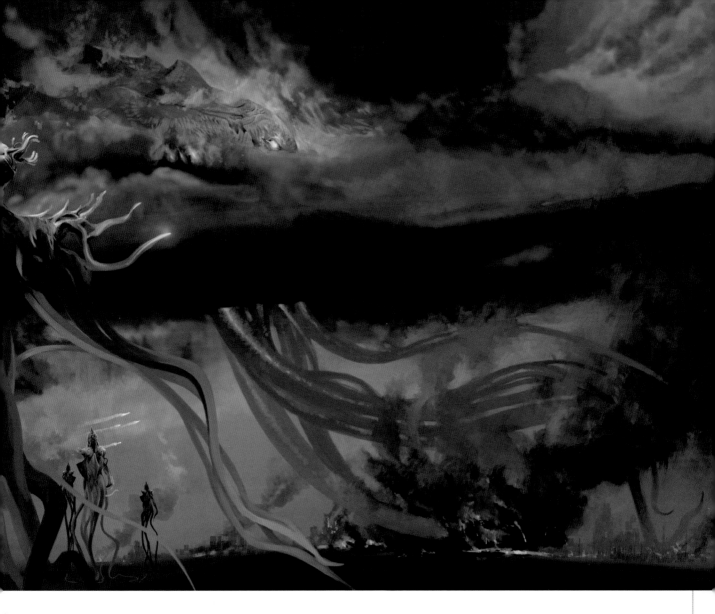

## BONUS ACHIEVEMENT
### Alien Overlords

Go back and rework your finished illustration. For each alien war beast included in your final illustration, gain a tier.

- Tier 1-5

### MINIMAL LAYERS IN AN ILLUSTRATION

Even though it is possible to stack an infinite number of layers and special effects in Photoshop, ultimately it's best to keep things simple. In this image there are only three planes: the background effect of the supercell clouds, then the painted elements of the alien mothership in the sky, its tentacles flaying the city, and the actual creatures in the foreground. The truth is, there's nothing actually painted behind the obscuring clouds and smoke.

The whole scene behind the characters only exists to convey the mood. It would be unnecessary work to design an alien mothership and then cover it up. You need only a few hints for the viewer to combine the elements into a story.

## 1  CREATE THE BASE LAYER

On the base layer we have the background effect of a supercell cloud formation. This painting is based on photographic reference of rotating thunderstorms. Think of this as the matte painting behind your character. You can hand-paint this digitally or create it with a photographic collage.

## 2  LAYER ON DETAILS

On the next layer paint a giant alien mothership half submerged in the clouds, its gigantic tentacles devastating a burning city below. Is this actually a huge alien creature? Or is it a massive machine? Who knows! It's just meant to imply a backstory. I've purposely hidden a lot of implied detail in the clouds. Anything covered by the clouds is not actually painted. This is, after all, just a supporting element for the character in front. If you needed to know what's under the clouds, you'd design the mothership for real with its own orthographic drawings.

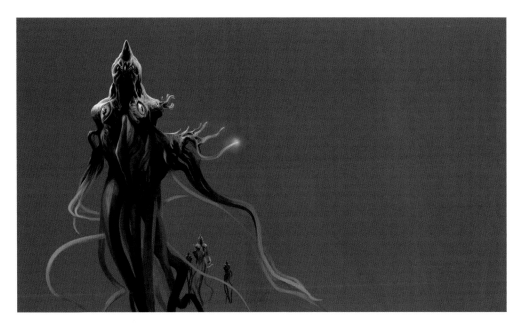

## 3 CREATE THE MAIN CHARACTERS

On the top layer we have our star actor! The giant alien striding towards us with a few more behind (quickly made by pasting and resizing the same drawing). When doing this, always spend a few minutes repainting the clones. It's lazy to leave them as identical copies.

This character was based on the idea of a walking squid. Did you know octopi (not squid) can really walk on land? Exaggerating from research really does give you the best ideas.

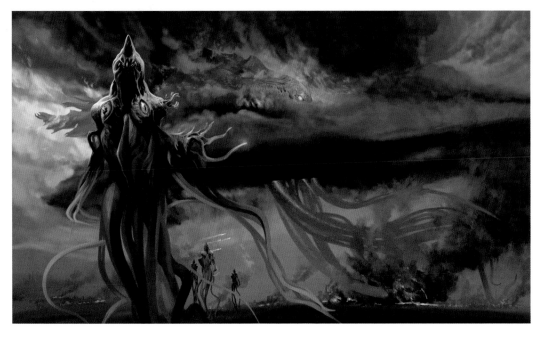

## 4 PUT IT ALL TOGETHER

While technically a character's design is just as useful with no background at all, you can see how this illustration sells your idea. You need to give only a few hints towards a story for viewers to invent a whole movie in their heads.

# THE WORLD TREE:
## *THE PEOPLE ABOVE*

This project goes hand in hand with the next project, *The World Tree: The Monsters Below*. We will begin with an alien setting: The entire surface of this planet is covered in a continuous jungle of miles-tall trees with a joined canopy. It is leafy and bright, home to any number of flying species. There is tremendous diversity of food, lush vegetation and animal life.

Down below, the world tree's herculean roots descend into thick beds of silty mud. The forest floor is in permanent twilight, suitable only for fungi, insects and monsters.

### DESIGN A TRIBAL CULTURE

Your task is to design an intelligent race of humanoids living among the sunlit branches. This is a primitive culture where people live in direct contact with nature. Consider a society where it was never necessary to develop technology as we know it. People live by working in harmony with animals, insects and plants.

In our own society, dogs are a perfect example. We have used them for hunting and combat, search and rescue, even guiding the blind. Looking at other animals, pigs are used to root out edible mushrooms. Cormorants can fish for us. Bees are put to work processing pollen into honey. Silkworms spin protein strands that become a luxurious fabric.

Your task will be to design the idyllic society your imaginary tribe has built based on domesticated and crossbred wildlife. Find ways to solve all the basic human problems of food gathering and production, clothing, shelter and, most importantly, security and defense. Do this all using biological, not mechanical means.

**ACHIEVEMENT**
**The People Above**

- As many brainstorming sketches as required
- A minimum of 7 presentation drawings of domesticated creatures
- A minimum of 5 presentation drawings of different forest-dwelling people. Explore social roles: Villager, Hunter, Chief, Youth, Elder, etc.
- A final illustration of a village up among the trees. Show your people and creatures living in harmony, working together. Describe their housing and artifacts.

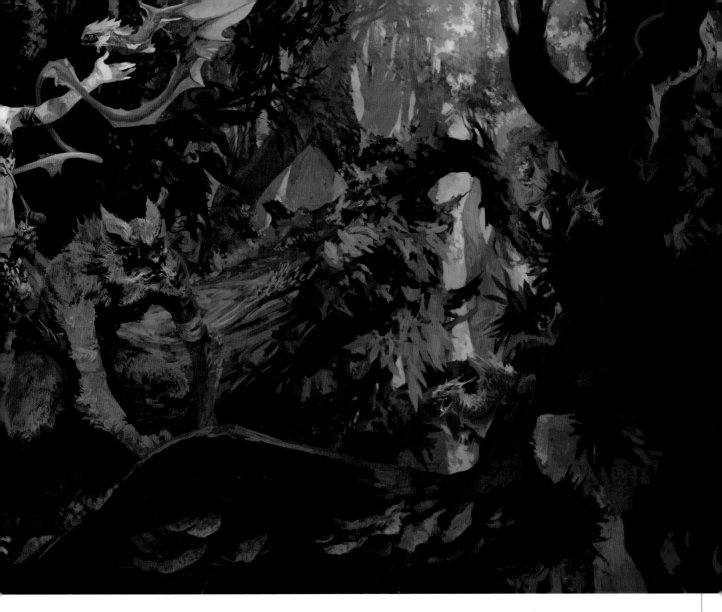

**BONUS ACHIEVEMENT**
**Well Bred**

Paint illustrations of your villagers and creatures working together. For each illustration showing a creature in action, gain a tier.

- Tier 1-5

**BONUS ACHIEVEMENT**
**Forest Allies**

Can you expand on the idea? Sketch new villagers or domesticated creatures, and choose the best sketch to upgrade to a final presentation drawing. For each new drawing, gain a tier.

- Tier 1-5

## 1 START WITH THE BACKGROUND

Rough in the background on its own layer before beginning to add characters over the top. Plan the composition of the giant trees to provide a good spot for the characters and to have an overall direction leading the eye into the scene.

Note how, even in a very rough stage, the image is broken into zones of color, becoming more blue-green and losing contrast as it goes off into the distance.

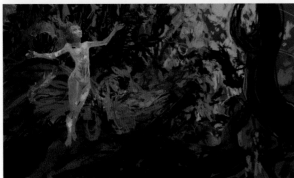

## 2 ADD ROUGH CHARACTER SHAPES

You get the greatest flexibility by painting each character on its own layer. This makes it easier to experiment with color changes or make adjustments in pose, size or position. As the pose is becoming final, concentrate on matching the color of the lighting to firmly place the character into the environment.

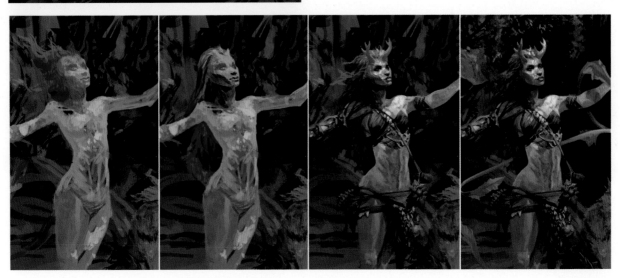

## 3 DEVELOP THE CHARACTER

A common technique for designing a costume is to sketch the figure naked, then add the clothing on top. In this example I started with a human skin tone but quickly color shifted it to an alien blue. Artists will often do the nude figure first to get the pose right, even if the costume is not revealing. With a body-hugging costume like this, it helps get the drape and tension of the belts and straps right. To emphasize that these people are at one with nature, illustrate seedpods and gourds she might use as containers, as well as shells or scales as decoration.

Painting progress can be so gradual it's hard to notice. But looking at the woman's face, you can see a gradual refinement from a coarse sketch to a more natural face. Paint in a leaf-dappling effect as you go—on a different layer for ease of editing. Try not to add extra layers if you really don't need them though. Too many digital tricks leads to an unnatural looking painting.

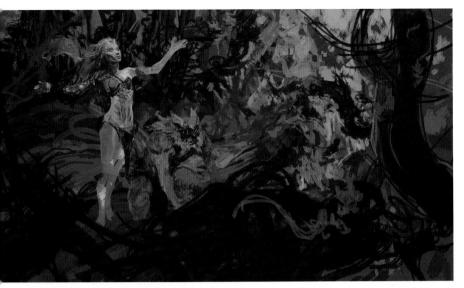

### 4 ADD A FOREGROUND

Partway through begin experimenting with a close-up foreground to add a layer of depth in front of the characters. Make a framing device around the characters and add a sense of the density of the forest.

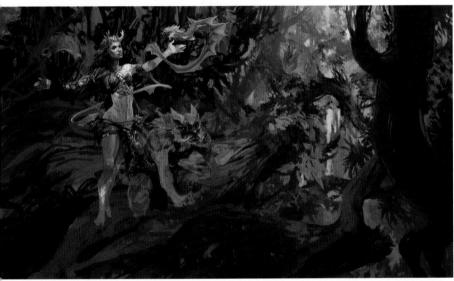

### 5 REFINE THE BACKGROUND

As the image advances, the background details get gradually tighter. You want to work from larger to smaller, paying the most attention to the edges between color zones. Pay close attention to the background behind the characters—build strong silhouette edges behind their heads, and carefully plan the points where they touch the environment. Spend time on the illusion of space created by the pattern of the bright teal sky holes between the tree trunks.

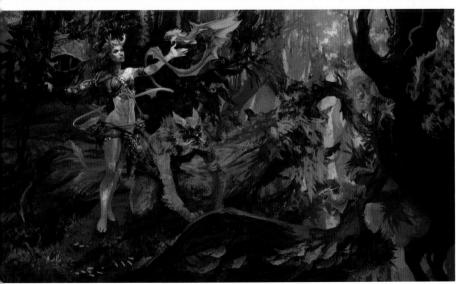

### 6 FINAL DETAILS

As the figures and the background are becoming finished, return to the foreground and begin adding smaller vines, moss and fungi on the branches. These details enhance the setting and serve to lead the eye inward.

The very last step is going back to the blue lizards on the right side and detailing them. This balances the composition and adds a bit more life to the scene.

# THE WORLD TREE:
## *THE MONSTERS BELOW*

This project goes hand in hand with the previous project, *The World Tree: The People Above*. Based on the same premise as *The People Above*, in this exercise we will describe the enemies living in the world tree's dark roots.

You may imagine a monstrous race existing down in the dark, feeding on grubs and fungi, or merely frightened prey for your horde. Perhaps they could be an intelligent race of humanoids with their own dark culture: worshiping strange gods down in between the roots, crafting poisons from vile fungi, interbreeding and cannibalizing, periodically swarming upwards seeking more delicious prey.

While your people above live in harmony with nature, the monsters below may have enslaved beasts they now breed for warfare. As well, there are even more dangerous creatures roaming in the dark, things that all tribes would have reason to fear.

### CREATE SILHOUETTES FIRST

This sketch was built with a slightly different process. Each major shape was made by drawing with the lasso and filling with the gradient tool. This way, instead of building up shapes from brushstrokes, they are more like a collage of cut paper silhouettes. This method allows you to see the composition very quickly. Each silhouette shape (on its own layer) can be separately adjusted for color and value before you begin painting details. Even without any drawing you can get the sense of a cavernous underground space filled with gnarled tree roots.

**ACHIEVEMENT**
**The Monsters Below**

- As many brainstorming sketches as required
- A minimum of 7 presentation drawings of enslaved beasts or wild predators
- A minimum of 5 presentation drawings of different root dwellers. Explore social roles: Slave, Warrior, Champion, Shaman, Stalker, etc.
- A final illustration of your creatures on the forest floor. Describe their grim existence.

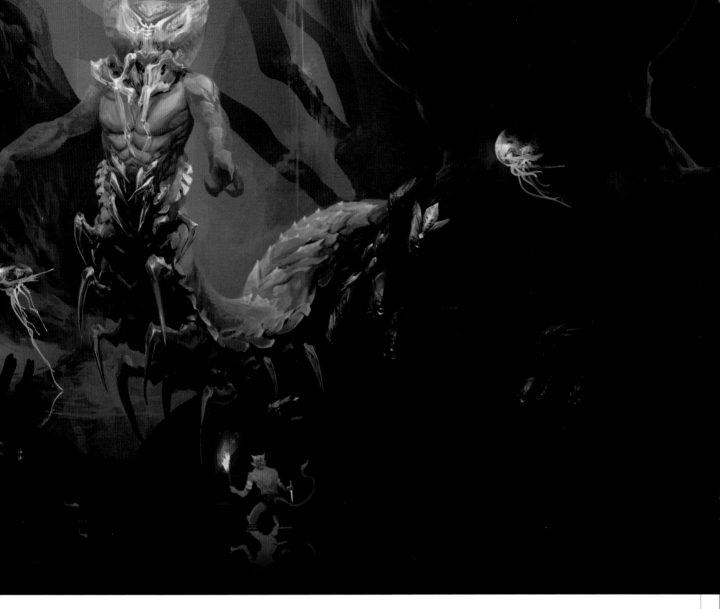

## ADD DETAILS ON TOP

After flattening a copy of the silhouettes, the details are painted on top. Colors can be sampled right from the sketch using the eyedropper tool, making it an easy matter to sculpt volume and detail on top of the flat design.

Smaller creatures and atmospheric details are added last, always working larger to smaller, so you know the composition and color space are correct before you invest more effort.

### BONUS ACHIEVEMENT
**Down in the Depths**

Invent key moments to illustrate, e.g., a raiding party attacking the leaf eaters or a battle with a wild predator. For each additional finished illustration of conflict, gain a tier.

- Tier 1-5

### BONUS ACHIEVEMENT
**Night Stalkers**

Can you expand on the idea? Sketch new enslaved beasts or tribal warriors and choose the best sketch to upgrade to a final presentation drawing. For each new drawing, gain a tier.

- Tier 1-5

PLATINUM ACHIEVEMENT
DESIGNING CREATURES & CHARACTERS

# AUTHOR'S NOTE: THANKS FOR PLAYING!

So, we've reached the end of the projects! We've covered the concept design process from how to generate a fountain of ideas to solving how creatures and characters move and act, and we've proven we can sell the project with awesome illustrations of your characters in action.

I hope you've grabbed the opportunity to do your best work and plenty of it. Your skills are growing stronger with every achievement you complete.

Art is one of the greatest human achievements, but it is within reach of anyone who is willing to put in the work and hone their talents.

As a student in art school, I always felt slightly out of place studying fine art painting and commercial illustration but knowing I was interested in gaming, comics and works of the imagination. These days people like us know exactly what we want: a career in video games or in film and animation.

I wrote this book for everyone out there like my younger self: the aspiring artist with the unbounded imagination who wants to put that mind to work on something they love.

Bringing entertainment to people is one of the most rewarding things an artist can do. We bring much needed escape and inspiration into people's daily lives, and we have so much fun doing it.

We have only one life to live and nobody should spend it on anything less than their passion.

And I know that many of you will achieve your goal: to level up from Dreamer to Professional Dreamer, all based on the hard work you put into your drawing every day.

Best of luck to everyone! And I hope to see your work in the games I play next or the movies I watch!

~Marc

# INDEX

a content + ecommerce company

Other fine IMPACT Books are available from your favorite bookstore, art supply store or online supplier. Visit our website at fwmedia.com.

20  19  18  17  16    5  4  3  2  1

DISTRIBUTED IN CANADA BY FRASER DIRECT
100 Armstrong Avenue
Georgetown, ON, Canada L7G 5S4
Tel: (905) 877-4411

DISTRIBUTED IN THE U.K. AND EUROPE
BY F&W MEDIA INTERNATIONAL LTD
Brunel House, Forde Close, Newton Abbot, TQ12 4PU, UK
Tel: (+44) 1626 323200, Fax: (+44) 1626 323319
Email: enquiries@fwmedia.com

ISBN 13: 978-1-4403-4409-1

Edited by Beth Erikson
Designed by Jamie DeAnne
Production coordinated by Jennifer Bass

# ABOUT THE AUTHOR

Canadian-born artist Marc Taro Holmes got his start in video game development in his hometown of Edmonton, Alberta. He worked as an interface designer, concept artist and art director with the then independent startup BioWare Corp. as they developed the fan favorite RPG series *Baldur's Gate* and *Neverwinter Nights*.

His work as a conceptual designer led him onto other studios, lending his visual imagination to projects as diverse as Turbine Inc./Midway Games' *Lord of the Rings Online*, Microsoft's *Age of Empires 3*, and their science fiction *Halo Universe*. His later work led him into the world of feature animation at Imagemovers/Disney. Today he works independently as a fine artist and art instructor, and continues to do design work for his first love, fantasy RPG games, most notably on Bioware/EA's *Dragon Age* series.

Marc has always based the inspiration for his designs on learning from the real world: sketching in museums, on the street, and traveling to draw exotic locations in Europe and Asia. As such, he is also the author of *The Urban Sketcher: Techniques for Seeing and Drawing on Location (North Light Books, 2014)*.

Marc publishes a free blog about art and drawing at citizensketcher.com, where you can find a steady stream of his sketches and stories about living an artist's life alongside a growing library of free drawing tips and painting demos.

# CONTRIBUTORS

## PAUL YATES

Paul Yates is an up-and-coming illustrator working out of the greater Montreal area. His deep love of the craft and passion for visual storytelling is the driving force behind his work. He hopes to leave a legacy that ushers in a new wave of modern myth for the next generation of readers, viewers, players and creators.

Paul is the illustrator and coauthor of the upcoming graphic novel *Halcyon*. Previous to this, his work has been featured several times in the Quebec comic anthology *Zidara 9*.

Paul's portfolio can be found at creyates.com.

You can follow Paul's progress down the road to mastery on his blog facebook.com/creyates where he regularly posts current works in progress, experiments and insights into his process.

## SEAN ANDREW MURRAY

Sean Andrew Murray (seanandrewmurray.com) is a freelance illustrator, concept artist, author and educator who has worked in the entertainment industry for nearly fifteen years.

The bulk of his career so far has been spent as a video game concept artist, working on such titles as *Dungeons & Dragons Online*, and *Kingdoms of Amalur: Reckoning*.

His freelance client list includes Legendary Pictures (Guillermo Del Toro), Dreamworks, Disney-Hyperion Publishing, Sideshow Collectibles, CoolMiniOrNot, Wizards of the Coast, Lego, EA Games, Privateer Press, Fantasy Flight Games, White Wolf Games, *ImagineFX* magazine and 3DTotal.

Sean was a finalist for a medal in the 20th annual *Spectrum: The Best in Contemporary Fantastic Art* competition and his work has been chosen for the past eight Spectrum annuals. He was also nominated in 2015 for a Chesley Award in the category of "Unpublished Black and White Work."

The production of Sean's illustrated fantasy book, *Gateway: The Book of Wizards*, was funded by a successful 2012 Kickstarter campaign. The book was a primer for a fantasy world centered on a vast city called Gateway, which Sean has been working on in his sketchbooks for more than fifteen years.

# DEDICATION

This book is the result of years reading comics, obsessively studying book cover illustrations, and most importantly, playing a lot of *Dungeons & Dragons*. If it had not been for my indulgent parents stocking my childhood library with science fiction and fantasy paperbacks, I would never have had the creative career I've enjoyed thus far.

It turns out, developing my imagination was the greatest gift of all.

This book is dedicated to them: Mary Fujiwara, Kenneth Morgan and Allen Holmes.

# Ideas. Instruction. Inspiration.

**Download FREE achievement icons at impact-books.com/designing-creatures-and-characters.**

**Check out these *IMPACT* titles at impact-books.com!**

These and other fine **IMPACT** products are available at your local art & craft retailer, bookstore or online supplier. Visit our website at impact-books.com.

Follow **IMPACT** for the latest news, free wallpapers, free demos and chances to win FREE BOOKS!

*Follow us!*

## IMPACT-BOOKS.COM

▸ Connect with your favorite artists

▸ Get the latest in comic, fantasy and sci-fi art instruction, tips and techniques

▸ Be the first to get special deals on the products you need to improve your art